CONSTANTINOPLE

AGENTS

AMERICA .	THE MACMILLAN COMPANY
	64 & 66 FIFTH AVENUE, NEW YORK
AUSTRALASIA	THE OXFORD UNIVERSITY PRESS
	205 FLINDERS LANE, MELBOURNE
CANADA	THE MACMILLAN COMPANY OF CANADA, LTD
	ST MARTIN'S HOUSE, 70 BOND STREET, TORONTO
INDIA . .	MACMILLAN & COMPANY, LTD
	MACMILLAN BUILDING, BOMBAY
	309 BOW BAZAAR STREET, CALCUTTA

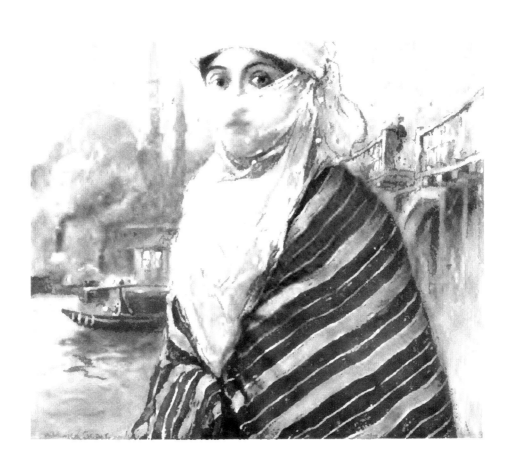

A TURKISH LADY IN OUT-DOOR DRESS

CONSTANTINOPLE

PAINTED BY WARWICK
GOBLE · DESCRIBED
BY ALEXANDER VAN
MILLINGEN, M.A., D.D.
PUBLISHED BY A. & C.
BLACK · LONDON · MCMVI

CONTENTS

CHAPTER I

CHAPTER II

CHAPTER III

CHAPTER IV

CHAPTER V

CHAPTER VI

LIST OF ILLUSTRATIONS

Map of Byzantine Constantinople at end of Volume

CONSTANTINOPLE

CHAPTER I

THE MAKING OF CONSTANTINOPLE UNDER CONSTANTINE THE GREAT

328–337 A.D.

THE foundation of Constantinople was an event of the utmost political significance. That personal feelings actuated Constantine the Great in the decision to establish a seat of government far from the walls of Rome is doubtless true. The insults to which he was exposed, on the occasion of his visit to the ancient capital of the Empire, in 326, on account of the execution of his wife and of his son, could not fail to annoy him, and make him willing to shake the dust of the rude city from off his feet. To have a placard put on his palace gates comparing him with Nero was not flattering. Certainly the Roman populace did not make respectful subjects. Diocletian also, before Constantine, had found Roman citizens insolent, and

1

fled from the slings and arrows of their sarcasm
without waiting to meet the Senate, or to be
invested with the consular dignity. But after all,
personal feelings go only a short way towards the
explanation of an event so serious in the history of
the Roman State as the establishment of another
seat of imperial authority. The volume and force
of a mighty river might as well be explained by the
drops of a shower which fall into its current Con-
stantine was too great a statesman to be swayed by
mere personal impulse. The foundation of Constan-
tinople was the outward and visible sign of profound
changes in the ideas and policy created and long
embodied by the city enthroned beside the Tiber.
It was the expression of the spirit of a new epoch, as
much so as the foundation of Alexandria signified a
change in the political conceptions of the Hellenic
world, or the building of St. Petersburg marked the
new aspirations heaving in the heart of Russia, or
the erection, in more recent times, of Washington
or Ottawa proclaimed the birth of new common-
wealths, and the application of new principles.
Old ideas and ancient institutions cannot be altered
in one day, or at the caprice of one man. They
are not the flimsy things which can be created or
destroyed by the wave of a magician's wand. Con-

THE QUAY IN GALATA

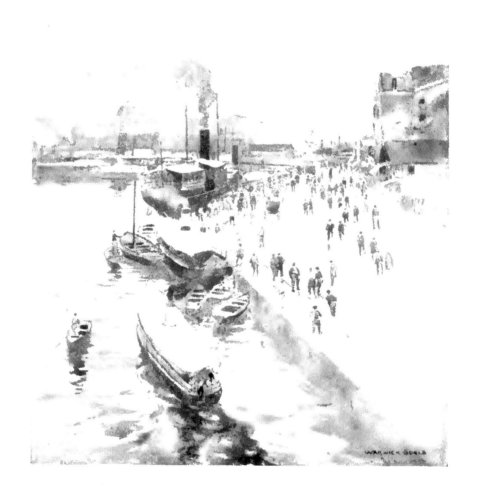

stantine only placed the copestone on an edifice which other hands, before his reign, had gradually raised from the foundations to the point demanding completion. He finished what others had begun. The creation of the new capital was the result of causes, long in action; not a whim or matter of taste.

In the first place, the political relation of the city of Rome to the Roman world had undergone a fundamental change. The citizens of that wonderful city were no longer the proprietors and sovereigns of the realm over which the Roman eagles had spread their wings. The Senate which assembled in the Curia, the people which gathered in the Forum Romanum, had ceased to rule subject cities and nations. That glory had departed. In Gibbon's mordant language, " The Senate was left a venerable but useless monument of antiquity upon the Capitoline hill." Every freeman within the Empire's bounds was now the equal of the men whose forefathers had been the kings of the world. Rome was now only one of the great cities of the Roman State, differing from her peers only in the memories and the prestige of a happier and grander past. The government of the world by the city had broken down, and was vested in

the hands of one supreme man. And that man had gradually become an absolute lord and monarch ; who exercised plenary authority wherever he chose to reside, who decked himself with jewels and resplendent robes, who made his throne the lofty peak of a vast hierarchy of nobles and officials, and introduced new methods of administration ; a man, perhaps, without a drop of the blood which Romans proudly bore, but a rude provincial, yet to whose will the Eternal City bowed as humbly as the remotest village beneath his sceptre. If a Cassius still lived he might, pointing to the Master of the Empire, well exclaim, "He doth bestride the narrow world like a Colossus, and we petty men walk under his huge legs, and peep about to find ourselves dishonourable graves. . . . Rome, thou hast lost the breed of noble bloods!" That a city which had been sovereign and self-centred should remain the head and representa-tive of a cosmopolitan State, and of an autocratic Government, was something incongruous and unnatural.

Nor was this the only respect in which the old order had changed and given place to new. Under Constantine the attitude of the Roman Government towards the Christian Church was the direct

opposite of that maintained by his predecessors. What they had regarded as a hostile organisation, he welcomed as an ally and friend. What they had endeavoured to uproot and destroy, he cultivated and supported. That he entertained a sincere respect for Christianity as a moral and social force, and believed that there was something Divine associated with it, cannot be doubted. And in his opinion, it was the part of true statesmanship to accept the religious and moral revolution that had come into the world, and to utilise it for the welfare of the Empire. This is not the place to discuss the question how wisely the alliance between Church and State was effected, or to decide how much the parties to the union thereby gained or lost. It is enough for our purpose to recognise that the union introduced as profound a change of policy as can be introduced into the affairs of men, that it widened the breach between the past and the present, and rendered the embodiment of the new system of things in forms peculiar to itself perfectly natural, if not inevitable. This was the more certain to occur, seeing Rome continued to be the centre of opposition to the new faith.

Yet another change in the Roman world which explains the appearance of a new capital was

the increased importance and influence of the
Eastern part of the Empire. Not only " captured
Greece " but captured Asia also " led captive her
captor." The centre of gravity was now in the
East. There commerce was more flourishing, and
intellectual life more active. There the population
was larger, and grouped in more important cities.
There Christianity had its home. Nor was it only
in thought, and art, and temper that the East
exercised an ascendency. It was, moreover, the post
of greatest danger. Its frontiers were exposed to
the most formidable attacks which the Roman arms
were now called to repel. The secular hostility of
Persia along the Tigris and Euphrates, the in-
cursions of Goths and Sarmatians across the lower
Danube into the Balkan lands, demanded constant
vigilance, and involved frequent warfare. The
military front of the Empire was turned eastwards.
There " the triumph of barbarism " was meanwhile
to be chiefly contested.

But to realise all the circumstances under which
Constantinople was founded, we should remember
yet another fact. The rule of the Roman world
by one man had broken down, just as the rule of
that world by the citizens of Rome had failed A
single arm, it was discovered, could not defend the

GALATA FROM THE AQUIDUCT
OF VALENS

Th Galat Tower, which is such a prominent feature
from this standpoint, is used as a station for signalling
any outbreak of fire, and also the quarter of the city
in which it occurs

frontiers of that vast realm against the numerous and fierce foes who threatened its existence; or repress the insurrections which ambitious men readily raised in widely scattered provinces, when the central authority was too distant to strike promptly and with the necessary vigour. Hence the famous scheme of Diocletian to divide the burden of defending and administering the Empire between four rulers, bound to one another by community of interest. As originally devised, it was a short-lived scheme. But it was superseded only so far as its details were concerned; its fundamental idea had come to stay. At first sight, indeed, the restoration of the system of single rule, in the person of Constantine, seemed to imply the abandonment of the multiple form of government which Diocletian had established. Possibly Constantine may have entertained such a purpose for some time. But eventually he adhered to Diocletian's plan, and thought to improve upon it by the introduction of the dynastic and hereditary factor, hoping that by distributing the government among members of the same family, joint rule would prove more cordial and permanent, because resting upon a more solid basis. Accordingly, he arranged that after his death the government

should be divided between his three sons and two nephews.

This was an excessive partition of power, and proved unsatisfactory. But the view that the welfare of the State required the attention and abilities of more than one ruler was consistently upheld, so long as Western and Eastern Europe formed integral parts of the same dominion.

As a consequence Rome ceased to be the capital of the Empire, even in the ordinary acceptation of the term. For multiplicity of rule involved, necessarily, as many seats of imperial administration as the number of rulers associated in the government of the Empire. Hence, under Diocletian, four cities boasted of being capitals. Furthermore, the selection of what cities should enjoy that honour would be determined by their fitness to become natural parts of the new organisation of the Roman world. Even Rome's claim to be one of the capitals would be submitted to that test. And when so submitted, the claim of the Eternal City was disallowed even in that portion of the Empire which included Italy, where, for strategic reasons, the choice fell first upon Milan and subsequently upon Ravenna. When it came to the turn of the East to provide suitable seats

of government, the honours were shared between Singidunum, near the modern Belgrade, and Nicomedia in Asia Minor. But for reasons which will immediately appear, Constantine preferred Byzantium, and, having changed the comparatively insignificant town into a splendid city, named it New Rome and Constantinople, to become the sole centre for the administration of the Eastern portion of the Empire, and the local habitation of the spirit of a New Age.

It would appear that the selection of Byzantium for its great destiny was made after the claims of other cities to that distinction had been duly weighed. Naissus (the modern Nisch in Servia) which was the Emperor's birthplace, Sardica (now Sofia, the capital of Bulgaria), Thessalonica were thought of for that purpose. They had the recommendation of giving ready access to the Danube frontier, along which the barbarians caused anxiety and demanded close attention. Some consideration was given to Nicomedia, which had already been selected by Diocletian for his capital. It is also said, though without any serious grounds for the statement, that Constantine actually began work for a new city near the site of old Troy, under the spell of the poetic legends which associated

2

Ilium with the origin of the Roman people. But the superiority of Byzantium to all rivals was so manifest that there was hardly room for long suspense as to the proper choice. The old oracle, " Build opposite the blind," which led to the foundation of Byzantium could still serve to guide Constantine in his search for the most suitable position of a new imperial city. There is no place in the wide world more eminently fitted by natural advantages to be the throne of a great dominion, than the promontory which guards the southern end of the Bosporus. There Asia and Europe meet to lay down that antagonism which has made so much of the world's history, and to blend their resources for man's welfare. A Power upon that throne, having as much might as it has right, should control a realm extending from the Adriatic Sea to the Persian Gulf, and from the Danube to the Mediterranean. From that point natural highways by sea and land proceed, like the radii of a circle, in all directions where rule can be enforced or commerce developed—to Russia, to Asia, to Africa, to the lands of the West. Its magnificent harbour was fitly named the Golden Horn, for it could be the richest emporium of the world's wealth. Under no sky can men find a more

STAMBOUL BEGGAR

One of privileged class who was caught to come on
duty

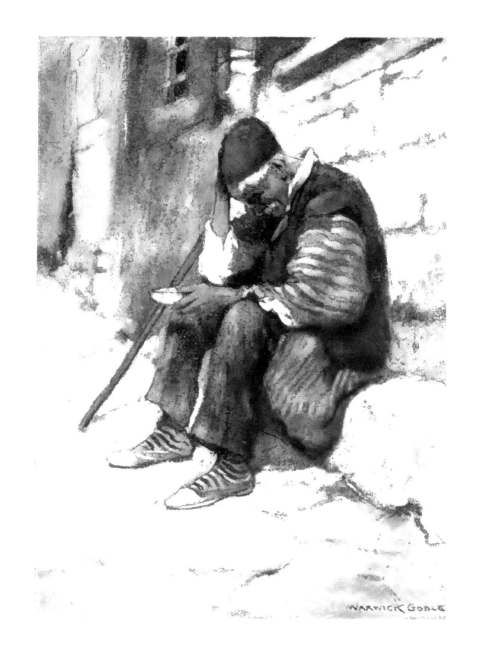

enchanting bower of beauty, or have more readily the charms of nature, the portion and delight of daily life. When Othman, the founder of the Ottoman power, beheld in his dreams this fair city, situated at the junction of two seas and two continents, it seemed to him a diamond set in sapphires and emeralds. Here, moreover, men could dwell secure. Foes advancing through Asia Minor would find their march upon the city arrested by the great moat formed by the Bosporus, the Sea of Marmora, and the Hellespont. The straits just named could be made impassable to hostile fleets approaching from the Euxine or the Mediterranean. While armies which had succeeded in breaking through the barriers of the Danube and the Balkans could be confronted by impregnable fortifications planted along the short landward side of the promontory. "Of all the events of Constantine's life this choice," Dean Stanley declares, "is the most convincing and enduring proof of his real genius." Dr. Hodgkin pronounces it, "One of the highest inspirations of statesmanship that the world has witnessed."

With these reasons for the choice made by Constantine, personal feelings may have been associated Such feelings could well play a part

in his attachment to Byzantium as in his detach-
ment from Rome. It was at Byzantium and on
the neighbouring heights of Chrysopolis (Scutari),
on the Asiatic side of the narrow straits between
the two towns, that Constantine had finally defeated
his rival Licinius, and brought the Roman dominion
under his own rule. To set up his throne amidst
the scenes of his crowning victories, where his
figure would stand out to view for ever in solitary
grandeur, as the inaugurator of a new epoch in the
world's history, was a consideration that would
appeal to the feelings of men far less ambitious
than the founder of Constantinople.

The long history of Byzantium, since the day
when a band of colonists from Megara settled there
in 658 B.C., to the day in 328 A.D. when Constantine
enlarged the town into New Rome, must not detain
us. It was a prosperous little town, much occupied
with fisheries, interested in the business of corn and
wine, and a port of call for ships trading between
the countries bordering the Euxine and the Ægean.
It was also celebrated as a fortress, being surrounded
by walls of extraordinary strength, which were de-
fended on more than one occasion with great heroism.
Situated on one of the principal highways between
the East and the West, "even in the force and road of

GYPSY BASKET-MAKER

With the knife he is holding he cuts long shavings
off the faggots suitable for plaiting into baskets

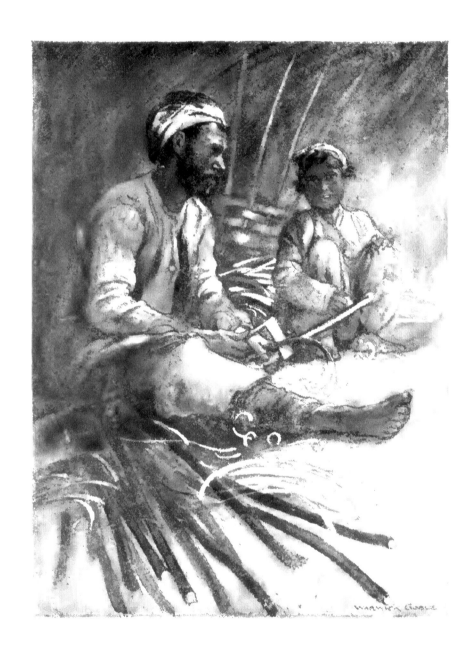

casualty," many of the chief movements of ancient
times in either direction passed by its ramparts, and
compelled its citizens to take a side in the conflicts
of the great powers of the day, and act a part on
the field of general history. When Darius I.
crossed the Bosporus into Europe to chastise the
Scythians in Russia, the town fell under the power
of Persia, and remained subject to the Great King
until Pausanias, the victor at Platæa, delivered it
from that yoke. In the struggle for supremacy
between Sparta, Athens, and Thebes, it was con-
trolled now by one of the rivals and then by another
of them. It acquired great fame by its resistance
to Philip of Macedon, when the star and crescent
moon, which have from that time been the device of
the city through all changes of fortune, exposed the
approach of the enemy and disconcerted his plans.
With the rest of the Greek world, Byzantium formed
part of the dominion of Alexander the Great. In
the war between Rome and Mithridates, it became
the ally of the former, and was eventually merged
in the Roman Empire. Septimius Severus levelled
its splendid walls to the ground, because of its
loyal adherence to the cause of his rival, Pescennius
Niger. He also deprived it of its higher rank
among the towns of the province, making it

subordinate to Heraclea. But he soon recognised the mistake of destroying a stronghold that guarded one of the great highways into the Empire, and ordered the fortifications to be rebuilt, and the town to be refurnished with temples, theatres, baths, and other public edifices. The subordination of the town to Heraclea, however, was maintained, with the result that the Bishop of Heraclea became the superior of his brother of Byzantium until Constantinople was founded. Then, naturally, the ecclesiastical chief of the new capital took precedence. But in virtue of the higher position held previously by Heraclea, the Bishop of that see acquired the right to preside at the consecration of the patriarch of Constantinople, and retains that right to the present day. So long may a comparatively trifling action leave its mark upon the world's history.

In the course of the third century, Byzantium suffered from the raids of the Goths, and in commemoration of the defeat inflicted upon the barbarians by the Emperor Claudius Gothicus at Nissa in 269 A.D., the graceful Corinthian column of granite, which still rises some 50 feet high on the slope above the Seraglio Point, was erected, bearing on its pedestal the inscription, " Fortunæ Reduci

ob devictos Gothos" (To Returning Fortune, on
account of the defeated Goths). Finally, here, as
already stated, the struggle between Constantine
and Licinius was decided by the fall of the town
into Constantine's hands, after a desperate defence.
From all this history of the town, one fact was
perfectly clear—the immense strategic value of the
place. When Constantine transformed Byzantium
into a new capital and a great bulwark of his
Empire, he only developed the innate capacities of
the site to their natural culmination. Constan-
tinople was Byzantium in flower.

Apart from the advantages offered by its situ-
ation, Byzantium had little to recommend it to
Constantine's regard. It presented neither ample
room, nor a large population, nor convenient and
splendid buildings to favour the rapid growth of a
metropolis. Of the tongue of land on which the
town stood, only the portion to the east of the line
drawn from the present Stamboul Custom House,
on the Golden Horn, across to the Seraglio Light-
house, on the Sea of Marmora, was occupied. In
the bay beside that Custom House lay the harbours
of the town, where shipping, traders, and merchants
did mostly congregate. The Acropolis stood on
the rocky hill now enclosed within the Seraglio

Grounds, and there several temples were found, that gods and goddesses might unite with men in the defence of the citadel. Against the steep side of the Acropolis, facing the blue expanse of the Sea of Marmora and the hills and mountains of the Asiatic shore, two theatres were built, while a stadium lay on the level tract beside the Golden Horn. The huge structure of the Hippodrome, which Severus had begun, was waiting to be completed, and to the north of it were the Baths of Zeuxippus and the adjoining public square which bore the same name. All this did not constitute a rich dowry for the future capital. But perhaps to the founder of Constantinople that fact was not a serious objection; the greatness and splendour of the new city were to be his own creation.

When precisely work upon the new capital commenced cannot be determined, but the year 328 A.D., as already intimated, may be regarded as the most probable date. The circuit of the fortifications which should guard the city was marked out by Constantine himself with solemn ceremonial, and comprised the territory that stretched for nearly two miles to the west of the old town. The north-western extremity of the enclosed area reached the Golden Horn somewhere in the neighbourhood of

A STEP STREET IN GALATA

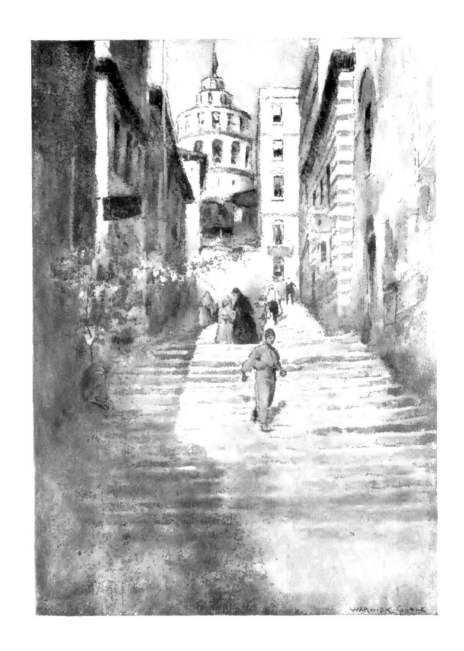

the Stamboul end of the Inner Bridge, while the
south-western extremity abutted on the Sea of
Marmora, at a point between the districts to which
the Byzantine names Vlanga and Psamatia still
cling. The most precise indication of the line
followed by the landward wall of Constantine is
found in the Turkish name Isa Kapoussi (the Gate
of Jesus), attached to a locality above the quarter
of Psamatia. The name refers to an ancient gate-
way which stood in the Constantinian fortifications,
and survived their disappearance until the year 1508,
when it was overthrown by an earthquake. It is
mentioned in late Byzantine days as "The Ancient
Gate," and on account of its imposing appearance as
" The very Ancient Beautiful Gate " (Antiquissima
Pulchra Porta). It was the original Golden Gate
or Triumphal Entrance of the city, and, like Temple
Bar in London, reminded the passing crowds both of
what the city had been, and of what it had become.

The name of the adjoining church, now known
as Isa Kapoussi Mesdjidi, probably suggested the
Turkish appellation of this interesting and import-
ant landmark. The addition made by Constantine
to the size of Byzantium was certainly considerable,
and the astonishment of his courtiers at the scale
of his plans had some ground in reason. But the

response of the Emperor brings us into closer touch with the emotion which animated the occasion. "I must go on," said the founder of New Rome, "until He stops who goes before me." It was a reply in harmony with the declaration made at another time, that he founded the city at the Divine command, *jubente deo*. The principal agent in a transaction of great moment often feels himself to be the instrument of a higher will than his own, and is haunted by the thought that he builds more wisely than he knows.

Of course a city such as Constantine designed could not be built in one day, but such was the eagerness with which the work was pressed forward, that by the spring of 330 sufficient progress had been made to permit the official inauguration of the capital of the East. The 11th of May in that year was appointed to be the city's birthday. Never is the region about Constantinople so beautiful as at that season. We can therefore readily imagine the splendour in which earth and sea and sky arrayed themselves to greet the advent of the new queen-city, and to match the state and pomp and joy with which men acclaimed that nativity. In honour of the event there was a long series of popular festivities for a period of forty days,

A FLOWER-MARKET, SCUTARI

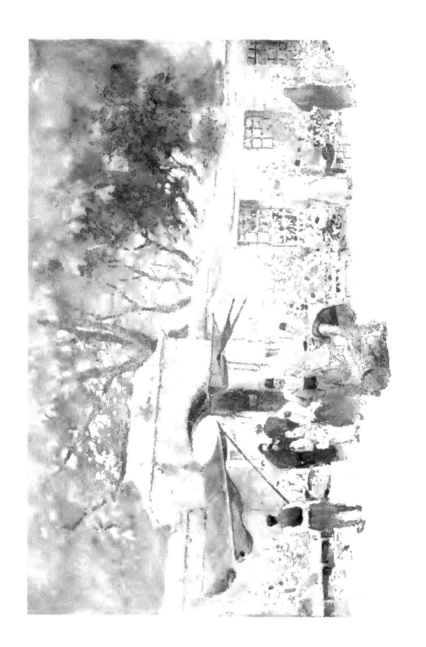

besides games in the Hippodrome, free access to
the Baths of Zeuxippus, free meals, and liberal gifts
of money. For many centuries the anniversary of
the day was observed as a public holiday, when
the Law Courts were closed and races were held
in the Hippodrome. And that the lofty scene of
the natal day might be acted over, a gilt statue
of Constantine, holding a Figure of the Fortune of
the city, was placed in a chariot, and under the
escort of soldiers in white uniform and carrying
lighted tapers in their hands, was borne round
the course to receive the homage of the reigning
Emperor and the assembled multitudes. Probably
the custom was a reminiscence of a procession in
which Constantine himself had taken part on the
day of the inauguration of the city.

What the feelings of the "oldest inhabitant" of
Byzantium were on that day it is not difficult to
imagine. Any regret at the disappearance of
ancient and familiar landmarks would be lost in
pride for the honour which the old place had
received, and in admiration of the magnificence
with which it was invested. Moreover, many
features of the past had only been transfigured, so
that the new was not altogether strange. The
Hippodrome, which had stood for more than 130

years an unfinished pile, was now completed; its
seats were packed with spectators, and around its
spina, chariots whirled like the wind. The Baths
of Zeuxippus kept their place, but enlarged and
beautified. The open space to the north of the
Baths was converted into a square, surrounded by
porticoes, and named Augustaion, after the title
Augusta bestowed upon the Emperor's mother.
On the eastern side of the place stood the Senate-
House, with a colonnade of six noble columns
before the entrance. At the north-western corner
of the square was the Milion, whence distances from
New Rome were to be measured. To the north,
the church dedicated to Irene proclaimed the new
faith of the Empire, and told of the peace which
had enfolded the Roman world when Constantine
became sole Emperor. The ground now occupied
by the Mosque of Sultan Achmed, to the east of
the Hippodrome, was appropriated for the build-
ings which were to constitute the imperial palace.
The fortifications along the west of the old town
had been removed, but instead rose ramparts which
could render greater service to mankind, and had a
wider outlook upon the world. On the territory
within the principal gateway of Byzantium, a
forum had been constructed, named after Con-

stantine, and there stood a porphyry column, surmounted by his statue watching over the city. The forum, elliptical in shape, was enclosed by a double tier of porticoes, with entrances on the east and the west through fine archways of marble. It was the business centre of the city. Proceeding westwards to the hill now occupied by the Turkish War Office, one came to buildings that recalled the Capitol of Rome; while on the hill now crowned by the Mosque of Sultan Mehemet rose the church dedicated to the Holy Apostles, in and around which the Emperors of Constantinople were to be laid to rest when, in the language of the Byzantine Court ceremonies, the Kings of kings summoned them to appear before Him. Aqueducts and cisterns provided an abundant supply of water for numerous public baths and fountains, as well as for private use. The principal streets were lined with porticoes affording shelter from sun and rain. The sewers ran deep underground. And the waters of a harbour, one of the greatest needs of the city, on its southern side gleamed in the bend of the shore of the Sea of Marmora, where the vegetable gardens of Vlanga Bostan now flourish. It was known, after the superintendent of the works, as the Harbour of Eleutherius.

Statues, many of them the work of the finest chisels of antiquity, had been collected from all parts of the Empire to make the new capital a museum of art, and to foster the love of the beautiful. Historical monuments also were there, to suggest the continuity between the past and the present, and to rouse the men of a new age to emulate the noble deeds of the old time before them. Of these monuments none was so inspiring as the Serpent Column brought from Delphi to the Hippodrome, upon whose lowest thirteen coils are graven the names of the heroic little States which hurled the Persians out of Greece. No monument stood more appropriately in a city whose supreme task was to resist the encroachments of barbarism upon the civilised world. Scattered over the city were palatial mansions, some erected at the Emperor's order for personages whom he wished to attract to the new capital, others built by men of wealth and rank who had come of their own accord to bask in the sunshine of imperial favour. Persons belonging to other classes of society had also been attracted in crowds by openings for business, demand for labourers, exemption from certain taxes, and by the free distribution of bread, for which the cornfields of Egypt furnished 80,000

·

THE GALATA BRIDGE

which spans the Golden Horn at the end near the
Bosporus forms the principal link between Galata
and Stamboul It is presented here as seen through
a window in a small cafe on one of the adjoining
steamboat quays

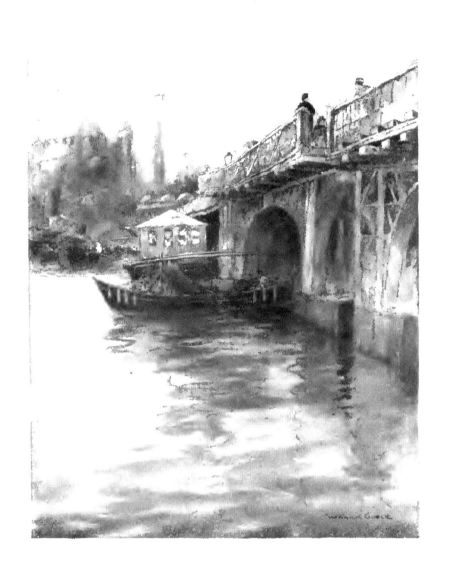

modii of wheat. After the pattern of Rome, the
good order of the city was secured by the division
of the city into fourteen wards or regions, of which
twelve lay within the walls, and two were suburban.
One of the latter, the 13th ward, was on the site
of Galata; the other, the 14th ward, the famous
suburb of Blachernæ, stood on the hill now occupied
by the quarter of Egri Kapou. Both of these
extra-mural suburbs were fortified. Each ward had
a curator, who attended to the general interests of
that portion of the city; a crier or messenger to
give public notice to its inhabitants of matters which
concerned them; five night watchmen; and a body
of men (colligiati) representing the trade-guilds, and
varying in number according to the size or import-
ance of the ward, to render assistance in case of fire.
After this survey of the new city, the most loyal
son of the old town might come to the ancient
Strategion—the ground devoted to military exercises
(on the level tract beside the present Stamboul
Railway Station)—and gladly bow to the decree
inscribed on a column erected there, that Byzantium
should henceforth be named New Rome.

CHAPTER II

THE MAKING OF CONSTANTINOPLE, UNDER THE EMPERORS CONSTANTIUS, JULIAN, VALENS, THEODOSIUS THE GREAT, AND ARCADIUS.

337–408 A.D.

AFTER visiting the sights of Rome, the Persian prince Hormisdas was asked to give his impressions of the city. "One thing disappoints me," he replied, "men die here just as in the humblest village of the Empire." So was it in New Rome. Seven years after the inauguration of the city he founded, Constantine the Great died in the neighbourhood of Nicomedia. His body was carried to Constantinople in a golden coffin, and, amid demonstrations of public grief, was laid to rest in a sarcophagus of porphyry in the Church of the Holy Apostles. The tomb was flanked by twelve pillars, representing, so the fact was construed, the glorious company of the Apostles, with whom he could fitly

24

A CEMETERY BY THE BOSPORUS

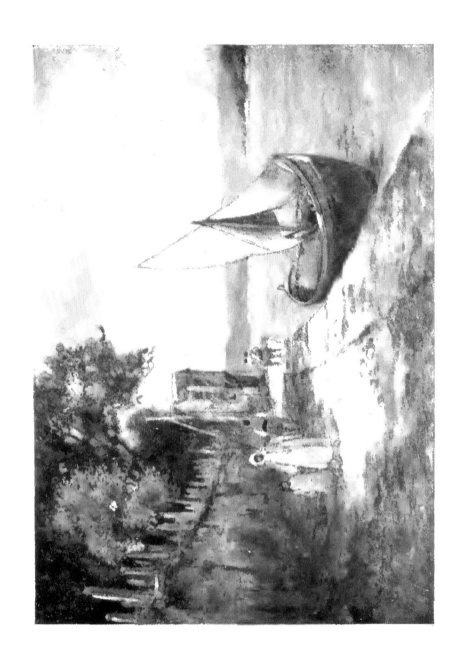

be associated as the champion of the Christian
faith. The good that men do is, however, not
always interred with their bones, and Constantinople
remained to attest the far-sighted wisdom of its
founder, and to grow in splendour and importance.
But one hundred and ten years had to come and
go ere the city attained its full stature. It is the
history of the growth of Constantinople during
this period that will now engage our attention.

Upon the death of Constantine, the eastern
division of the Empire came under the rule of his
second son, Constantius, who soon discovered how
much work upon the new seat of government re-
mained to be done. Nor could his visit to Old Rome
fail to impress upon his mind the greatness and the
difficulty of the task before him. "Having entered,"
says the historian, Ammianus Marcellinus, speaking
of that visit of Constantius, "the Forum of Trajan,
the most marvellous structure in the whole world,
he was struck with admiration, and looked around
in amazement without being able to utter a word,
wondering at the array of gigantic buildings, which
no pen can describe, and which men can create and
see but once in the course of centuries. Abandon-
ing all hope of ever being able to erect anything
which would approach even at a respectful distance

4

Trajan's work, he turned his attention to the equestrian statue found in the centre of the Forum, and said to his followers that he would have one made like it. Hormisdas, who accompanied the Emperor, quietly remarked, pointing to the Forum, 'For such a horse, you must first provide such a stable.'"

Nevertheless, Constantius carried forward the improvement of New Rome to such an extent that Themistius, a contemporary, speaking of the Emperor's services in the matter, declares that the city was indebted to Constantine the Great only for its name, and owed its actual construction to Constantius. During this reign the fortifications of the city were completed, the Church of the Holy Apostles underwent repair, and the Church of S. Sophia, usually ascribed to the founder of the city, was built, the date of its dedication being the 15th of February 360, two years before Constantius died. Constantius, moreover, placed the city, like Rome, under a Prefect—*Præfectus Urbis*—and, what is worthy of note, endowed the new capital with a library, thus placing in its hand the lamp of learning which was to shine so far in the world's history. If we may judge by the terms in which Themistius refers to the foundation of this

library, the value of books was fully appreciated in those days. "Thus," he exclaims, "the Emperor has recalled and raised from the dead the souls of wise men and of heroes for the welfare of the city; for the souls of wise men are in their wisdom, mind, and intelligence, while their monuments are the books and writings in which their remains are found." The author of the *Areopagitica* said no more when he declared, "A good book is the precious life-blood of a master spirit embalmed and treasured up to a life beyond life."

Julian, the successor of Constantius, was attached to the city by special ties. It was the place of his birth, and there he had received part of his early education. The school he attended was attached to the Basilica which stood on the site of the Cistern now styled Yeri Batan Serai, a little to the south-west of S. Sophia, and thither he went under the conduct of his pædagogue, Mardonius, to study grammar and rhetoric, dressed simply and associating freely with his fellow-students. His progress in his studies soon became the talk of society, and in public opinion presaged his fitness to become, in due time, the ruler of the Empire. Whereupon the jealousy which besets despotic rule was roused in Constantius, and Julian was banished to Nicomedia.

But Julian always retained a warm affection for
the home of his childhood and youth Speaking
of Constantinople in one of his letters he says, " I
love her as my mother, for I was born and brought
up there, and I can never be guilty of ingratitude
towards her." Nor had he reason to complain of
his Alma Mater's feelings towards himself. When
he approached the city, in 361, to assume the crown,
the whole population poured out to meet him, and
hailed him with transports of joy as at once their
sovereign and fellow-citizen. The young capital
acquired a greater sense of dignity and importance
at the thought that one who had been cradled
within its precincts now occupied the throne of
the Roman world. Julian spent only ten months
in Constantinople as Emperor, his stay being cut
short by war with Persia, whose hostility was not
less intense since the chief seat of the Empire had
been brought nearer to the frontier between the two
States. Into those few months, however, Julian
put an immense amount of work. The condition
of affairs in his native city was not after his heart,
either as a statesman, philosopher, or devotee of
the ancient faith of Athens and Rome. There the
Christianity he would fain destroy was strongly
entrenched. There wrangling sects of the new

"A KAFEDJI

Turkish coffee is to be obtained everywhere, a "katedji" has here set up his little stall at the corner of a street

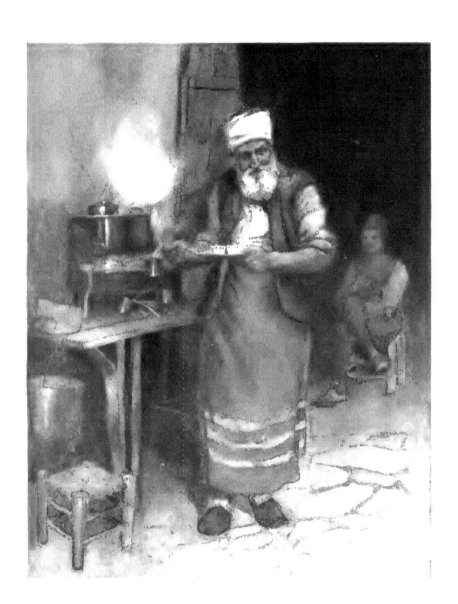

creed, more difficult to appease than the wild Franks
and Alemanni, who had felt the strength of his arm
upon the banks of the Rhine, kept the population
in constant turmoil. There was found an Augean
stable of official corruption, of unpunished crimes,
of relaxed military discipline, and of extravagant
luxury at the court. According to Libanius, a
thousand cooks, a thousand hairdressers, more than
a thousand cup-bearers, a crowd of waiters, swarm-
ing like bees in a hive, and eunuchs, thick as flies
in early summer, were employed in the service
of the imperial palace. One day Julian sent for a
barber, and in answer to the summons an official
in a gorgeous uniform made his appearance. "But
I called for a barber, not for a receiver-general,'
exclaimed the indignant Emperor. An investigation
of the case having been made, it was discovered
that in addition to a large salary the barber enjoyed
the right to many perquisites, and received daily
rations sufficient for twenty men and as many
horses. Julian swept the palace clean of such
abuses. Furthermore, Julian increased the import-
ance of the Senate of the city by the embellishment
of the Senate-House, by additional privileges con-
ferred on the members of that body, and by taking
part in the deliberations of the assembly. He also

constructed another harbour on the southern side
of the city, placing it in the hollow ground below
the heights on which the Hippodrome stands, and
thus provided for the convenience and safety of
ships that found it difficult to make the Golden
Horn from the Sea of Marmora, in the face of the
northern winds that prevail in the Bosporus. The
harbour was first known as the New Harbour and
the Harbour of Julian, but, in the sixth century,
it was also named the Harbour of Sophia or the
Sophias, in view of extensive repairs made at the
instance of the Empress Sophia, the consort of
Justin II. The basin of the harbour can still be
traced in the configuration of the ground it once
occupied, where its memory is preserved by the
present name of the locality—Kadriga Limani, the
Port of the Galley. ' At the head of the harbour
Julian built a portico, a crescent in shape, and
therefore spoken of as the Sigma, from its resem-
blance to the curved form of that letter in the Greek
alphabet. Very appropriately the portico became
a favourite lounge of the philosophers in Constan-
tinople, and the scene of their discussions. But
what Julian doubtless considered his richest and most
filial gift to the city of his birth, was the presenta-
tion to its public library of his collection of books.

GOLDEN HORN FROM THE BRITISH
HOSPITAL, GALATA

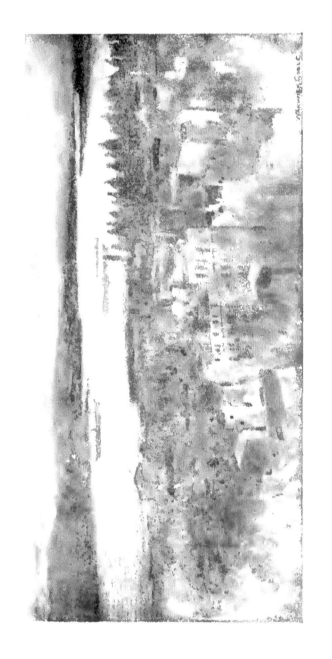

Valens, the next Emperor concerned with the growth of the city, gave special attention to the water-supply of Constantinople—always a serious question owing to the comparative scarcity of water in the immediate neighbourhood. The picturesque aqueduct which, with its double tier of arches garlanded with ivy, still transports water across the valley between the hills surmounted respectively by the Mosque of Sultan Mehemet and the War Office, was built in this reign. It was an addition to the system of water-supply provided by Constantine; a system which, probably, had previously served the town of Byzantium, and which he only extended and improved. Near the eastern end of the aqueduct a splendid public fountain was placed. The Cistern of the Prætorian Prefect, Modestius, now used as a Saddle-Market, near the Mosque of Sultan Mehemet, belongs to this period; and, as a result of the abundance of water thus introduced into the city, several public baths were erected. The Baths or Thermae of Roman Constantinople, we should remember, are the models of what we style the Turkish bath, and it is a curious fact that this mode of bathing has been continued as a habit of popular life only in countries comprised in the eastern division of the Empire.

But what, perhaps, makes the reign of Valens chiefly memorable in the history of the city is that in his time the citizens of Constantinople had their first experience of a usurpation of the throne, and of an attack upon their walls.

The former event was brought about by a certain Procopius, a cousin of the Emperor Julian.

Making the most of his relationship to the family of Constantine, he took advantage of the discontent which the administration of Valens had provoked, and having won the populace of the city and a body of troops by means of liberal donatives, seized the palace and installed himself as Emperor A sharp war with Valens ensued, in which the usurper was at length captured and put to death, while his partizans, and even persons suspected of having favoured his cause, were put to the torture, and had their property confiscated. Thus Constantinople learned—not for the last time—the meaning of a reign of terror. A signal example also was made of Chalcedon (Kadi Keui), on the opposite Asiatic shore, because its inhabitants had sided with Procopius. The walls of the town were ruthlessly torn down, and it was with the material thus made available that the Aqueduct of Valens was built and that the Baths of Constantine were repaired. Yet

more serious was the quarrel of Valens with the Goths, whom he had permitted to cross the Danube in their retreat before the Huns, and settle in the territory we know as Bulgaria. The officials entrusted with the control of the refugees, and with the duty of providing them with food, did their work with such stupidity and rapacity that the high-minded Goths flew to arms, and, at the close of a struggle extending for upwards of a year, inflicted in 378 an overwhelming defeat upon the imperial forces, outside the walls of Adrianople. The Emperor himself and two-thirds of his army lay dead upon the field. The Roman legions had not known such a disaster since they were defeated by Hannibal at Cannæ. Flushed with victory, the Goths marched upon Constantinople, assailed the walls, and nearly burst the gates open. The honours of the defence fell to the widow of Valens, the Empress Dominica, who, with the money found in the treasury, raised a body of troops among the citizens, arming them with what weapons could be found. A body of Arab soldiers, recently arrived in the city, also rendered valuable aid. Sallying forth, they closed with the Goths in a desperate struggle. Victory wavered between the two sets of barbarians; when, suddenly, a long-haired, almost naked Arab, utter-

ing a loud, hoarse, and doleful cry, like a bird of evil omen, rushed upon the Goths, and drawing his dagger, cut the throat of an opponent, and then slaked his thirst at the flowing wound. What with the impression produced by this horrid incident, added to a growing sense of the impossibility of their taking a fortified place, the Goths gave up the contest and retired from the city. This was the first siege of Constantinople.

With the accession of Theodosius I., a brighter day dawned upon the Empire. He not only subdued the Goths, but converted them into allies, and persuaded them to put 40,000 of their brave troops at his service. He even induced their aged king, Athanaric, who had sworn never to set a friendly foot upon Roman soil, to visit Constantinople. The visitor was profoundly impressed by the appearance of the city. "Now," said he, "I see what I often heard of, but never believed, the renown of this great city." Then, surveying the city's situation, the movement of ships coming and going, the splendid fortifications, the crowded population made up of various nationalities, like streams coming from different directions to gush from the same fountain, the well-ordered troops, he exclaimed, "Verily, the Emperor is a god upon

STREET SCENE CLAY WORKS

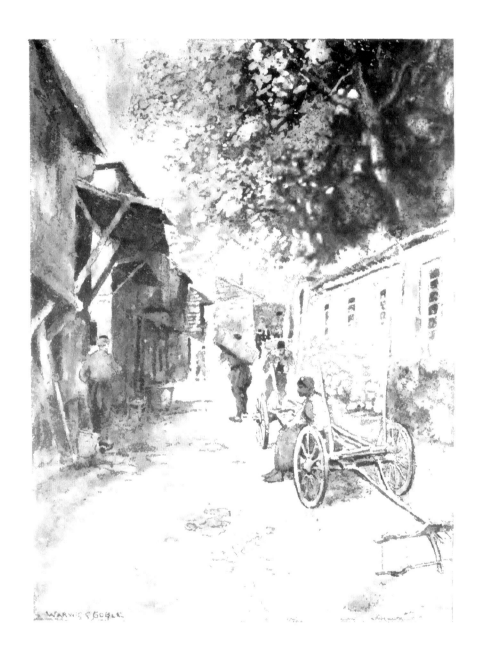

.

earth ; whoso lifts a hand against him is guilty of his own blood." Upon the death of Athanaric, which occurred about a fortnight after he reached Constantinople, Theodosius buried the body of his guest with royal honours in the Church of the Holy Apostles, and, by this act of chivalrous courtesy, bound the Goths more firmly to his side.

The barbarians, however, were by no means the only disturbers of the peace of the Empire with whom Theodosius found it necessary to deal. Society in the Roman world was distracted by the conflict between pagans and Christians on the one hand, and by the keener strife between Christian sects on the other, and it was the ambition of Theodosius to calm these troubled waters. For this laudable end he employed the questionable means of edicts for the violent suppression of heathenism and heresy. To destroy the old faith of the Empire was comparatively an easy task, although it involved him in a war with the pagan party in the West. But to uproot the tares of heresy was a more formidable undertaking ; they were so numerous, vigorous, and difficult to distinguish from the true wheat. For the space of forty years, the views of Arius on the Person of Christ had prevailed in Constantinople, and the churches of the city were

in the hands of that theological party. Only in one small chapel, the Church of Anastasia, was the Creed of Nicæa upheld there by Gregory of Nazianzus, and despite his eloquence he was a voice crying in the wilderness. But Theodosius, having been won over to the Nicene Creed, determined to make it the creed of the State. Accordingly, upon his arrival in Constantinople on the 20th of November 380, he sent for Demophilus, the Arian bishop of the city, and commanded him either to accept the orthodox views or leave Constantinople. Demophilus had the courage of his convictions, and, bidding his flock in S. Sophia farewell, left the capital in obedience, as he said, to the injunction, "When they persecute you in one city, flee ye to another." All the churches of the city were now transferred to the orthodox party. The Arians, however, maintained religious services according to their own tenets outside the city walls, in the district known as the Exokionion (quarter of the outside column). The name was due to the presence there of a column surmounted by a statue of Constantine. Owing to their association with the district, Arians were sometimes designated Exokionitæ. The district lay immediately outside the gateway in the Constantinian walls already noted as the Ancient

STREET SCENE, STAMBOUL

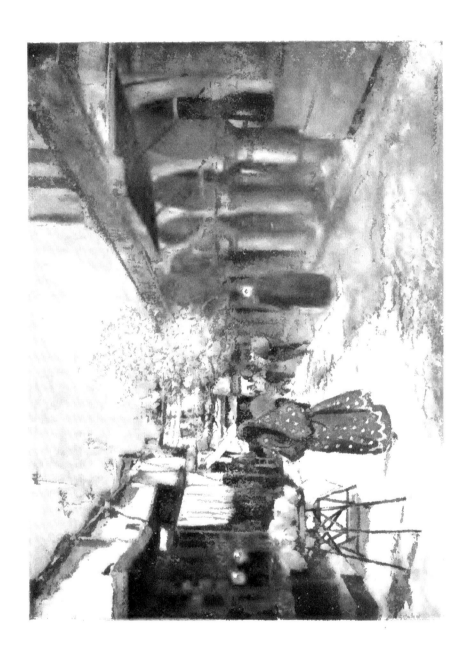

Gate of late Byzantine times, and as Isa Kapoussi since the Turkish Conquest. It can therefore be readily identified, and, curiously enough, under the disguise of a Turkish garb—Alti Mermer, the Six Marbles—the locality still retains its old name. For the Turkish designation is due to a misunderstanding of the meaning of the term Exakionion, a corrupt form of Exokionion frequently employed by Byzantine writers.

In pursuance of his religious policy, Theodosius furthermore convened at Constantinople an assembly of 355 bishops, known as the Second General Council, to reaffirm the Nicene Creed as the true Catholic faith, and to restore the orthodox character of the capital of the East. At this Council, the question of precedence between the Sees of Rome, Antioch, Jerusalem, Alexandria, and Constantinople, which awakened burning jealousies in the Christian world, was finally settled. The first place was assigned to the Bishop of Rome, the prestige of the ancient capital asserting itself, but the second place was given to Constantinople, because it was New Rome, notwithstanding the closer connection of the remaining rival Sees with the earlier history of the Christian faith. In this decision, political reasons outweighed religious considerations.

But while thus occupied with high matters of
Church and State, Theodosius did not forget the
embellishment of his capital. On the contrary, what
Theodosius did for that object, and left to his
son and grandson to complete, entitles him to be
regarded as the second founder of Constantinople.
Under his auspices, a great forum, named the
Forum of Theodosius and the Forum of Taurus,
was constructed on the summit of the hill now
occupied by the Turkish War Office. It was the
largest forum in the city, and there Theodosius
erected a hollow column, *columna chochlis*, similar
to the column of Trajan and the column of Marcus
Aurelius at Rome. For better or worse, the desire
to emulate Rome was always an ambition of
the young capital. Around the exterior of the
column winded a spiral band of bas-reliefs com-
memorating the exploits of the Emperor, while the
stairway within led to his statue on the summit.
Up that stairway, the Emperor Murzuphlus was
taken to the top of the column by the Crusaders of
the Fourth Crusade after their capture of the city
in 1204, and then barbarously hurled to the ground.
Certain persons, who became wise after the event,
then pointed to a figure represented on the column
as falling from a high turret, and read there the

prophecy of this outrage upon humanity. The column was taken down by Sultan Bajazet II. (1481-1512) to furnish material for the bath he constructed in the vicinity. So does glory vanish. To the forum was attached, as usual, a Basilica, the Basilica Theodosiana, 240 feet long by 140 wide, remarkable for twelve marble columns 25 feet in height. To the same Emperor is also ascribed a lofty pyramidal structure, in or beside the forum, surmounted by a movable bronze figure to indicate the direction of the wind, and appropriately named the Anemodulion. Judging from the descriptions we have of it, the edifice displayed considerable artistic taste. Upon it stood, in characteristic forms, the statues of the twelve winds on the list of ancient meteorologists. There, one could hear youths blowing trumpets, see laughing Cupids pelting each other with apples, and admire wreaths of foliage, flowers, and fruit. It recalls the Temple of the Winds at Athens. Another erection of the time of Theodosius was the Golden Gate which was subsequently incorporated in the fortifications built by his grandson and namesake, Theodosius II. It was originally designed as a triumphal arch to celebrate the victory of Theodosius I. over Maximus, who had usurped the throne of the western division

of the Empire, and through that archway Theo-
dosius passed three years later, when he returned
to Constantinople in triumph. Like similar monu-
ments, the Golden Gate consisted of three arches,
the central arch being loftier than its companions,
and was decorated with statues of the Emperor,
Victory, the Fortune of the city, and a group of
elephants in bronze. Upon the two fronts of the
central arch was a Latin inscription in gilt metal
letters, gleaming like a crown of gold upon the
head of the gateway. The legend, "Theodosius
adorns this place, after the doom of the usurper,"
looked towards the west; while the words, "He
who constructed the Golden Gate brings in the
Golden Age," faced the east. When incorporated
in the fortifications of Theodosius II., the Golden
Gate served as the State entrance to the city.

Another monument of the city due to Theo-
dosius is the obelisk which still keeps its place, as
though the symbol of eternity, amid the ruins of the
Hippodrome. It was brought from Egypt before
the Emperor's reign, but was successfully placed in
position under his auspices, and two inscriptions,
one in Latin, the other in Greek, record the pride
which the achievement excited. They read to the
effect that what others had vainly attempted was

A VILLAGE STORE AT KAVAK

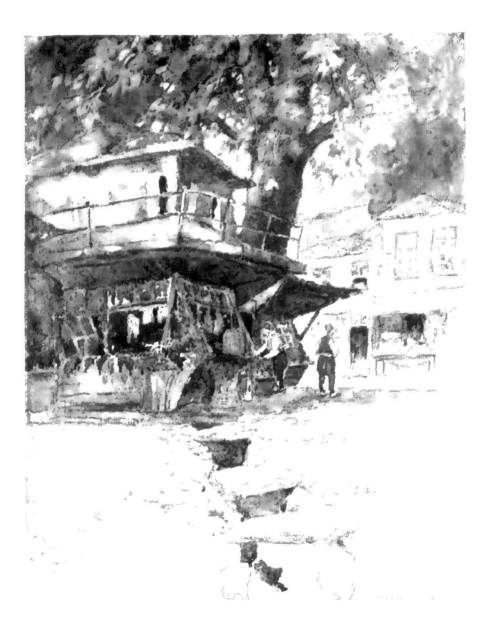

accomplished by Theodosius during the prefecture
of Proclus—the time taken being thirty days
according to the Latin legend, thirty-two days
according to the Greek version.

The bas-reliefs of the pedestal on which the
obelisk stands, however little they flatter the art
of the period, are extremely interesting for the
glimpses they afford us of life in Constantinople
under Theodosius I. Any one who wishes to look
upon the events of that distant day, and cares to
breathe the atmosphere in which his fellowmen
then lived, should come and linger before these
weather-worn figures in which the Past is per-
petuated They are not of "Attic shape"; they
have not the "fair attitude" of "the brede of
marble men and maidens," with which Grecian urns
were overwrought. Nevertheless, they too set the
permanent against the transitory scenes of our
human history. Here the obelisk is still being
dragged through the city to the Hippodrome amidst
the deafening shouts of an enthusiastic population ;
it is still hoisted in breathless silence and suspense
from the ground, and set firm upon its base to stand
erect for these fifteen centuries. Here four-horse
chariots are still driving furiously around the *spina*
of the race-course; the banners of the Factions—

6

blue, green, white, red—still wave frantically in the
air; the crack of whips, the cheers of spectators,
urging steed and driver onward and faster, may
still be heard : the acclamations, the strains of
music, the joyous dance, the wild frenzy when the
Emperor crowns the victor's brow with laurel still
rend the air. Theodosius, his Empress, his two
sons, Honorius and Arcadius, still stand or sit
before us. Here are the senators of New Rome,
and the courtiers in attendance upon the Emperor.
Barbarians, eastern and western, are here doing
homage on bended knee to their conqueror, and
offering him tribute. Here are the Gothic troops
which Theodosius subdued and won to his side,
wearing their golden collars, and guarding him
with spear and shield. Here the people of the
city hold colloquy with their sovereign through
the tall heralds—mandatores—who stand on the
steps leading to the imperial tribune. Here
Christianity with the Labarum in its hand triumphs,
and in the Greek and Latin speech inscribed upon
these stones we still listen to the voices that
mingled in the Græco-Roman world.

Other works of Theodosius could be mentioned,
such as the improvement of the Harbour of Eleu-
therius (at Vlanga Bostan), and the palaces erected

GALATA TOWER FROM THE BRIDGE

The stairway down which the Turkish lady is
hurrying leads to one of the many steamboat piers
adjoining the bridge

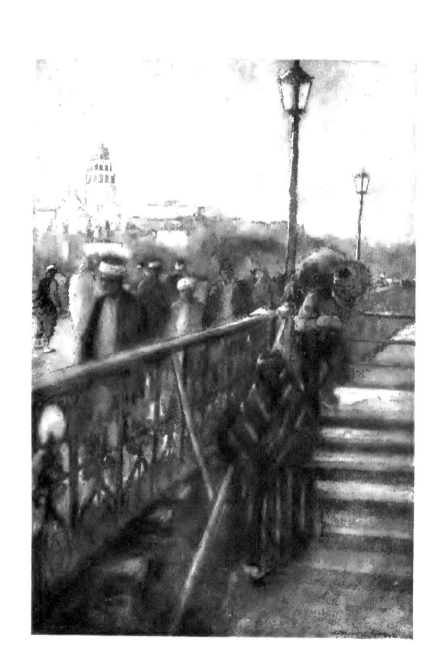

for the accommodation of members of the imperial
family. But perhaps we shall obtain a more vivid
impression of the extent to which the growth and
improvement of Constantinople were due to this
Emperor, from the impression which the changes
he introduced made upon the mind of a con-
temporary who had known the city from the days
of Constantius. "No longer," exclaims Themistius,
as he surveys the altered aspect of the place,
"no longer is the vacant ground in the city more
extensive than the ground occupied by buildings;
nor is the land under cultivation within the walls
more than that which is inhabited. The beauty
of the city is no longer scattered over it in patches,
but is now continuous throughout its whole area,
like a robe finished to the very fringe. The city
is resplendent with gold and porphyry; it boasts
of a new forum, named after the Emperor; it is
provided with baths, porticoes, gymnasia, and what
was its former extreme limit is now its centre. If
Constantine could see the city he founded, he would
look upon a glorious and splendid scene, not upon
a bare and naked void; he would behold it fair,
not with apparent, but with real, beauty." The
mansions of the wealthy were now larger and more
stately; the suburbs also had grown. "The city,"

continues the orator, "is full of carpenters, builders, decorators, and every other class of artisans, so that it might fitly be described as a workshop of magnificence. Should the zeal of the Emperor to adorn the city continue, a wider circuit will become necessary, and the question will arise, whether the city added to Constantinople by Theodosius does not excel in splendour the city which Constantine added to Byzantium."

In the reign of Arcadius, events of great moment in the history of the city occurred. In the first place, the government of the Empire, which had been in the hands of Theodosius alone for a few months, was now again divided between his sons, the West falling to Honorius, the East becoming the dominion of Arcadius. This proved the final division of the government, and prepared the way for the ultimate sundering of Europe into two worlds. For it stimulated a conflict of interests and occasioned a warfare of intrigues that strengthened the tendency for the parts of the Empire to fall apart and form, practically, distinct States. Thus, however, the individuality and independence of Constantinople came to be clearly and fully asserted. In the next place, under Arcadius, the question how far Constantinople and the Balkan lands were

to remain under the control of the Germans settled
to the south of the Danube reached its most critical
stage. Would the East be Teutonized, as the
West was destined to be? Was the unity of
Europe to assume a Germanic form after the old
Roman unity was broken? There were moments
in the reign of Arcadius when the signs of the
times indicated that the same destiny awaited both
divisions of the Empire. Alaric, at the head of the
Visigoths, was ravaging the Balkan peninsula, and
seemed ready to establish a permanent kingdom
there. Constantinople was full of Germans. A
fair-haired German lady, the Empress Eudoxia,
shared the throne of Arcadius. Germans were
largely employed as workmen and as household
servants. Germans demanded liberty to worship
in a church within the walls, according to the
Arian views introduced among them by Ulfilas.
Chrysostom, opposed their demand, and carried on
a mission for the conversion of the Goths in the
city to the orthodox faith. The politicians of the
capital were divided into a Roman and a German
party. Gainas, a Goth, was in command of the
army, and had become all-powerful. At his
instance, Rufinus and Eutropius, successively chief
Ministers of the Government of Arcadius, were

put to death. He incited the Ostrogoths settled
in Asia Minor to rebel, and brought them over to
Europe to support his ambitious plans. He filled
Constantinople with Gothic soldiers, and twice
attempted to burn down the palace. And when,
in view of the precautions taken against him, he
found it prudent to quit the city, it was with the
idea of returning with a larger force to make
himself the master of the place. His plan failed,
as such schemes often fail, through an accident of
an accident. A Gothic soldier treated a poor
beggar woman roughly; a citizen took her part
and struck the assailant dead. In the condition
of the public mind, this proved the spark which
produces a tremendous explosion. The city gates
were immediately closed and the ramparts manned,
while an infuriated mob went through the city
hunting for Goths, and did not cease from the mad
pursuit until the blood of 7000 victims had stained
the streets of the city. Gainas was pursued and
defeated, and eventually his head was sent to Con-
stantinople by the Huns among whom he had
sought refuge. This, indeed, did not put all further
trouble at the hands of Goths to an end, but it was
the knell of German domination in Constantinople
and the East. The reign of Arcadius is the water-

shed upon which streams, which might have flowed
together, separated to run in opposite directions
and through widely diverse scenes of human affairs.
The inscription, "*ob devictos Gothos*," upon the
column of Claudius Gothicus now acquired a deeper
meaning.

But one cannot think of the reign of Arcadius
without recalling the fact that for six years of that
reign Constantinople was adorned by the virtues,
and thrilled by the eloquence, of John Chrysostom.
Although popular with the masses, he provoked
the bitter hostility of the Court and of a powerful
section of the clergy, by his scathing rebukes of
the frivolous and luxurious habits of fashionable
society, and by the strictness of his ecclesiastical
rule. He had the misfortune to quarrel with the
ladies of the city, including the Empress, for their
extravagance and looseness of manners. Ladies of
fashion, for instance, saw nothing unbecoming in
taking a swim in the public cisterns of the city.
A sermon, preached while a statue of the Empress
was being inaugurated close to the cathedral of
S. Sophia, filled the cup of his offences. It may
not be true that in the course of the discourse he
compared the Empress to Herodias demanding the
head of his namesake, John the Baptist. But

whatever the precise form of his words, he said
enough to exasperate her to a degree that made
her insist upon his final banishment, notwithstand-
ing all the popular opposition to that step. By a
strange fate, the pedestal of the column which bore
the statue still remains, being now placed for safe
keeping within the railing that encloses a narrow
strip of ground on the northern side of the Church
of S. Irene, in the first court of the Seraglio. A
Latin inscription upon it records the erection of
the monument in honour of Eudoxia, ever Augusta,
by Simplicius, the Prefect of the city ; while an
inscription in Greek adds the information that the
statue was of silver, the column of porphyry, and
that the monument stood near the Senate-House.

Notwithstanding, however, the anxieties of the
period, the improvement of the city continued to go
forward. The splendour of the Court was increased
by the erection of four princely mansions, placed
respectively at the disposal of the Empress and her
three daughters, Arcadia, Marina, and the famous
Pulcheria. New Thermæ were built, one of them,
the Thermæ Arcadianæ, situated near the Sea
of Marmora on the level tract below S. Irene,
being a great ornament to the city. A more
abundant supply of water was secured by the con-

REFUGEE HUTS ON THE MARMORA

This pile of huts is perched on the old seaward walls overlooking the Sea of Marmora. Petroleum cans are largely used for building material

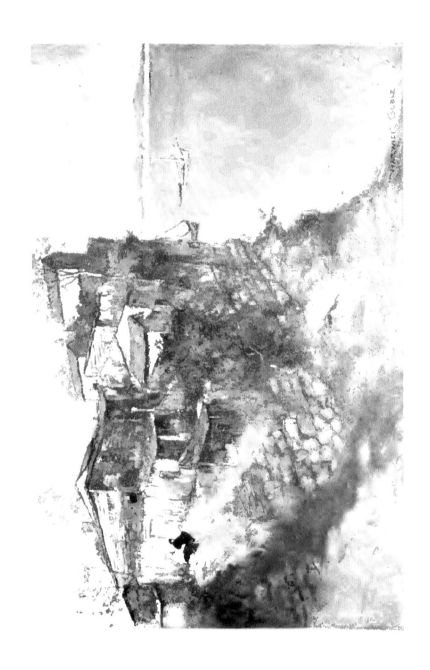

struction of the large open reservoir, whose basin, 152 metres square, now occupied by vegetable gardens and houses, is still seen to the south-west of the Mosque of Sultan Selim, above the quarter of the Phanar. But the most notable addition to the equipment of the capital was a great forum placed upon the summit of the Xerolophus, the hill at the south-western corner of the city. It was commonly known as the Forum of Arcadius, but sometimes also as the Forum of Theodosius, on account, probably, of additions made to it by Theodosius II., the son and successor of Arcadius.

As usual, the forum was surrounded by porticoes and adorned with many statues ; but its chief orna-ment was another lofty hollow column similar to that in the Forum of Theodosius I., thus furnishing the city with the same number of that class of columns as Rome possessed. On the summit of the monument stood the statue of Arcadius, and the procession of sculptured figures that winded their way around the shaft to his feet celebrated his victories over the Goths. The column held its place, in spite of storms, earthquakes, and fires, until 1715, when, threatening to fall, it was taken down as far as its pedestal, for the safety of neigh-bouring buildings. But it was inspected by many

7

European visitors to Constantinople previous to
that date, with the fortunate result that we
have drawings and descriptions of the monument
which allow us to form some adequate idea
of its general appearance and artistic merits. It
stood upon a platform of three steps, the upper-
most step being $33\frac{1}{2}$ feet square. The pedestal,
a hollow cube, rose 20 feet high, each side con-
sisting of six huge blocks of marble. Along
its upper portion it was adorned profusely with
wreaths, eagles, genii, and other usual forms of
architectural decoration, while the eastern, western,
and southern sides were covered with triumphal
scenes in bas-relief. "Along the highest part of
the pedestal, on the southern side," says the traveller
Wheler, "one sees the Labarum in a wreath held
by two Victories. Below it, are the Emperors
Arcadius and Honorius, in honour of whom the
column was erected, with two Victories crowning
them in presence of a crowd of senators. Still
lower down, in a third line, appear Victories con-
tending with one another, and several figures wear-
ing mural crowns, representing the cities conquered
by the armies of the two Emperors." From the
pedestal to the summit of the column 23 drums
of marble, so well joined as to seem one piece of

TURKISH DELIGHT FACTORY

The contents of the large copper pans are kept
stirring for two hours or more over a wood fire,
various flavourings are added during this process
according to the result desired, those mostly in use
are essence of almonds, vanilla, rose leaves almonds
and pistachios

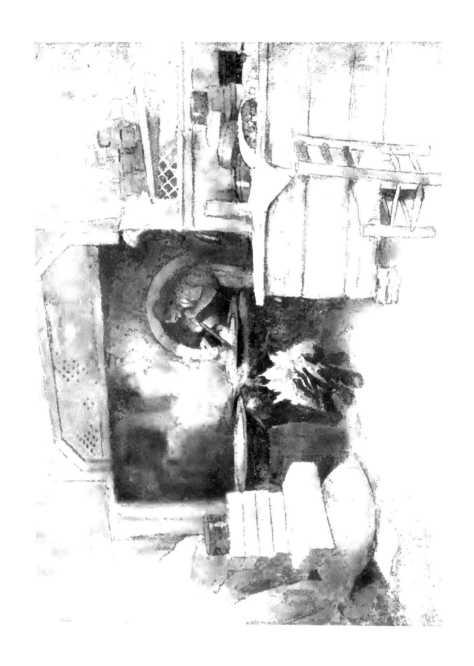

stone, soared some 121 feet higher to give the monument a total altitude of 146 feet. The figures on the upper part of the shaft were larger than those nearer the ground, so as to appear of the same size as the latter when seen from a distance. The hollow shell of the shaft was 28 feet round, and from 2 feet to $1\frac{3}{4}$ foot thick, the thickness diminishing as the shaft ascended. From the door in the northern side of the pedestal 233 steps, lighted by 50 lights, led one through the shaft to a door opening upon the abacus of the capital, a platform $17\frac{3}{4}$ feet square, from which to survey securely the glorious panorama presented by the great city below, and the surrounding landscape of sea and islands and mountains.

CHAPTER III

Such ornamental public works, as have been
described, were, like the blossoms on a plant, in-
dications of the general growth and flourishing
state of the city. In point of fact, we learn
from historians of the times that the population
increased at an extraordinary rate, and put a
severe strain upon an adequate supply of food
and of sufficient accommodation. The ships im-
porting wheat from Egypt, Asia Minor, Syria, and
Phœnicia had all they could do to provide enough
bread for the hungry multitudes of the new capital.
The dwellings in the city were so closely packed,
that the inhabitants, both at home and out of doors,
felt cribbed, coffined, and confined. The narrow
streets were so encumbered with beasts of burden

52

FLOWER-SELLERS

Some of the gypsies wear garments rivalling in
brilliancy the flowers they sell

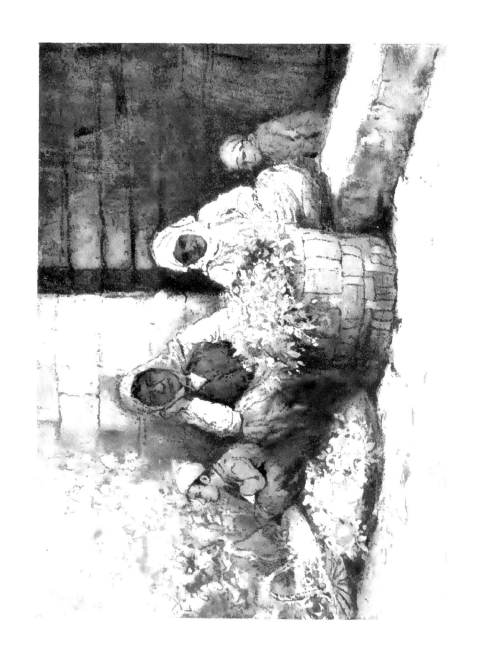

carrying building material in all directions, that it was dangerous to walk abroad. Ground for building had become so scarce that land had to be made by filling in portions of sea along the shores of the city, and the houses on that artificial ground alone formed a considerable town. And so the time came when it was no longer possible to keep the city within the bounds prescribed by its founder, and measures had to be taken to give Constantinople the size and strength required by the altered circumstances of its history. This was done in 413, early in the reign of Theodosius II., and eighty-five years after the foundation of the city. The western limits of New Rome were then carried to the line of fortifications, whose ruins, like veteran warriors loth to quit their post, stretch to-day from the Sea of Marmora to the old Byzantine Palace, known by the Turkish name Tekfour Serai. At the latter point the new bulwarks joined the walls which guarded the outlying 14th ward, the suburb of Blachernæ, and thus enclosed the city down to the Golden Horn. By this change the area of Constantinople was almost doubled, and reached its final size. Any additions to the dimensions of the city after 413, as in the 7th century when the

tract now occupied by the quarter of Aivan Serai was enclosed, or again in the 11th century when the Palace of Blachernæ was protected by new ramparts, were extremely insignificant additions, and were made not for the sake of obtaining more room but for strategic reasons.

This extension of the city's limits involved, of course, the erection of new fortifications. Indeed the demand to make the capital of the East a mightier stronghold was not less urgent than the necessity to enlarge its borders. No statesman of the 5th century of our era could fail to realise the formidable character of the barbarian peril which then lowered over the Empire. A period in which an Alaric, an Attila, a Genseric, insulted the majesty of the Roman name, and trampled upon Roman strength, a period in which the Eternal City was captured and sacked, in which Carthage was lost, and the original fabric of the Empire in the West was levelled to the ground, must have been a time when the minds of serious men were troubled by fears and anxieties. These disasters necessarily cast, ere they came, long and dark shadows before them.

Most fortunately for the eastern division of the Empire it had, early in this critical period, a states-

man at the head of the Government who compre-
hended the situation, and who had the sagacity
to devise measures by which the strength of the
impending storm might be greatly reduced, if not
broken. During the first six years of the reign of
Theodosius II., who ascended the throne when
a child of eight years, the government was in the
hands of Anthemius, the Prætorian Prefect of the
East. His abilities and character had already made
him conspicuous towards the close of the reign of
Arcadius. Chrysostom admired him greatly, and
described him as a person who honoured any office
he held more than the office honoured him. And
now that he was Regent of the Empire he did
all in his power to prepare the ship of State to
encounter the coming tempest. His first step for
that purpose was to establish peace with Persia,
the standing rival and foe of the Empire. In the
next place, he forced the Huns who had appeared
to the south of the Danube to retrace their steps,
and placed a flotilla of warships upon the river to
prevent the return of those fierce barbarians. At
the same time he strengthened also the Illyrian
fortresses to render the north-western frontier more
secure. Then, warned by a bread riot in Con-
stantinople due to a scarcity of wheat in the city,

he made arrangements for a more regular supply of grain from Egypt, thus making the population of the capital more friendly to the Government. And lastly, as the crowning act of his administration, he decided to array the city in new and better armour, and make it the strongest citadel in the Roman world. The great wall, flanked by ninety-six towers, which forms the innermost line of the fortifications along the landward side of the city, notwithstanding the changes it has undergone since his day, is even in its ruins, a magnificent monument to his wisdom, and to his devotion to the public weal. Those ramparts proved the shield of European civilisation for more than a thousand years. Their erection was one of those great acts in history which confer priceless benefits on mankind.

The change made by Anthemius in the position of the landward walls involved also the extension of the seaward fortifications to join the extremities of the new western limits. But, although that work must have been included in the plans of Anthemius, it was postponed for no less than a quarter of a century. Lack of funds, or the demands of more urgent necessities, or that happy sense of security from naval attack, in which the Government of Constantinople was tempted to indulge, in view

CARPET-MENDERS

These boys are engaged in patching up the holes in
old carpets, they are very skilful in matching the
faded colours that are so highly prized in the genuine
antique

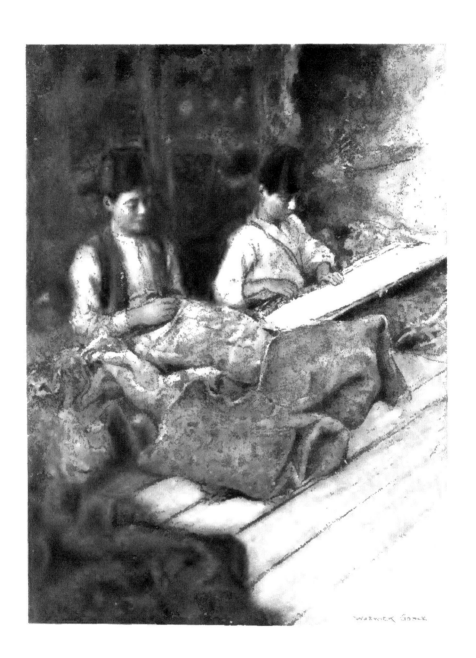

of the city's geographical position, may account for the delay. But whatever the explanation of the postponement, the gap in the defences of the capital could not be left open indefinitely, and at length, in 439, the thirty-first year of the reign of Theodosius II., the shores of the city were enclosed by Cyrus, the then Prefect of the city. It was the year in which the Vandals took Carthage, and possibly the alarm excited by their successes in Africa roused Constantinople to defend itself at every point.

Scarcely, however, had the city girded on its full armour, when, in the year 447, one of those violent earthquakes, to which Constantinople was liable, shook the city, and overthrew a large portion of the wall of Anthemius, with fifty-seven of its towers. The seaward walls of Cyrus were also injured at the same time. Struck with panic, the population rushed from the city to the open country, as far away as the plains about the suburb of the Hebdomon (Makrikeui), and there, with Emperor, Senate, and clergy, offered prayers and supplication that the quaking earth should keep still. It was a terrible catastrophe under any circumstances, but it was the more so at the moment when Attila was sweeping everything before him in his advance upon the city.

The crisis was, however, met with extraordinary
energy. Under the direction of the Prefect Constan-
tine (whom some authorities identify with Cyrus) the
calamity which had overtaken the city was turned
into an opportunity of building more formidable
fortifications than those which had been destroyed.
Requisitions of money and materials were made upon
the citizens, and the Factions of the Hippodrome
now vied with each other in the race to build the
most and the fastest. Not only was the wall of An-
themius repaired, but at a distance of about twenty
yards in front of it was placed a second wall, also
flanked with ninety-six towers, and then at a distance
of some twenty yards from the latter line a broad
and deep moat was constructed, with a battlement
breast-high surmounting its inner side. So vigor-
ously was the work pressed forward that the second
wall was completed in two months. Thus, the
capital stood behind a barricade 190-207 feet thick
and 100 feet high, comprising four lines of defence,
that rose tier above tier to permit concerted action,
with ample room for the operation of large bodies of
troops, and affording numerous points of vantage
from which to pour upon an enemy every missile of
death in the arsenal of ancient warfare—arrows,
stones, and Greek fire. If men did their duty, the

city was now impregnable, while the Prefect
Constantine earned the right to be associated with
Anthemius, as one of the forgers of the weapons
with which Constantinople defended the higher
life of mankind against the assaults of barbarism
for ten centuries. Two inscriptions on the Gate
Yeni Mevlevi Khaneh Kapoussi (the ancient Gate
of Rhegium)—one in Greek, the other in Latin—
have proclaimed the services of the Prefect Con-
stantine from his day to the present time. "In
sixty days, at the command of the sceptre-loving
Emperor, Constantine the Eparch built wall to wall,"
says the former in modest terms. The Latin legend
breathes the pride and satisfaction which the work
inspired. "By the commands of Theodosius, the
second month not being completed, Constantine
set up these strong fortifications. Scarcely could
Pallas have built so quickly so firm a citadel."

But the erection of the new walls of the capital
was not by any means all the building done in
Constantinople during the reign of Theodosius II.
The area added to the city naturally offered a wide
field for further construction. Much damage caused
to the older portions of the city by frequent fires
and repeated earthquakes in the course of the
Emperor's reign, or shortly before it, had also to be

made good. The Church of S. Sophia, and probably the adjoining Senate-House, now rose from the ashes to which they had been reduced when Chrysostom was exiled. The Baths of Achilles and the Public Granaries in the vicinity, destroyed in the fire which burnt down the quarter now marked by the Stamboul Custom House, were likewise rebuilt at this time. To the ornaments of the Hippodrome were now added the four gilt bronze horses of Lysippus, which to-day adorn the Church of S. Mark at Venice, whither they were carried as trophies of the capture of Constantinople, in 1204, by the fleet of the Doge Henrico Dandolo.

In this work of city improvement no one made himself so prominent as the Prefect Cyrus, already mentioned as concerned in the fortification of the shores of the city. He was a poet, a student of art and architecture, and, if not a pagan, strongly imbued with the spirit of the old faith. Moreover, he was distinguished for great integrity, a rare virtue among the officials of the day, and, in consequence, had been appointed simultaneously Prætorian Prefect of the East and Prefect of the city four times. It was doubtless with the view of checking corrupt practices that he restricted the powers of the Prefect of the city in the administration of the

FRUIT-MARKET, STAMBOUL

The street dogs always select the busiest and most
inconvenient places for resting.

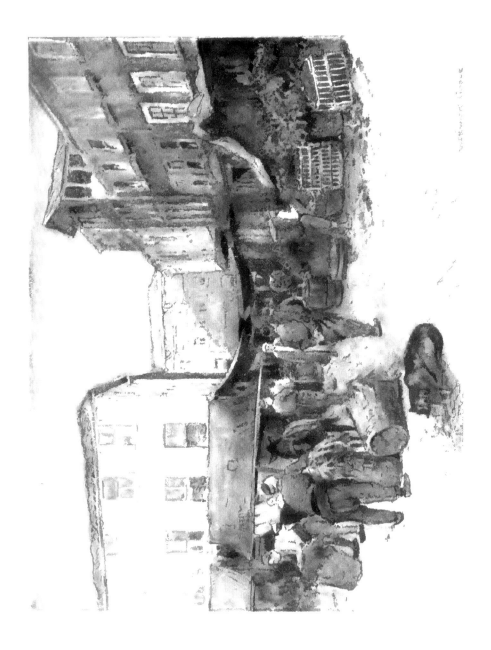

municipal revenues. Among the improvements
he introduced, the proper lighting of shops in
the evening is mentioned. His character and
services made him immensely popular; but the
fact did not make him happier. The dread of the
fickleness of fortune ever cast its shadow over his
mind, and he was often heard to say, "I do not
like Fortune when she smiles much." At length,
his worst fears were realised. Taking his seat one
day in the Hippodrome, he received a great ovation
from the vast crowds assembled to witness the
races. "Constantine," they shouted, "founded
the city; Cyrus has restored it." Never had the
capricious goddess smiled so benignantly upon him,
and never did she prove more treacherous. Such
popularity offended Theodosius, and he decided to
break the idol of the people to pieces. Cyrus was
dismissed from office, deprived of his property,
and reduced to a political nonentity, by being
consecrated Bishop of Smyrna or of Cotæum in
Phrygia. Such a proceeding appears very strange,
but probably we are ignorant of facts which would
explain this transformation of a pagan official into
a Christian priest. One can hardly believe that a
man like Cyrus was insincere in his new character.

The post assigned to the ex-Prefect was not

attractive. Four of his predecessors in the diocese had been murdered by brigands, and the people committed to his care doubted the soundness of his faith. But in a sermon preached on Christmas Day he conciliated his flock by orthodox statements, pointing out at the same time that the mystery before their minds was most honoured by silence. And he died unmolested by robbers. It is curious to observe, in passing, how punishment here assumes a religious form, and how men tried to hide their cruelty under the pretence of doing good to the souls of their victims. In the subsequent history of Constantinople, this species of penalty became common. It was a symptom at once of the mildness and the meanness of the times.

But the reign of Theodosius II is not distinguished only for the material growth of Constantinople. It is not less memorable for the advance of the city in its intellectual character, as the nursery of learning and the seat of justice. In this reign the University of Constantinople was opened. It found a home in the building known as the Capitol, on the hill now occupied by the Turkish War Office. Judging from the descriptions we have of the building, it resembled in its arrangements a Turkish theological school,—

medresseh,—an open court, surrounded by class-
rooms on the level of the court. Some of the
rooms were spacious halls, richly decorated, and
accommodating large audiences. The studies
pursued were chiefly grammar, rhetoric, and
literature, both in Latin and in Greek, there
being thirteen professors for these studies in the
former language and fifteen in the latter. To
philosophy only one professor was assigned, while
the department of law was in charge of two
professors. In the charter, so to speak, of the
University, particular stress is laid upon the need
of a separate class-room for each teacher, lest the
different classes should disturb one another by
simultaneous talking and variety of languages,
with the result that the ears and minds of the
students would be diverted from their proper
occupation. A candidate for a professor's chair
was required to undergo an examination before the
Senate both as to his learning and his character.
After twenty years' service a professor was rewarded
with the title of a Count of the Empire. Only
the professors attached to the University were
allowed to lecture in public, and they were not
permitted to give private instruction. The founda-
tion of the University had two objects mainly in

view—to prepare young men for the civil service, and to supersede the pagan schools of learning. It had certainly a lofty ideal, for, in the language of an inscription that refers to the institution, it was to be "a glory to scholars, an ornament to the city, the hope of youth, weapons to virtue, and wealth to the good." Thus, while the shadows of ignorance were gathering to settle down upon western Europe, the light of knowledge was kept burning in the capital of the East until the darkness passed away. The study of Latin indeed was erelong abandoned in Constantinople, but Greek learning had always its friends there, who handed that treasure down from century to century, and bequeathed it at last to safer keeping and wider use.

Another act that does honour to the reign of Theodosius II. is the codification of the laws enacted since the time of Constantine the Great. The compilation took nine years to be made, and is known as the Theodosian Code. How great a need it supplied is quaintly set forth in the preamble to the Code. "The chaos presented by the state in which the laws were found was such that few persons had an adequate knowledge of the subject, even though their faces have grown pale from late lucubrations" "When we consider," to quote

CARPET WAREHOUSE

The interior of an old Khan now used as a show-
room for antique rugs and carpets

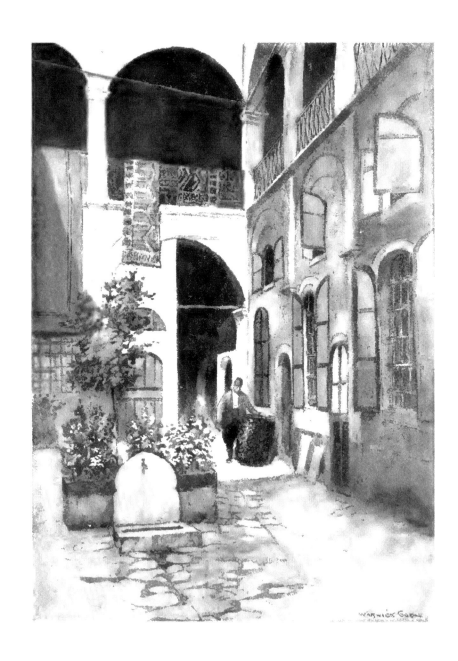

Professor Bury's translation, "the enormous multitude of books, the divers modes of process, and the difficulty of legal cases, and further the hugeness of imperial constitutions, which, hidden as it were under a veil of gross mist and darkness, precludes men's intellects from gaining a knowledge of them, we feel that we have met a real need of our age, and, dispelling the darkness, have given light to the laws by a short compendium."

On 23rd December of the year 438, the Code compiled at Constantinople was presented to the Senate of Rome and recognised by that body. It was a curious reversal of the part which the elder city had acted in the world. The teacher had become the pupil. Or is it truer to say, the pupil then did homage to the teacher? The Theodosian Code was superseded by the Code of Justinian the Great, but the earlier compilation retains the honour of being the first great legal instrument to confer upon New Rome the distinction of becoming the tribunal which has guided the most civilised nations of the world into the paths of righteousness and justice in the dealings between man and man. Into the religious controversies which agitated Constantinople while Theodosius II. was upon the throne, this is not the place to enter. But Con-

stantinople would not have been itself without a
hard theological problem to discuss, if not to solve,
and we do not know the soul, so to speak, of
Constantinople unless we recognise what may be
termed the religious temperament of the city. At
a period, indeed, when a great religious revolution
in the faith of men had taken place, and men were
called to make clear to themselves what exactly
they believed. and how their beliefs were to be
harmonised with their philosophy and the general
principles of reason, religious questions could not
fail to be prominent everywhere. They were as
naturally prominent in the fourth and fifth centuries
of our era, when Christianity became the religion
of the State, as they were at the time of the
Reformation. But Constantinople made these
questions peculiarly its own. It could not well
be otherwise where the seat of the chief bishop
of the Church in the East was found, and in the
capital of a Government which concerned itself in
these debates as matters of political importance.
Nor can it be denied that in the discussion of
the subjects before the public mind we often
witness great intellectual acumen, and a profound
religious spirit. Able and pious men anxiously
sought to reconcile faith in the unity of the Divine,

SHOEMAKER, STAMBOUL

His business plant consists of an awning propped up against the wall of a fountain and a few broken-down old stools

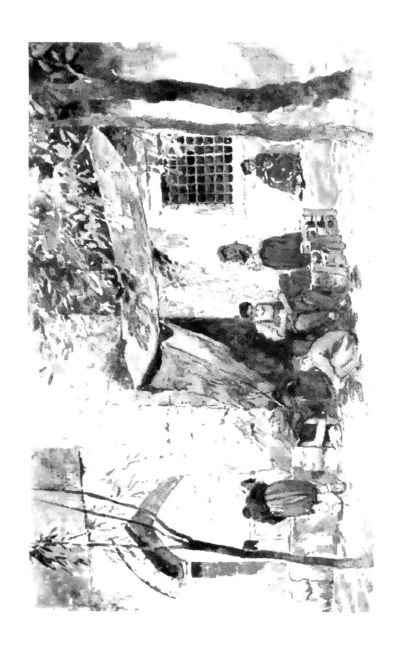

with faith in the intimate oneness between the Divine and the human manifested in the life of Christ. No age is dishonoured by keen interest in that theme.

On the other hand, these discussions sometimes degenerated into idle debate, and displayed some of the most odious feelings of human nature. And Constantinople laid itself open to the well-known satirical description of its theological bias by Gregory of Nyssa. " The city is full of mechanics and slaves, who are all of them profound theologians, and preach in the shops and in the streets. If you desire a man to change a piece of money for you, he informs you wherein the Son differs from the Father ; if you ask the price of a loaf, you are told by way of reply that the Son is inferior to the Father ; and if you inquire whether the bath is ready, the answer is that the Son was made out of nothing."

Under Theodosius II., the interest taken by the citizens of Constantinople in theological controversy was all the greater, inasmuch as the points at issue were raised by religious teachers in the capital itself ; one of the heretics being no less a personage than Nestorius, the patriarch of the city. He denied the propriety of the epithet, Theotokos, Mother of

God, commonly bestowed upon the Mother of our
Lord. A great controversy followed, in which
all classes of society, from the Emperor and his
family to the monks and populace, took part, and
displayed, as usual in such cases, a spirit unworthy
of the Christian name. So great was the com-
motion caused by the questions in dispute, that
two General Councils of the Church — that of
Ephesus in 431, and that of Chalcedon in 451—
were convened to affirm the orthodox faith, if not
to restore peace. And thus for some twenty years
people in Constantinople had all the theology they
could wish to discuss. One result of these religious
troubles was to evoke the latent antagonism
between the different races which composed the
population of the Empire. Under the guise of
religious differences, national diversities asserted
themselves. Rome and Constantinople, the West
and the East, did not learn to love each other
better in the heat of such debates. While from
the Council of Ephesus and the Council of
Chalcedon, the Armenian Church and the Coptic
Church date, respectively, their separation from the
main body of Christendom. The extent to which
religious and political aspirations are associated in
the minds of the populations of the modern East

casts much light upon the formation of different Churches along national lines in the earlier days of the Christian world, and also enables us to understand why religious conflicts caused so much anxiety to the imperial Government of New Rome.

Another feature in the religious life of Constantinople that became very distinct in the time of Theodosius II., was the veneration cherished for relics, and the growing desire to consecrate and enrich the city by their presence. The body of Chrysostom was taken from its grave in Pityus and entombed in the Church of the Holy Apostles, as an act of reparation for the wrongs he had suffered, and as an atonement for the sins of his persecutors. The supposed relics of Joseph and of Zacharias, on their arrival in the city, were received with great pomp by the Emperor, the Senate, and great officials, as though the saints were being welcomed in person. Pulcheria brought the relics of the Forty Saints martyred at Sivas, and enshrined them in a church she erected on the Xerolophus. To her also is ascribed the foundation of the three principal churches dedicated to the Mother of the Lord, S. Mary of Blachernæ, S. Mary Chalcoprateia and S. Mary Hodegetria, to become treasuries rich in relics of the Theotokos. The Empress

Eudocia, on her return to Constantinople from a pilgrimage to Jerusalem, brought with her, besides other relics, the portrait of Christ ascribed to S. Luke. In this way, Constantinople grew to be a sacred city, a sanctuary to which pilgrims came to acquire merit and receive benefits, almost as great as those obtained by a pilgrimage to the land over whose acres walked the blessed feet of the Saviour.

To omit all reference, however brief, to the influence of ladies in the public life of Constantinople while Theodosius II. occupied the throne, would be to omit an important feature of the time; a feature which often reappeared in the subsequent life of the Empire, and profoundly affected the course of its history. Pulcheria, the sister of Theodosius II., was the power behind her brother's throne. She directed his education, arranged his marriage, and was, with brief interruptions, the presiding genius of his career. The vow of virginity which she had taken, and which she persuaded her sisters to take, her charities, her activity in building churches, her orthodoxy, all rendered her popular in devout circles and with the dominant ecclesiastical party. To her was due the strong religious tone of the Court, and in the theological

STREET SCENE, ROUMELI HISSAR

Roumeli Hissar is the most interesting of the many
Turkish villages on the shores of the Bosporus

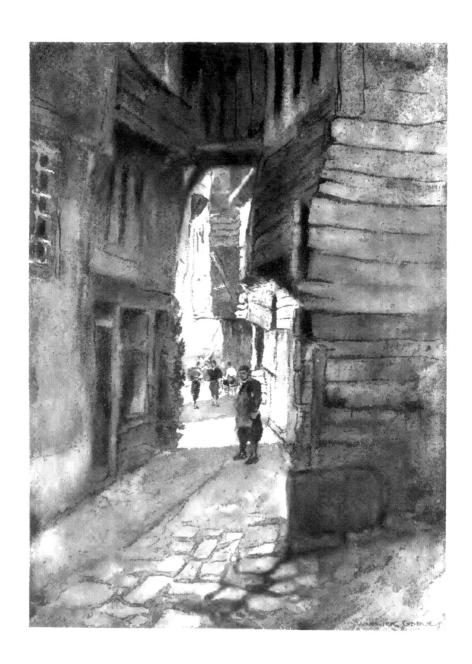

disputes that agitated the Church and the State in
her day she took an active interest, and helped
materially to determine the particular form of their
settlement. Her opposition to Nestorius and
Eutychius had much to do with the condemnation
of their views. And notwithstanding the occasional
loss of her influence over a brother who was too
weak to adhere steadily to a single course, she
triumphed at last over all her rivals, and upon
his death mounted the throne as the consort of
Marcian.

The story of Athenais, and her marriage to
Theodosius II., is well known, but it will always
retain the attraction which belongs to a life in which
romance and tragedy acted their opposite parts. A
beautiful and talented girl, brought up as a pagan
by her father Leontius, who cultivated philosophy
in the schools of Athens, she came to Constantinople
to seek redress for what she deemed a great wrong.
Her father, at his death, had divided his fortune
between his sons, and left her to struggle with the
world almost penniless. This arrangement was a
philosopher's eccentric way of indicating his ap-
preciation of his daughter's loveliness and genius,
and his confidence that they would win greater
success for their possessor than any prosperity his

money could ever secure. But either because of her modesty or her practical sense, Athenaïs differed from her father on that point, and wished his decision reversed. We can readily imagine how her story would circulate in the society of the capital, and make its heroine a topic of general conversation and interest. It raised so many questions to discuss, it appealed to the sympathy of so many feelings. Naturally, the charming girl was introduced to Pulcheria. She soon won the affection and admiration of the princess, under whose austerities a woman's heart still beat, and it was not long before Pulcheria thought she could do more for Athenaïs than obtain for her a share in the fortune of Leontius. In fact she considered no one so fit to become the Emperor's wife. The interest of Theodosius was readily excited by a description of the maiden's charms: large eyes, the nose of Aphrodite, a fair complexion, golden hair, a slender figure, graceful manners, clever, accomplished, and "of wondrous virtues" Accompanied by his friend Paulinus, he went to his sister's apartments, and standing concealed behind a curtain, saw the fair form and was conquered. So Athenaïs received baptism, and under the name of Eudocia became the bride of the Emperor of the

GRAND BAZAAR, STAMBOUL

One of its many vault-like passages in which the
merchants are displaying their goods

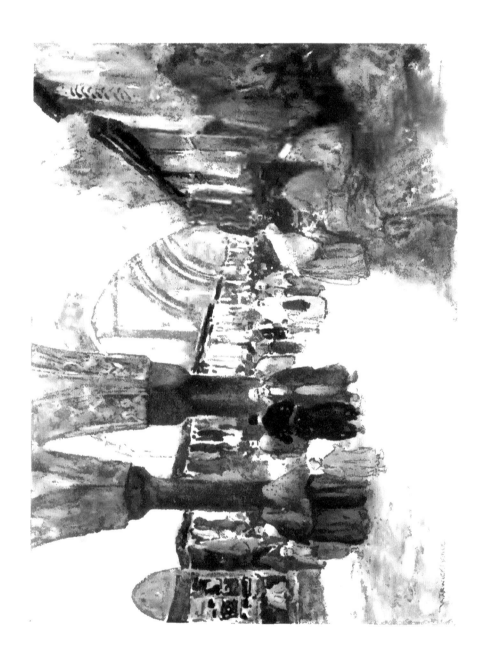

East. Like Portia, her father had scanted her and
hedged her by his wit that she might reach the
pinnacle of human joys. And with the spirit of
Joseph in Egypt, she forgave the brothers who had
injured her, summoned them to Constantinople,
and secured for them high positions. Her talents
appeared in her writings, and in her friendship with
the most intelligent men of the day. But erelong
clouds began to gather on this sunny sky. First
came the natural rivalry between herself and
Pulcheria as to whether a wife's influence or a
sister's would be stronger over the mind of the
Emperor; then estrangement, due to their different
temperaments and education; then diversity of
theological opinion, Eudocia taking the side opposite
to Pulcheria in the controversy raised by Nestorius.
But perhaps these clouds might have passed away,
and the heavens grown radiant again, had not
the friendship between the Empress and Paulinus
aroused the jealousy of Theodosius, and excited his
worst suspicions. According to a discredited tale
the crisis was brought about under the following
circumstances :—" One day the Emperor was met
by a peasant who presented him with a Phrygian
apple of enormous size, so that the whole Court
marvelled at it. And he gave the man a hundred

10

and fifty gold pieces in reward, and sent the apple to the Empress Eudocia. But she sent it, as a present to Paulinus, the Master of the Offices, because he was a friend of the Emperor. But Paulinus, not knowing the history of the apple, took it and gave it to the Emperor as he reëntered the palace. And Theodosius having received it, recognised it and concealed it, and calling his wife asked her, " Where is the apple that I sent you?" She replied, " I have eaten it." Then he bade her swear by his salvation the truth, whether she had eaten it or sent it to some one. And Eudocia swore that she had sent it to no man, but had herself eaten it. Then the Emperor showed her the apple, and was exceedingly angry, suspecting that she was enamoured of Paulinus, and had sent it to him as a love-gift; for he was a very handsome man." But however idle this tale may be, the fact is that Paulinus was put to death, and the Empress was banished to Jerusalem. She spent the last sixteen years of her life there in retirement and abounding charities, and died protesting her innocence.

Before concluding this account of the making of Constantinople, we must note another of the characteristics which the city gradually manifested in the development of its life—the tendency to cease

to be Roman and to become Greek. It is true, that in one sense Constantinople always remained Roman, and this character of the city should never be ignored. The people preferred to be known as Romans rather than by any other name. No title of the Eastern Emperors was so glorious in their view as to be styled the Great Emperor of the Romans. Roman law ruled in the Empire of which Constantinople was the head. The auto-cratic power inherited from strictly Roman days was maintained there to the last. Names of offices, epithets of officials, the denomination of taxes, legends upon the coinage of the realm, the terms in which Emperors were acclaimed by the army or the Factions were long preserved in their old Latin forms, but slightly, if at all, altered, and showed clearly the family connection that bound Rome upon the Bosporus to Rome upon the Tiber. Nevertheless, the daughter-city, though proud of her lineage, was also eager to declare her independence and to assert her individuality.

It could not be otherwise. A city exalted to be the capital of the part of the Empire under the sway of Greek traditions, and employing the Greek language as a vernacular speech, would inevitably consider itself called upon to embody and champion

the peculiar properties of the society of which it was the constituted head. Nor could a community whose religious life was under the direction of a Church that worshipped in the Greek tongue, and was stirred by the eloquence of the Chrysostoms, the Gregories, and the Basils of the East retain a Roman complexion and character without serious modifications. So long, indeed, as the western division of the Empire existed, the political union between Rome and Constantinople proved a check upon the Greek bias of the latter city, owing to the necessity of using Latin, as the language whose writ could run equally in both parts of the Roman world. The Popes of Rome, with characteristic insight, recognised the value of a common official language as a bond of unity, and an instrument of maintaining universal rule. The use of the Latin in the services and administration of the Roman Church is a master-stroke of political genius. But when partly by the estrangement of the two portions of the Empire, and partly by the Fall of the Empire in the West, the need of a common speech ceased to exist, the stream of tendency in the East was left free to follow its natural bent.

Within the period under review we see, of

A BLACKSMITH'S SHOP

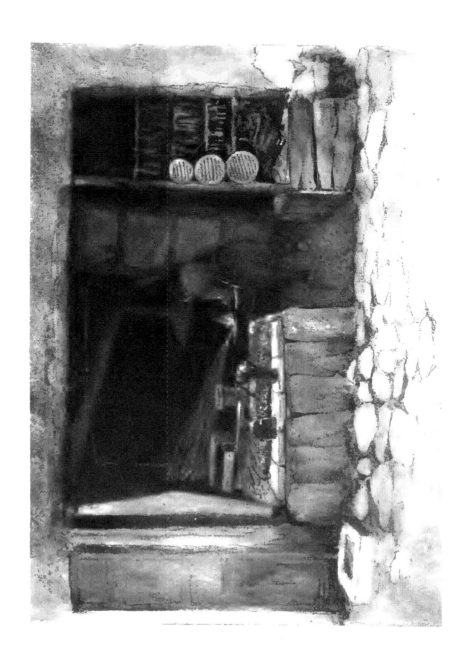

course, only the early symptoms of the Greek bias
to gain ascendency, but though these symptoms are
comparatively slight, they are the proverbial straws
that indicate the direction of the wind. While Latin
alone glitters in the inscriptions upon the Golden
Gate, Greek also is allowed a place in the legends
which celebrate the elevation of the obelisk upon
its pedestal in the Hippodrome. The pedestal
adorned by the statue of the Empress Eudoxia
likewise bore a bilingual inscription. The extra-
ordinary energy displayed by the Prefect Con-
stantine in the erection of the outer Theodosian
Wall is lauded, on the Gate of Rhegium, in both
languages. Probably the same was the case in
the record of that splendid achievement put upon
another gate of the fortifications—the Gate Xylo-
kerkou—although the historian, owing doubtless
to his ignorance of Latin, has preserved only the
Greek version. But the balance inclines in favour
of Greek, when, at the University of Constantinople,
there are more professors attached to the studies
in that language than to the studies in the tongue
of the elder Rome. At the same time also, the
Prefect Cyrus introduced the custom of publishing
decrees in Greek instead of in Latin. And along
with this preference for Greek in speech, there is a

marked growth of what was Greek in spirit. Thus in the relations between the Empire and Persia, as well as in the relations between the Empire and the barbarians, the Goverment of Constantinople depends now for success rather upon the devices of diplomacy than upon the force of arms. The negotiations between the Court of Theodosius II. and Attila are a remarkable chapter in the history of the diplomatic art—not of the noblest character. When Marcian replied to the demand of Attila for an increase of the tribute paid to the chief of the Huns by the Government of Constantinople, in the haughty terms, "We give gold to our friends, and steel to our enemies," words were spoken that had become somewhat unfamiliar, while the first Greek Emperor, as Theodosius II. has been styled, sat upon the throne.

Furthermore, it is the Greek spirit, not the Roman, that appears in the theological speculations of the Eastern Church, in the stress laid on correct thinking, and in the philosophical development of Christian dogma. After making every allowance for the vast difference between the splendid genius of Ancient Greece and the mental life that flourished in New Rome, it does not seem too much to say, that the old intellectual temperament of Hellas

survived and prevailed in the capital of the East. There was undoubtedly, at all times, enough and to spare of ignorance, superstition, and narrow-mindedness in Constantinople, but no period in the history of the Byzantine world quite corresponds to the Dark Ages in Western Europe. As in the Parthenon on the Acropolis of the city with the violet crown, so, under the dome of S. Sophia, beside the blue waters of the Bosporus, men agreed that the highest attribute of the Divine, and the ideal of human attainment, is Wisdom.

CHAPTER IV

FOR a person wishing to become acquainted with a great city, ready to admire beautiful scenery, and furnished with adequate information, nothing of the kind can be more interesting and memorable than to make the circuit of the old fortifications of Constantinople. It is a tour of thirteen miles, in the course of which, the city, set in the frame of its splendid natural surroundings, is seen from many different points of view, while at the same time the historical student travels through eleven long centuries, crowded with events not only of local interest but of world-wide importance.

Along the Walls beside the Sea of Marmora

The aspect which the city presents towards the Sea of Marmora and the Asiatic coast is by many persons considered to be the most beautiful view

of Constantinople. It is certainly a very attractive
view. Seated on ground rising with long and
steep ascent to the ridge of the promontory, the
city lies spread before you, from the Seraglio Point
to the Seven Towers, over an area five miles in
length. As from every other point so here also,
Constantinople shows as much as possible of itself
at a time. It always appears in large dimensions,
lofty, spacious, far-reaching; never descending from
its throne, never laying aside its majesty, but
constantly maintaining an imperial mien. Along
the sky-line is an array of domes and minarets
that, in brilliant sunshine, gleam as though made
of whitest alabaster. While at the feet of the city
lies a sea of sapphire, lovely as a lake; not so
broad as to place the city into dim distance, yet
wide enough to give the great metropolis sufficient
foreground to set off its size and dignity, to
obliterate petty details, to render prominent its
salient features, to soften any ruggedness, to
silence its din, and make the quiet grey tones of
its dwellings blend harmoniously with the over-
hanging heavens and with the surrounding waters.
It is, if the expression is allowable, the most
poetical view of the Queen of Cities. Sometimes,
an early watcher on the Asiatic shore beholds a

11

vision of extraordinary beauty. The silhouette of
the slumbering capital is seen against a darker
mass of clouds that gathered in the west during
the hours of the night. Suddenly, in the hush
of dawn, a delicate pink light gleams on a minaret
here or a dome yonder. It tints minaret after
minaret, dome after dome, house after house. It
spreads downwards and athwart, transfiguring
everything its rosy fingers touch, until the city,
still set against a dark background, is radiant with
indescribable grace. Very beautiful also is the scene
towards sunset, when the slopes descending to the
Marmora are in shade, and the glowing vault of
heaven is a canopy of glory ; when the windows
in the dome of S. Sophia, as the last beams of
day shine through them, sparkle like jewels in a
coronet, and the sea beneath seems woven of
crimson, gold, and purple. Nor can one fail to
recall the soft tranquil beauty of the scene when
the Sea of Marmora glitters in the moonlight, and
the golden waters kiss the shadows of the broken
towers and battlements that watched and guarded
the city in the days of old.

There is a grave in the British cemetery at
Haidar Pasha, which, contrary to the usual mode
of interment, fronts westwards to be turned

SERAGLIO POINT FROM "THE STONES"

On the Seraglio hill in the middle distance is the
palace formerly occupied by the Sultans

towards this side of the city. It is the grave
of an Englishwoman, who, from her Asiatic
home near Kadikeui, looked upon these views
for many years, and felt their spell so strongly,
that by her express order she was laid to rest in
a position in which she might face their beauty
even in death.

The fortifications beside the Sea of Marmora
consisted of a wall that, for the most part, followed
closely the sinuosities of the shore, and was
flanked, if the account of a mediæval traveller may
be trusted, by no less than 188 square towers.
The works attained their full extent in three
distinct stages, corresponding to the successive
periods in the growth of the city. The portion
from the Seraglio Point to the neighbourhood of
Achour Kapoussi represented the bulwarks of old
Byzantium. The portion from the latter point to
the vicinity of Daoud Pasha Kapoussi, the ancient
Gate of S. Æmilianus, was added by Constantine
the Great, and possibly the wall bounding the
vegetable gardens of Vlanga Bostan, formed part
of the original defences erected by the founder
of New Rome. The extension of the line from
Daoud Pasha Kapoussi to the southern ex-
tremity of the landward walls was a consequence

of the enlargement of the city in the reign of
Theodosius II. For the protection of these ram-
parts against the waves of the Marmora in angry
mood, boulders ranged in loose order were placed
in the sea, at a short distance from the shore, to
serve as a breakwater. Still, like Canute, the
emperors of Constantinople often found that the
sea scorned their control, and was the worst foe
these bulwarks had cause to dread. For instance,
a furious storm which occurred on the 12th
February 1332 hurled the waves over the battle-
ments, opened breaches, forced the gates, and
poured devastation into every adjoining quarter
In the spring of 764 the walls near the Seraglio
Point were damaged under most extraordinary
circumstances The preceding winter in the regions
along the northern and the western coasts of the
Black Sea had been so severe, that the sea itself
was frozen hard to an immense distance from
the shore. Upon the breaking up of the frost-
bound waste, a long procession of ice-floes entered
the Bosporus on their way to the south. They
came in such numbers that for some time the
channel at the Marmora end of the straits was
blocked, and men crossed from Scutari to Galata
and to S. Mamas (Beshiktash), and from Chalcedon

THE SERAGLIO LIGHTHOUSE AND SCUTARI

The lighthouse occupies a prominent position near the old palace of the Sultans overlooking the Sea of Marmora

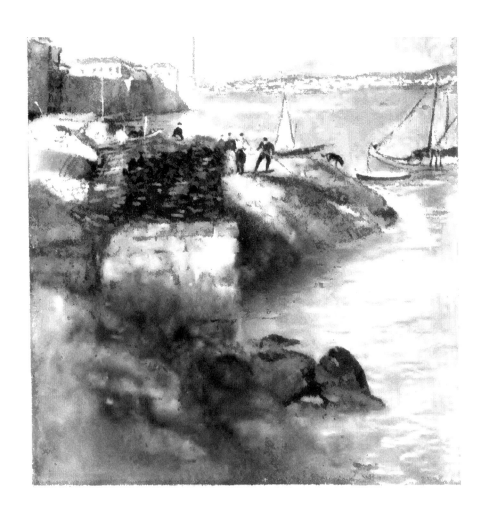

(Kadikeui) to the city (Stamboul) with perfect
safety. When at length the ice broke again and
moved forward, two huge fragments were flung
against the Seraglio Point by the swollen currents
coursing in that direction. The strange assailants
towered above the battlements, and made the city
quake with fear before the weird enemy at whose
cold touch strong bulwarks crumbled to pieces.
How frequently these walls suffered from their
exposure to storm and weather appears in the
numerous inscriptions found upon them in honour
of restorers of the works. The most extensive
repairs were made in the reign of Theophilus
(829-842), and large portions of the existing walls
belong to his reign. But many other emperors were
likewise concerned in maintaining these fortifica-
tions in proper order, as for example, Leo the
Wise, Basil II., Manuel Comnenus, Michael
Palæologus, Andronicus II., and Andronicus III.
The legends commemorating repairs are usually
formal, laconic records of the names and titles of
the rebuilder of a tower or of the curtain of the
wall. Three of the inscriptions, however, allow us
to see more into the heart of the persons they
celebrate, and bring us into touch with the spirit
of the times. One of them, forming a line 60

feet long, is found on the wall to the north of
Deirmen Kapoussi, and reads to the following
effect :—" Possessing Thee, O Christ, as a wall
that cannot be broken, Theophilus the pious
sovereign and emperor, erected this wall upon new
foundations ; which (wall) Lord of All, guard with
Thy might, and display to the end of time stand-
ing unshaken and unmoved." The second inscrip-
tion referred to speaks more directly of the injury
sustained by the wall owing to the proximity of
the sea :—" In the year 1024, Basil, the pious
sovereign, erected from the foundations this tower,
which the dashing of the sea, battering it for a
long time with many and violent waves, compelled
to fall." The third inscription tells that in the
year 1448, only five years before the fall of the
city, George, the Despot of Servia, contributed
funds towards the repair of these defences, thus
showing clearly how well he understood that the
fate of his kingdom was bound up with the fate
of Constantinople.

The fortifications beside the Sea of Marmora
were not called to occupy a prominent place in
the active defence of the city ; that is to say, they
were never the object of a serious hostile attack.
This was only what might be expected so long

as the Empire maintained its naval superiority to
the enemies with whom it was called to contend.
But the Empire was not always master of the sea.
And the immunity of these fortifications from
attack was then due to the difficulties which the
currents that sweep along this shore place in the
way of the approach of ships within striking
distance. The fear that the currents would carry
his ships out to sea was the reason why Dandolo
refused to bring the fleet of the Fourth Crusade
into action against this side of the capital. The
nearest semblance of an attack upon these fortifica-
tions was when Heraclius, in 610, brought up a
fleet from Carthage to depose the tyrant Phocas,
and took up a position before the Harbour of Julian
or Sophia, the remains of which are seen in the
quarter of Kadriga Limani below the Hippodrome.
But that was more in the nature of a hostile
demonstration than an active assault, for the citizens
welcomed Heraclius as a deliverer, and carried
Phocas to him as a prisoner. Still the compara-
tive security of these walls from attack did not
warrant leaving them in a state to tempt an
enemy to strike a blow, and accordingly, though
sometimes neglected in time of peace, they were
promptly put in order whenever a hostile fleet

was expected. This was particularly the case during the period of the Palæologi, when Genoa and Venice and the Ottoman Turks ruled on the sea, and the naval strength of the Empire had fallen into utter decay. In the siege of 1453, the Turkish fleet blockaded this side of the city from the Seraglio Point to Vlanga.

In following the course of these walls to note the arrangements of the city, and to recall historical associations, only a very brief mention of what is most prominent and memorable is here possible. Beginning at the head of the promontory, we have first the eastern portion of the Seraglio Grounds, presenting to view the crags upon which stood the Acropolis of old Byzantium. To become the master of that hilltop, with its wonderful out-look and great strategic value was the ambition of Xenophon and "The Ten Thousand" on their famous retreat from Persia, of Philip of Macedon, of Severus Septimius, of Constantine the Great, not to mention other aspirants. After the foundation of Constantinople, until Turkish days, the site of the Acropolis formed an ordinary part of the city, the most conspicuous edifice on that position being the Church of S. Irene. There also was the hospital of Sampson, as well as that of Eubulus.

CRIMEAN MEMORIAL BRITISH
CEMETERY, HAIDAR PASHA

Erected to the memory of the British soldiers and
sailors who fell in the Crimean War

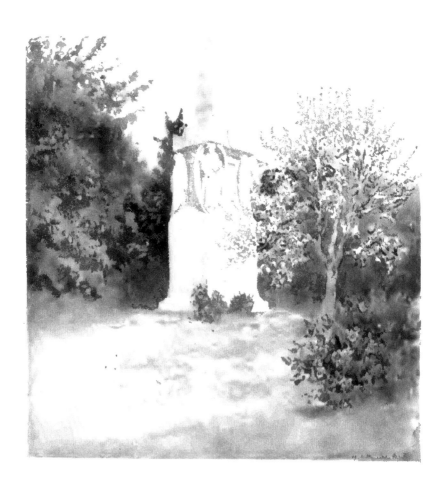

Among the buildings on the level tract below
the Acropolis were two theatres, inherited from
Byzantium, one of which has left its stamp in the
hollow ground now occupied by the vegetable
gardens to the rear of Deirmen Kapoussi. Scattered
over the adjoining territory was a crowd of churches
in which saints encamped to guard this exposed
point of the city; a host led by S. Barbara,
patroness of arms, S. George, the Slayer of the
Dragon, S. Mary Hodegetria, with her icon ascribed
to S. Luke, and regarded as a palladium. The Man-
gana or Arsenal, stored with military engines for
the defence of the walls, also stood in this vicinity.
The vaulted substructures near the ruins of Indjili
Kiosk belonged to the Palace of the Mangana, to
which the imperial household resorted to enjoy
the cool breezes that winged their way down the
Bosporus from the north. Here also was a public
park, the Philopation, and an atrium built by
Justinian the Great, crowded on summer after-
noons, when this side of the city is in shade, by
people who loved to look out upon the sparkling
water, and the hills of the opposite Asiatic shore,
resplendent in the mellow light of the setting sun.
The fine building that formed the Thermæ of
Arcadia was in this neighbourhood, and a portion

12

of the polo grounds, Tzycanisterion, attached to the palace of the Byzantine emperors.

Fifteen years after the Turkish occupation, Sultan Mehemet the Conqueror transferred his residence from his palace on the hill now surmounted by the War Office to this quarter of the city, and for the security of his new abode built the wall that, on its way across the promontory, from the Sea of Marmora to the Golden Horn, passes to the north of S. Sophia. In its general plan the Seraglio was a series of three courts, opening one into the other; and around and within them, embowered in groves of plane-trees and of cypresses, rose the numerous and picturesque edifices which served the convenience of the imperial household. But however inferior in the magnificence created by art, no royal abode has ever been invested by nature with the beauty and lordliness surrounding that in which the Ottoman Sultans sat enthroned from Mehemet the Conqueror to Abdul Medjid, with its grand outlook over Asia, Europe, and the great waterway between the lands on the north and on the south.

"It was at once a royal palace, a fortress, and a sanctuary; here was the brain and heart of Islam, a city within a city, inhabited by a people, and

guarded by an army, embracing within its walls an infinite variety of edifices, places of pleasure or of horror; where the Sultans were born, ascended the throne, were deposed, imprisoned, strangled; where all conspiracies began and the cry of rebellion was first heard; where for three centuries the eyes of anxious Europe, timid Asia, and frightened Africa were fixed, as on a smoking volcano, threatening ruin on all sides."

The slopes which descend from S. Sophia and the Hippodrome to the Sea of Marmora, immediately outside the Seraglio Enclosure, are also haunted by memories of splendour and power, for upon them stood the great palace of the Emperors of New Rome from the time of Constantine the Great to almost the end of the Byzantine Empire. The site did not command so extensive a view of the Bosporus as the Seraglio enjoyed, nor had it the outlook of the latter upon the Golden Horn and the busy life of the harbour. But its prospect over the Sea of Marmora and the hills and mountains of the Asiatic coast, rising to the snows of Mount Olympus or merged in the pale blue of the distant horizon, was wider. It had also the advantage of a sunnier and more temperate climate. The site was furthermore recommended by its

proximity to the Hippodrome, as direct com-
munication between the palace and that arena of
the city's public life, in serious or gay mood, was
of paramount importance in Constantinople as at
Rome. We must therefore imagine these slopes
wooded with trees, and crowded with stately
buildings, often domed, for the accommodation of
a Court which sought, in pomp and luxury never
surpassed, to find all that power and pleasure can
do to satisfy the human heart. As in the case of
Byzantine churches, so in the edifices forming the
"Sacred Palace," artistic effort was chiefly devoted
to the decoration of the interior, and it was with
similar means, marble revetments and mosaics, that
artistic effects were produced.

The throne-room, for instance, was, as we shall
find in the sequel, almost a facsimile of the Church
of SS. Sergius and Bacchus. Like that church
it was an octagonal hall enclosed in a square, and
surmounted by a dome pierced by windows.

Each division of the octagon formed a bay
under a semi-dome, and above the bays was a rich
entablature, with a cornice that projected so as to
constitute a gallery. The floor was paved with
slabs of porphyry and variegated marbles, arranged
to form beautiful designs and set in borders of

silver, while walls and vaults gleamed with mosaics.
The hall was entered from the west, and in the
bay directly opposite stood the throne, with an
icon of Christ in mosaic in the conch above it.
The bay immediately to the south of the throne
was the emperor's robing - room, leading to a
chapel in which his robes of state, his crowns
and arms, and two enamelled gold shields, studded
with pearls and precious stones, were kept under
the guardianship of S. Theodore. The other state
rooms of the palace were all varieties of the
same type, displaying more or less skill and taste,
according to the fluctuations of art in Constanti-
nople. Of all the magnificence that once adorned
these slopes, nothing remains but unshapely
masses of brickwork, broken shafts, fallen capitals
and empty sarcophagi ! Slopes that vied with the
Palatine as a seat of power, they are without a
vestige of the grandeur that lingers around the
ruined home of the Cæsars ! The higher part of
the site of the palace is now occupied by the
Mosque of Sultan Achmed, the six minarets of
which, combined with the four minarets of S.
Sophia, make so striking a feature in the aspect
of this part of the city. Upon the lower slopes
lives a Turkish population that never dreams

of the splendour buried beneath its humble dwellings.

Close to Tchalady Kapou, and at the water's edge, are the ungainly ruins of the residence of Justinian the Great and Theodora, before their accession to the throne. Here began the romance of their lives. In course of time additional buildings were put up at this point, and the group thus formed became the Marine Residence attached to the Great Palace. Here was the little harbour at the service of the Court, with marble steps descending to the water from a quay paved with marble, and adorned with many marble figures of lions, bears, bulls, and ostriches. Here the Emperor embarked or disembarked when moving in his imperial barge from one part of the city to another by water. One of the pieces of statuary, representing a lion attacking a bull, bestowed upon this Marine Residence the name Bucoleon (The Bull and Lion), under which designation it is frequently mentioned in Byzantine history. There was enacted the tragedy of the assassination of the noble Nicephorus Phocas by John Zimisces, with the connivance of the Empress Theophano, the victim's wife; a typical instance of the intrigues and crimes that often dishonoured

INTERIOR OF THE MOSQUE OF SULTAN
AHMED I

This mosque is beautifully decorated with blue and
green tiles, on the right is the minber (pulpit) built
of marble intricately carved and delicately tinted,
behind it is one of the four great marble columns
that support the roof

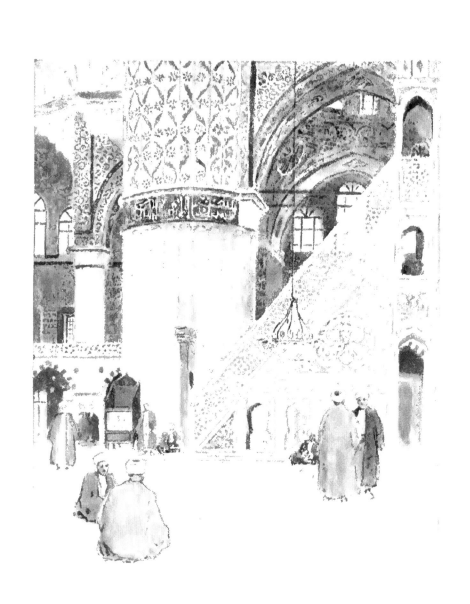

the palace of the Byzantine emperors. The
story has recently been told by the brilliant pen
of Mr. Frederic Harrison, and therefore must not
be repeated. But the visitor to the spot can
recall the event with startling vividness, so well
preserved is the stage on which the tragedy was
acted. Directly opposite, on the Asiatic shore, is
Chalcedon, where the conspirators joined Zimisces
to proceed to the scene of their cruel work. The Sea
of Marmora over which, on that fatal night, a snow-
storm spread a veil to hide the boat which bore the
conspirators across the sleeping waters, comes up
to the very base of the palace. From one of the
palace windows overhanging the sea, a basket,
attached to a rope, was let down again and again to
the boat, and again and again drawn up, with one
conspirator in it at a time—Zimisces being the last
—until the whole band stood within the imperial
abode. And somewhere in the vaulted building we
still find at the water's edge, and whose ruins seem
haunted by evil ghosts, was the chamber in which
the doomed emperor lay slumbering on the floor,
and was rudely awakened to know all the bitterness
of ingratitude and the sharpness of a cruel death.
Geography and topography are certainly the eyes
of history.

To the west of the Bucoleon is the beautiful Church of SS. Sergius and Bacchus, erected by Justinian the Great; for some account of which the reader is referred to the chapters on the churches of the city. The district extending thence to the ancient Gate of S. Æmilianus (Daoud Pasha Kapoussi) is remarkable for having been occupied by the artificial harbours, constructed, from time to time, on the southern side of the city in the interest of commerce, or for the use of the imperial navy. They were four in number, and, notwithstanding the changes of centuries, they have left their impress upon the ground to a degree which allows their site and contour to be clearly identified. First in the order of position, though not of time, came the Harbour of the Emperor Julian, below the Hippodrome. It has already been noticed in the history of the making of Constantinople. It was used for some time even after the Turkish Conquest, but was ultimately abandoned for the deeper water found along the shores of the Golden Horn. The Harbour of the Kontoscalion followed; in the quarter which the Greek population still designates by that old name, but which is commonly known as Koum Kapoussi. It has been filled in, but the mole remains, as well as a considerable

portion of the wall around the basin of the harbour. The entrance could be closed against an enemy by great gates of iron bars, and in bad weather three hundred galleys, of fifty or a hundred pairs of oars, might be seen taking refuge here, waiting for a favourable wind.

Next in order was the Harbour of Kaisarius, known also as the Neorion or Dockyard of the Heptascalon, which stood where the Turkish quarter of Tulbenkdji Djamissi is now situated. But few traces of it are left. Indeed its position had been forgotten, and its distinctness from the other harbours along this shore ignored, until 1819, when a great fire in the district revealed the fact that the quarter of Tulbenkdji Djamissi stood in the basin of an old harbour, enclosed by a wall built in three tiers of huge blocks. This agreed with other indications of the presence of a harbour at this point hitherto left unexplained—a mole in front of the shore of the quarter, and a gap in the mole forming an entrance to which corresponded an old opening in the city walls, now closed by masonry of Turkish construction. It harmonised also with the description which the historian Pachymeres gives of a harbour constructed or restored by the Emperor Michael Palæologus on this side of the

13

city. Here Phocas placed troops to oppose the landing of Heraclius, and here also the Emperor Constantine Pogonatus, in 673, stationed his ships, armed with Greek fire, to await the fleet of the Saracens in the first siege of Constantinople by that formidable foe.

Last in order of position was the harbour on the site of the vegetable gardens of Vlanga Bostan, a work, as we have seen, belonging to the time of the founder of the city, and known first as the Harbour of Eleutherius, its original constructor, and later as the Harbour of Theodosius I., who improved it. Its mole and extensive portions of the walls around it remain, and carry thought back to the city's earliest days.

These harbours are a monument to the great commercial activity of the city during the Middle Ages, and formed a feature in the life and aspect of the place which has disappeared. Occasionally, in the fruit-season, a considerable number of the ships and large caiques engaged in the coasting trade between the city and the ports of the Sea of Marmora anchor off the points once occupied by these harbours, and help the imagination to recall the animation, the busy crowds, the varied merchandise, the picturesque craft and

PRINKIPO (PRINCES ISLANDS

A favourite summer resort of wealthy residents
Constantinple

strange crews that made what is now an almost
silent shore one of the liveliest and most interest-
ing quarters of New Rome. Owing to the sand
thrown up against this coast, all these harbours
demanded frequent cleaning and restoration, and
had a hard struggle for existence. They were
at length neglected, and, one after another, turned
into dry land on which to plant market gardens,
or build dwellings for the poor.

The tract of the city extending from Vlanga
Bostan to the landward walls was noted for the
number and importance of its churches and monas-
teries. Conspicuous among them was the Church
and monastery of S. Mary Peribleptos in the dis-
trict of Psamatia. It was destroyed by fire in
1782, and is represented by the modern Armenian
Church of S. George, generally styled, after the
cistern beneath the old edifice, Soulou Monastir.

The Church of S. John Studius, now a sad
ruin, stood likewise in this part of the city. So
did the Church and monastery of S. Diomed, upon
whose steps one day, towards sunset, a way-worn
youth in quest of fortune lay down to rest, after
his long journey from Macedonia, and rose to
become, in a capital where strange careers were
possible, the Emperor Basil I. He founded a

dynasty that occupied the throne of the Byzantine Empire for two centuries, and counted among its members such notable sovercigns as Basil II. the Slayer of the Bulgarians, Nicephorus Phocas the Conqueror of the Saracens, John Zimisces who drove the Russians out of Bulgaria across the Danube.

CHAPTER V

THE fortifications which defended the side of the city along the Golden Horn consisted of a single line of wall placed, for the most part, close to the water's edge and flanked, it is said, by one hundred and ten square towers. Like the bulwarks along the Sea of Marmora, they attained their full length gradually, according as the northern extremity of the landward walls, which they were to join, was carried farther to the west, when Byzantium expanded into the City of Constantine, when the City of Constantine grew into the City of Theodosius II, and, finally, when, in 627, the outlying level portion of the suburb of Blachernæ was brought within the bounds of the capital. The points along the shore of the Golden Horn thus reached were successively the Stamboul head of the Inner Bridge, the eastern border of the

quarter of Aivan Serai, and the present point of junction with the landward walls on the west of that quarter. But the actual wall is, substantially, the work of the ninth century, when the Emperor Theophilus reconstructed the fortifications along both shores of the city, as the inscription, "Tower of Theophilus, Emperor in Christ," found until recently upon almost every tower of the line, proclaimed to the world. In the course of the improvements made in the quarters along the Golden Horn, extensive portions of the fortifications have disappeared, leaving scant remains to interest the visitor. It should be added that the safety of this side of the city was further secured by a chain stretched across the entrance of the harbour, from a tower near Yali Kiosk Kapoussi, the Gate of Eugenius, to a tower known as the Tower of Galata, somewhere near Kiretch Kapoussi on the opposite shore.

The view of Constantinople from the Golden Horn, whether seen from the bridges that cross the harbour, or from Pera, is universally admitted to be as impressive and beautiful a spectacle as any city in the world can present. The visitor of a day recognises its wonderful attractions at the first glance, and long familiarity never allows

one to feel satisfied that he has given to the scene
all the admiration which it deserves. The domi-
nant feature of the view is lordliness, although
beauty is almost equally manifest. Men spoke
truly when they conferred upon New Rome the
title "The Queen of Cities," for the aspect of the
city is not only lovely, but carries in its aspect
the unmistakable air of the majesty and authority
that befit the capital of a great Empire. Here is
an eye "to threaten and command." The city
spreads itself before you for some three miles on
both sides of the Golden Horn, seated upon hills
that rise steeply from the water's edge, and lift the
long and wide panorama high into view. The
buildings are packed close together, and rise tier
above tier from the shore to the summit of
the hills. Great mosques, rectangular buildings
surmounted by domes and flanked by graceful
minarets, occupy the most commanding positions,
and crown the city with a diadem of oriental
splendour. The Golden Horn, one of the finest
harbours in the world, where the war-ships of a
nation may ride at ease, and great merchantmen
can moor along the shore, is so inwoven with the
city as to be its principal thoroughfare, its "Grand
Canal," alive with boats of every description,

and spanned by bridges over which the population streams to and fro in great tides. The city is generally irradiated by an atmosphere of extraordinary clearness, brilliance, and warmth of colour. Sometimes the solid earth seems transfigured by the light into a glorious spiritual essence. Early in the morning, Constantinople is often shrouded in a thick veil of mist, and, as the sun gains strength, it is beautiful to see the veil gradually rent at different points, and the objects it covered emerge, piece by piece, one by one, now here now there, a dome, a minaret, a palace, a red-tiled roof, a group of cypresses, as though a magician was constructing the city anew in your presence, until the immense capital gleams before you in its mighty proportions and minute details. Nor is the vision less memorable towards sunset, when the lights and shadows paint this varied surface of hills and valleys, of land and water, while the long array of mosques and minarets upon the hills overhanging the Golden Horn rests against the deepening glory of the sky. It is the vision which Browning saw with a poet's eye :—

> Over the waters in the vaporous West
> The sun goes down as in a sphere of gold
> Behind the arm of the city, which between,
> With all that length of domes and minarets,

GOLDEN HORN, EARLY MORNING

Beyond the pile of buildings in the foreground a
glimpse of the Golden Horn is seen with Stamboul
partly shrouded in mist in the distance

Athwart the splendour, black and crooked runs
Like a Turk verse along a scimitar

The portion of the Golden Horn to the east of the Galata Bridge is crowded with foreign steamships, among which those bearing the flags of Britain, France, Austria, Italy, Germany, Greece, and Roumania, are the most conspicuous. It may not be to the credit of the country, nor for its greatest advantage, that so much of the commerce of the place should be in foreign hands, but this gathering of the nations in the harbour of the city is imposing; it is an indication of the central position occupied by the city in the world's affairs, and contributes largely to form the cosmopolitan character for which Constantinople is distinguished. Here the nations assemble to compete with one another as nowhere else in the world, at least in a way so manifest and decisive. This was a feature of the life of the city also before Turkish days. There was a time, indeed, during the Middle Ages when the commerce between the East and the West was exclusively in the hands of the subjects of the Byzantine Empire, when the merchants of Constantinople were the merchant princes of the civilised world. But not to speak of the interference of the Saracens with the trade of the city,

14

the formidable competition of the Italian Maritime
States began to make itself felt towards the close
of the eleventh century, and from that time on-
wards became more and more serious until it well-
nigh destroyed the business carried on by the
native inhabitants. This was due partly to the
enterprise of the Italian merchants, and partly to
the policy which purchased the aid of the Western
States against the foes of the Empire by means of
commercial concessions which proved detrimental
to domestic trade. It was thus that Alexius
Comnenus secured the help of Venice against the
Normans, and that Michael Palæologus obtained
the support of the Genoese, when, in 1261, he
undertook the task of recovering Constantinople
from its Latin occupants. The attack upon Con-
stantinople in 1203-1204 by the Fourth Crusade,
at the instigation of the Doge Henrico Dandolo,
was essentially a piratical expedition to capture
the commerce of the East for the benefit of the
merchants of Venice. In the course of time the
foreign traders in Constantinople were allowed by
the Byzantine emperors to occupy the territory
extending along the southern shore of the Golden
Horn from the Seraglio Point to Zindan Kapoussi.
They were grouped according to their nationality,

THE BRIDGE FROM GALATA

The sailing boats used in these waters are constructed so that the mast and sail can be lowered in a few seconds to shoot the arches of the bridge

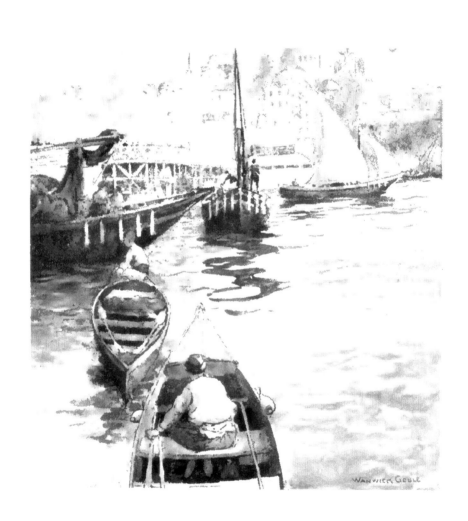

and placed beside one another in the following
order, Saracens, Genoese, Pisans, traders from
Amalfi, Venetians. After 1261, the Genoese were
settled in Galata, where they have left a monument
of their occupation in the strong and massive
Tower of Galata, that formed their watch-tower
and citadel, and where they established, at the
very gates of the capital, so strong a rival,
that, as Gibbon observes, "The Roman Empire
might soon have sunk into a province of Genoa,
if the Republic had not been checked by the
ruin of her freedom and naval power." These
foreign communities were allowed to be self-
governing, so far as the Byzantine Govern-
ment was concerned. They had their own courts
of justice, and their own places of worship,
even the Saracens being allowed to possess a
mosque. A certain number of houses, a certain
extent of territory, and particular piers at which
their ships could moor for discharging or receiving
cargo, were assigned to them, and, as a rule, they
paid lower duties than native merchants did.
Sometimes, it seems they were liable to render
military service, as though feudal vassals, but to
all intents and purposes they enjoyed under the
Byzantine emperors very much the position which

foreigners in Turkey now occupy, in virtue of the
Capitulations granted by Sultans to European
residents. The original copies of several of the
commercial treaties between the Empire and the
Italian States are preserved in the archives of
Venice, Genoa, and other cities of Italy, and
furnish an interesting chapter in the history of
diplomacy and commerce.

The most picturesque portion of the Golden
Horn is that which lies between the two bridges.
Along the Galata shore, a large flotilla of gaunt
native barges, with short masts and long oblique
yards, is generally moored, waiting to be employed
in the transhipment of the cargoes that leave or
reach the port. Here also a mass of native shipping
is laid up for the winter, after the fashion of the
early days of navigation It is a dense forest of
bare masts and poles involved in a network of
cordage, with the steep hill, upon which the stone
houses of Galata and Pera are built, as a rocky
background. After a night of rain, the scene
changes. Then from every yard and mast, heavy,
damp sails are spread in the warm, misty, morning
air, and you seem to look upon a flock of great
sea-birds opening their wings to bask in the sun-
shine. Along the opposite shore, surmounted

GOLDEN HORN

Seen from the water's edge on a misty morning, crowning the distant heights is the Mosque of Suleiman the Magnificent

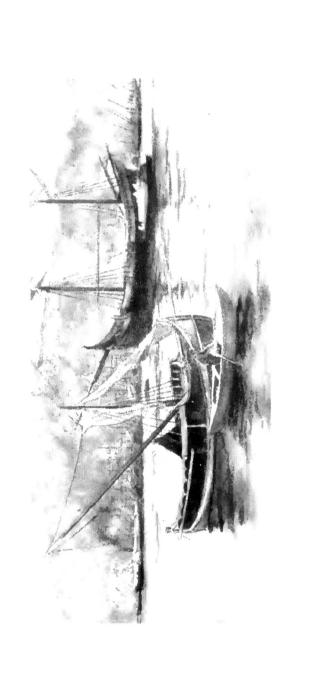

by the domes and minarets of the Mosque of
Sultan Suleiman, the bank is fringed with native
craft, laden with fruit or oil from the islands of the
Ægean Sea, or bringing planks and beams to the
timber - yards at Odoun Kapan from the lands
beside the Danube. Timber has been stored at
that point ever since the days of Justinian the
Great, if not ever since the city was founded.
Caiques flit to and fro, as if shuttles weaving the
sundered parts of the city together. While com-
panies of fearless sea - gulls spread grey wings
and white breasts over the blue waters, and
dance around in every graceful form that motion
can assume. It is the portion of the harbour in
which the world of the East is still most clearly
reflected. The reach of the Golden Horn beyond
the Inner Bridge is specially devoted to the service
of the Turkish navy, and there may be seen such
modern things as ironclads, torpedo boats, and
torpedo destroyers. The time was when the Otto-
man fleet which gathered here formed an imposing
display of naval strength. The Admiralty, Naval
Hospital, and Dockyard are situated on the northern
bank. On the hill above the Dockyard is the Ok-
meidan, the field to which the Sultans whose strong
arms built up the Ottoman Power came to exercise

themselves in the use of the bow. It is studded with pillars commemorating the long shots made by the imperial archers.

The southern bank, with its steep slopes crowded with konaks, gardens, mosques, minarets, is noteworthy for the number of Byzantine churches still found beside the shore or upon the hill-sides, preserving the memory and something of the aspect of the ancient city. Among them are, S. Theodosia (Gul Djamissi), Pantocrator (Kilissé Djamissi), Pantepoptes (Eski Imaret Djamissi), Pammakeristos (Fetiyeh Djamissi), Chora (Kahriyeh Djamissi), SS. Peter and Mark (Atik Mustapha Pasha Djamissi). Close to the western extremity of the shore stood the Church of S. Mary of Blachernæ, once the object of profoundest reverence on account of the wonder-working power attributed to the reputed girdle and mantle of the Mother of the Lord, enshrined among its relics. The site is marked by the Holy Well formerly attached to the sanctuary. On the hill above the Well are the scanty remains of the famous Palace of Blachernæ, once the favourite residence of the Byzantine Court. In the quarter of Phanar the humble residence and the cathedral of the Patriarch of Constantinople are found. What a contrast to

SULEIMANIYEH AT SUNRISE

The Mosque of Suleiman the Magnificent occupying on of the finest sites in the city is seen here at early sunrise emerging from the mist on the Golden Horn

the days when the chiefs of the Eastern Church
were enthroned under the dome of S. Sophia!
In the quarter of Balat, and at Haskeui on
the opposite shore, are large settlements of Jews,
to whose lowly dwellings belongs the historical
interest that they are the homes of the descendants
of the Jews who were expelled from Spain by
Ferdinand and Isabella, and found refuge here
among Moslems from persecution by Christians.
They still use the Spanish language, although not
with the music of the speech of Castile. The
suburb of Eyoub at the foot of the hills at the
head of the Golden Horn, and the meadows beside
the fresh-water streams which enter the harbour
at that point (the Sweet Waters of Europe) are
interesting to all who delight in Oriental scenes.
No quarter in or around the city is so Turkish in
its appearance and spirit as the suburb of Eyoub.
It contains the reputed grave of Eyoub, the
standard-bearer of Mahomet, who was present at
the first siege of Constantinople (673-678) by the
Saracens, and who died during its course. The
grave was identified, so it is believed, in 1453,
when the city fell at last into Turkish hands,
and the mosque erected over the tomb is the
sanctuary in which Sultans, upon their acces-

sion to the throne, gird on the sword which con-
stitutes them sovereigns of the Ottoman Empire,
and standard-bearers of Islam. It is a ceremony
which embodies the inmost idea of a Moslem State.
No Christian is permitted to enter the mosque.
On a recent occasion the veneration in which the
edifice is held served a noble purpose. During the
massacres of 1896, a crowd of Armenians took
refuge in the court of the mosque, with the courage
of despair. A wild mob followed, intent upon the
death of the fugitives. A terrible scene seemed
inevitable. When, at the critical moment, the
imaum of the mosque appeared, and forbade the
desecration of the holy ground by the shedding of
blood upon it. The appeal was irresistible. The
horde of murderers bowed to the command to be
gone, and their intended victims were allowed to
escape. The sacred associations of the suburb
have made burial in its soil to be esteemed a
great honour, and, accordingly, many distinguished
Turkish personages have been laid to rest here
from early times. The old turbaned tombstones,
inscribed with Arabic letters, painted with floral
designs, shaded by trees and overrun by climbing
plants, form as picturesque a cemetery as one can
wish to see. The influence of the suburb is not

CEMETERY AT EYOUB

A cobble-paved pathway in the most picturesque cemetery in Constantinople

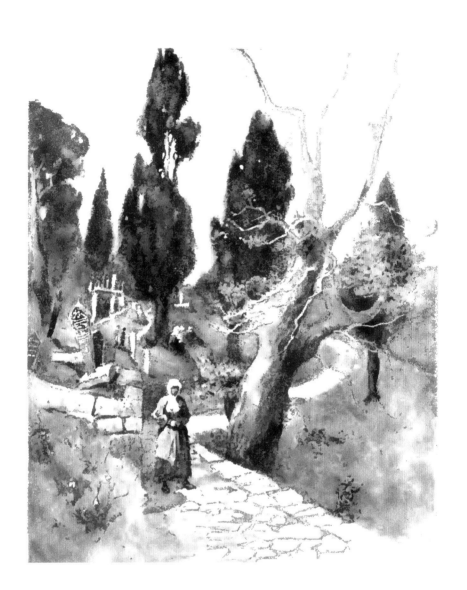

weakened by the fact that it enters into the life of
Turkish children by being a great factory of their
toys. The hill above Eyoub commands a mag-
nificent view of the Golden Horn and the city.
As to the scene in the valley of the Sweet Waters,
where Turkish ladies gather on Fridays in early
spring, it is no longer what it once was. The
exchange of native vehicles for carriages such as
may be seen in Paris or London, and the general use
by Turkish ladies of quiet colours in their mantles
and head-dress instead of bright hues, have robbed
the spectacle of almost all its gaiety, originality,
and decorative effect. The scene offers now rather
a study in the transformation of the Turkish woman,
than a presentation of her peculiar aspect and charac-
ter. Still, as the change is not complete, a stranger
may yet find pleasure in seeing what vestiges of
former manners and customs have not disappeared.

Of the historical events of which the Golden
Horn has been the theatre, the most important are:
first, the attack upon the walls along this side of
the city, in 1203, and again in 1204, by the
Venetian fleet which accompanied the Fourth
Crusade; second, the transportation by Sultan
Mehemet into its waters in 1453, of warships
over the hill that separates the harbour from

15

the Bosporus. The movements of the Venetian
fleet and of the army which accompanied it
can be followed step by step, so minute is
the description of Ville - Hardouin and so un-
altered the topography of the country. Upon
approaching the city the invaders put in at San
Stefano, now a favourite suburban resort upon the
Sea of Marmora. A south wind carried them next
to Scutari. From that point they crossed to the
bay now occupied by the Palace of Dolma
Bagtché, near Beshiktash. There the army landed,
and advancing along the shore attacked the tower
to which the northern end of the chain across the
harbour's mouth was fastened. Upon the capture
of the tower after a feeble resistance, the chain was
cut, and the fleet of Venice under the command of
Dandolo, flying the ensign of S. Mark, rode into
the Golden Horn and made for the head of the
harbour. At the same time, the troops marched
towards the same point, along the northern shore,
where Cassim Pasha and Haskeui are now situated.
At the latter suburb they crossed the stone bridge
that led to Eyoub on the southern bank. Then
turning eastwards, they seized the hill facing the
portion of the city walls above which the windows
and domes of the Palace of Blachernæ looked

GALATA AND STAMBOUL FROM EYOUB

From the cemetery at Eyoub, overhanging the Golden
Horn at the upper end an attractive panorama is
presented On the right are the domes and minarets
of Stamboul stretching away to Seraglio Point, in
the distance is Mount Olympus on the Asiatic coast,
while on the right are Galata Per , and the Arsenal

towards the west. While the army prepared to attack that point, the ships of Dandolo stood before the harbour walls, in a long line from Aivan Serai to the Phanar and the neighbourhood of the present Inner Bridge. A desperate assault followed, in which twenty-five towers were carried by the Venetians, and the day would have been won, but for the repulse of the land forces and the necessity to hasten to their relief. Soon a revolution within the city against the usurper whom the Crusaders had come to depose, and in favour of the restoration of Isaac Angelus, whose claim to the throne they supported, seemed to bring the struggle to an end. As a sign that amicable relations had been established, and to avoid the danger of angry collisions with the citizens, the invaders removed their forces to the northern side of the Golden Horn. But the conditions on which help had been rendered to Isaac Angelus were too hard to be fulfilled; and insistence upon them provoked the national feeling against the foreign intruders. The imperial protegés of the Crusaders were murdered, or died from fear, and the smouldering embers of the strife burst once more into flames. The army of the Crusade was therefore taken on board the fleet, and proceeded to make a

joint attack upon the portion of the harbour walls
which Dandolo had once before captured. Victory
wavered from side to side At length, on Easter
Monday 1204, Venetian ships approached so near to
the walls in the Phanar quarter that bridges
attached to the masts settled upon the parapet of
the fortifications. Brave knights rushed across, cut
down the defenders, clambered down into the city,
and threw open the nearest gates. The blind Doge,
ninety years old, leaped upon the beach, with the
banner of S. Mark in his hands, and summoned
his men to follow. The Emperor Murtzuphlus,
who watched these operations from the terrace of
the Church of Pantepoptes, fled, and for the first
time in its history, Constantinople became the prize
of a foreign foe.

The transportation of a fleet over the hill that
rises some two hundred and fifty feet between the
Bosporus and the Golden Horn was a skilful piece
of strategy, and formed one of the most striking
incidents in the siege of 1453. By compelling atten-
tion to the safety of the walls along the harbour,
it extended the line of attack, and weakened
the defence of the landward walls To effect the
passage, a road was made through the ravines
leading from Beshiktash on the straits to Cassim

GOLDEN HORN AFTER SUNSET

When all traffic ceases, caiques, lighters, steamboats, and craft of all kinds are taken to their moorings and the waters are silent and deserted

Pasha on the Golden Horn. On that road well-greased logs were laid, like the sleepers on a railway, and then some seventy or eighty galleys, of fifteen, twenty, or twenty-two pairs of oars, were placed in ships' cradles and dragged by men, oxen, and buffaloes, in the course of a single night, up one slope and down the other, from sea to sea. The incongruous form of navigation put everybody concerned in making the voyage into good humour. Drums beat, fifes sounded, and to add to the zest of the enterprise, the sails were unfurled, the oars were pulled, the rudders set, as if the vessels were proceeding over their native element. But the apparition of the enemy's ships in the Golden Horn afforded no amusement to the besieged. It increased immensely their anxiety and the difficulties of their task. A brave attempt to burn the Turkish vessels failed, and though the flotilla actually did little in the way of direct attack, it remained a standing menace to the northern side of the city until the close of the siege, a thunder-cloud keeping men in constant dread of the bolts that might dart from its black bosom. Very appropriately, the Turkish Admiralty stands on the shore of the bay in which an Ottoman fleet first rode the waters of the Golden Horn.

CHAPTER VI

ALONG THE LANDWARD WALLS

In the third chapter, occupied with the story of the making of Constantinople, some account has been given of the portion of the landward walls erected in the earlier half of the fifth century, when the city was enlarged under Theodosius II., viz. the portion extending from the Sea of Marmora, on the south, to the ruins of the Palace of the Porphyrogenitus (Tekfour Serai) on the north. That seemed the most appropriate place to speak of the origin and character of fortifications which were built as much for the growth and convenience of the city in its civic relations, as for its security as the citadel of the Empire. To that chapter the reader who desires to recall the information given on the subject, is referred. Here, after a brief account of the additions made to the Theodosian walls, in subsequent times, we

shall consider the historical importance of the land-
ward walls as a whole, and glance at some of
the scenes enacted before them.

The post-Theodosian portions of the walls that
guarded Constantinople on the side of the land
extend from the courtyard of the Palace of the
Porphyrogenitus to the shore of the Golden Horn
at Aivan Serai. They replaced an older line of
fortifications which ran, at a short distance to
the rear, between the same points, and were con-
structed to strengthen the weak places which
time revealed in this part of the city's armour.
First in the order of position, though not in
the order of time, comes the wall erected by
Manuel Comnenus (1142-1180), for the greater
security of the Palace of Blachernæ, his favourite
residence, which stood within the old bulwarks,
just mentioned. It terminates at the foot of the
steep hill on which the quarter of Egri Kapou is
situated. With its nine noble towers it presents
a striking likeness to the fortifications of a feudal
baronial castle, and its solid masonry defied the
Turkish cannon in 1453. Then follow walls, the
original date of whose construction cannot be
precisely determined, as they evidently underwent
frequent repairs and alterations. Here is found

the Tower of Isaac Angelus, and, in the body of
the wall to the north of the tower, are three stories
of large chambers, very much ruined, which some
authorities regard as the cells of the State Prison
of Anemas. More probably, they were either
barracks or store-rooms attached to the imperial
residence, and at the same time buttresses for the
support of the terraced hill on which the palace
was built. Beyond this chambered wall there
is a double line of fortifications. The inner wall
was erected in 627, under Heraclius, after the
siege of the city by the Avars, to protect the
quarter of Blachernæ and its celebrated Church
of S. Mary of Blachernæ more effectively in the
future than when assailed by that enemy.

The outer wall was built as an additional de-
fence in 813, by Leo the Armenian (813-820),
in view of an expected attack upon the city by
the Bulgarians under Crum.

The territory outside the landward walls has
indeed a charm of its own, in its quiet rural
aspect, and in the glimpses it affords of distant
blue water seen through dark groves of cypresses.
But it cannot pretend to the splendid natural
scenery which confronts the shores of the Sea of
Marmora or of the Golden Horn, and makes the

THE WALLS, THE TOWER OF
ISAAC ANGLIUS

Part of the old fortifications now in ruins stretching
from the Marmora to the Golden Horn

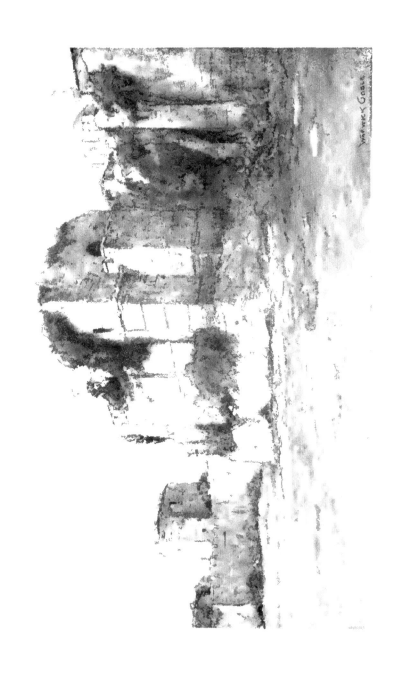

beauty of Constantinople famous throughout the
world. This, however, is not altogether a dis-
advantage, for it allows the visitor to view without
distraction the imposing line of bulwarks ranged
across the promontory from sea to sea, and to
appreciate calmly all their significance. On the
other sides of the city, the fortifications which
guarded the Queen of Cities are comparatively
unimportant, and are easily lost sight of in the
beauty of their surroundings. Here the walls
and towers are everything. Here they attained
their greatest strength ; here they rendered their
greatest service ; here, like troops bearing the
wounds and scars of a great campaign, they force
the beholder to realise the immense debt which
the civilised world owes to Constantinople for the
strength, the valour, and the sacrifices devoted
through long centuries to the defence of the
highest life of mankind against terrible foes.

Nor does the scenery which the walls them-
selves present need to borrow attractions from any
other source to render it the most picturesque and
impressive spectacle of the kind in the world. The
alternate courses of grey stone and red bricks in
the structure of the fortifications ; the long lines of
wall ranged in ranks, and rising tier above tier to

16

support one another in the terrible struggles they were called to maintain ; the multitude of towers, marshalled to guard the city and Empire, great and small, of every shape, square, round, polygons looking in six, seven, or eight directions, some intact after all the storms of centuries, others bare, broken, fissured from head to foot, yet holding together ; inscriptions recalling wars, earthquakes, names of men who have made history ; towers crowned with ivy ; trees interspersed between the walls or standing upon the summit, like banners ; crenellated parapets affording glimpses of the blue sky behind, as though, in Oriental phrase, the ramparts rose to the very heavens ; all this stretch-ing for mile upon mile, from sea to sea, presents a scene of extraordinary beauty and grandeur, not less attractive because of the heroism and achieve-ments of which it has been the theatre.

This is not the place for an extended history of the services which these walls, and the Empire of which they were the citadel, rendered as the shield of European civilisation. Enough to remem-ber that the dread of them dissuaded Attila and his Huns from delivering an attack upon the city, although he approached as near to Constantinople as Athyras, now Buyuk Tchekmedjé, some twelve

miles distant. Doubtless they often restrained the
wrath also of other barbarous hordes. In vain
did the Avars, in 627, beat against these walls
between Top Kapou (Gate of S. Romanus) and
the Gate of Adrianople (Charisius). In vain did
the Arabs invest these bulwarks from the spring
to the autumn of four successive years (673-677).
As unsuccessful was the second siege of the city
by the same foe for twelve months (717-718).
These fortifications defied the Bulgarians both
under Crum in 813 and under Symeon in 924.
In 1203 they repelled the valour of the knights
and barons engaged in the Fourth Crusade. They
mocked the assaults of Sultan Murad, in 1422.
And when they succumbed, at length, to the
artillery of Sultan Mehemet in 1453, it was be-
cause their defenders were few and divided, and
their assailants were armed with weapons before
which ramparts of stone, alike in the West and in
the East, crumbled to pieces, and old systems of
society were swept away.

The battles fought directly before the walls
of New Rome do not, indeed, give us the com-
plete story of her warfare "per benefitio de la
Christiantade et per honor del mundo." On eight
occasions, at least, the armies of the East Roman

Empire were drawn up on the plain outside the Golden Gate to celebrate victories won on distant battlefields, and to enter the triumphal Gate of the capital with prisoners, standards, and spoils captured on hostile territory. To the shouts " Glory to God, who has restored to us our sovereign crowned with victory! Glory to God who has magnified you Emperor of the Romans! Glory to Thee All - Holy Trinity, for we behold our Emperor victorious! Welcome Victor! most valiant sovereign!" the triumphal car of Heraclius drove into the city, after his splendid campaign of seven years against the Persians; the campaign which brought the long struggle between Europe and Persia since 492 B C. to an end. The same shouts rent the air, when Constantine Copronymus returned from the defeat of the Bulgarians, and twice again, when Basil II., by two murderous wars with that people, earned the title, the Slayer of Bulgarians, Bulgaroktonos. Theophilus, on two occasions, and Basil I. passed through the Golden Gate as victors over the Saracens. And Zimisces received the same honour for beating back the Russians under Swiatoslaf. These were great days in the history of the city, nay, of mankind, for they

stayed the waves of barbarism that threatened to
overwhelm the civilised world. But after all, it is
when the enemy stands arrayed before the very
capital of the Empire, and delivers assault after
assault upon the citadel which guarded its fate
and the destiny of Europe, that the struggle waged
between civilisation and barbarism during the his-
tory of New Rome is fully recognised to have been,
indeed, a struggle for life, and that we learn to ap-
preciate what we owe to the Warden of the Gates
to the Western World. To these walls may be
applied the words in which Mr. Gladstone appraised
the value of the services rendered by the Christian
populations of the Balkan Peninsula, in a similar
connection. "They are like a shelving beach that
restrained the ocean. That beach, it is true, is
beaten by the waves; it is laid desolate; it pro-
duces nothing; it becomes perhaps nothing save a
mass of shingle, of rock, of almost useless sea-weed.
But it is a fence behind which the cultivated earth
can spread and escape the incoming tide. . . . It
was that resistance which left Europe to claim the
enjoyment of her own religion, and to develop her
institutions and her laws."

Although inferior as military works to the other
portions of the landward walls, great historical

interest is associated with the fortifications between
the Wall of Manuel and the Golden Horn, for they
guarded the Palace of Blachernæ, the favourite
residence of the Byzantine Court from the time
of Alexius Comnenus (1081-1118) until the fall
of the Empire. As already intimated, the palace
stood on the terrace buttressed by the Tower of
Isaac Angelus and the chambered wall to the
north of the tower, where the Mosque of Aivas
Effendi is now found. The terrace was almost
level with the parapet-walk of the fortifications,
commanding fine views of the Golden Horn, and
of the hills at the head of the harbour; and there
the most splendid Court of the Middle Ages long
displayed its wealth and pomp. What with the
Crusades, and what with the relations, hostile and
friendly, between the Italian Republics and the
Government of Constantinople during the period of
the Palæologi, it was in that palace that Western and
Eastern Europe came into closest contact for good
or for evil. On the hills and in the valleys seen
from the western windows of the palace, the armies
of the First Crusade encamped. To that resi-
dence came Peter the Hermit, Godfrey of Bouillon,
Robert of Normandy, Bohemond, Tancred, "the
mirror of knighthood," Count Robert of Paris, to

wonder at the marvels of Byzantine Art, and to
attempt the co-operation of the East and the West,
in the great political and religious undertaking of
the times. On the hill immediately in front of
the walls the soldiers of the Fourth Crusade
pitched their tents, and thence Baldwin of Flanders
and Hainaut, Henry his brother, Louis of Blois and
Chartres, and Hugo of Saint Paul, led four divisions
of the army against the wall erected by Leo the
Armenian. The wall was held by Varangian troops,
the imperial body-guard, recruited from England,
Denmark, Norway, and Russia. "The assailants,"
to quote the words of Ville-Hardouin, a witness
of the combat, and the historian of the Crusade,
"placed two scaling-ladders against an outer wall
near the sea; the wall was furnished with English-
men and Danes, and the attack was strong, and
good, and hard. And by sheer force some knights
and two sergeants mounted the ladders, and became
masters of the wall. Fully fifteen reached the wall,
and they fought hand to hand with axes and
swords. And the men within returned to the
charge and drove them (the assailants) out, right
rudely, even taking two of them prisoners. And
those of our men who were captured were led
to the Emperor Alexis, and he was very highly

delighted. So ended the attack by the French. And there was a considerable number of men wounded and of maimed; and the barons were very angry about it."

The recovery of Constantinople from the Latins in 1261 did not diminish Italian influence over the life of the city On the contrary, from that time to the close of Byzantine history that influence, modified indeed by the rival force of Ottoman power, grew stronger and stronger. Commercial interests, political necessities, schemes of ecclesiastical union, literary sympathies, possibilities of aggrandisement at the expense of an Empire hastening to ruin, made Italy, especially Genoa and Venice, take a most active part in the affairs of New Rome. A Western atmosphere, so to speak, then enveloped Constantinople, very much like that which surrounds the City of the Sultans to-day.

But the portion of the walls about which the greatest and most pathetic interest gathers is where Sultan Mehemet delivered his fatal blow upon the Byzantine Empire, and won the title of "the Conqueror." It is the portion which stretches from Top Kapoussi (Gate of S. Romanus) to Edirné Kapoussi (Gate of

Charisius), across the ravine through which the little stream of the Lycus, on its way to the Sea of Marmora, enters the city. Owing to the depression of the ground and the impossibility of constructing a deep moat there, this was the weakest point in the Theodosian fortifications, and here the bravest of the defenders, under Giustiniani of Genoa and the Emperor Constantine, manned the walls to oppose the best troops under the command of the Sultan. Against this part of the walls the enemy pointed his heaviest cannon, and here the contest raged for more than seven weeks. Both the besieged and the besiegers fought with the determination and the valour worthy of the issues at stake. When the Turkish artillery broke down the Outer Wall, Giustiniani and his Genoese and Greek comrades held their ground, and replaced the fallen ramparts by a stockade built of stones, barrels full of earth, beams, branches of trees—of anything within reach that would hold together. Against that barricade wave after wave of Turkish troops dashed and beat furiously and long. There were moments when the defenders seemed to have gained the day. But like gleams of sunshine that pierce storm clouds, they only served to make the impending

17

catastrophe more tragic. Giustiniani was wounded and left the field. A band of bold Turks entered the city through the postern of the Kerkoporta, thoughtlessly left open, and, mounting the walls, planted their banners upon the parapet. Anon, the cry "The city is taken" burst upon the air and reverberated from tower to tower. A panic seized the besieged. The Sultan, grasping his opportunity, roused his janissaries to a supreme effort, and hurled them against the battered and half-deserted barricade. The Emperor Constantine did everything in his power to rally his followers and repel the terrible onset. It was hopeless. He then sought and found a soldier's death, rather than survive the fall of his Empire. "All was lost save honour." And over his dead body the tide of conquest poured into the city.

Thus ended the history of more than a thousand years. Then Asia dealt its worst blow upon Europe. Then the last vestige of the State, ruled first by Rome from the seven hills beside the Tiber, and afterwards by New Rome enthroned on the seven hills beside the Bosporus, disappeared. Then the Crescent gained its greatest triumph over the Cross. Not many spots in the world have been the scene of such momentous events as took place

CONSTANTINOPLE AND GOLDEN HORN
FROM THE CEMETERY AT EYOUB

Many a charming vista may be seen through the
cypress trees in the cemetery at Eyoub

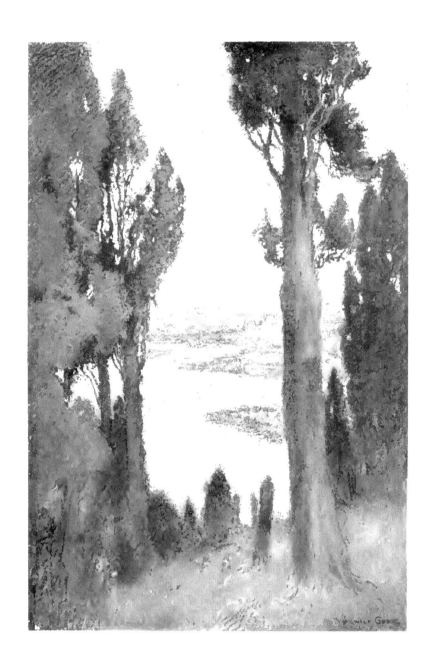

in the little valley of the Lycus on the 29th of May, 1453. There an Empire died, and a long and great epoch closed.

It is very natural, when thoughtful men tread the road which skirts these ancient fortifications, that the mind should be profoundly impressed by the vanity of earthly might and greatness. On the one hand, the way is strewn with the wreck and ruin of ramparts once deemed impregnable :

O'er each mouldering tower,
Dim with the mist of years, grey flits the shade of power.

On the other hand, stretch great silent cemeteries, beneath whose dark cypresses lies the dust of a dead multitude more than can be numbered. As one has expressed the feeling awakened by this spectacle of wreckage and mortality, " It is walking through the valley of the Shadow of Death." And yet, seeing there must be an end to all things, is it not wiser and more just to dwell rather upon the glory that crowns these bulwarks for their long defence of the civilised life of the world ?

For a full account of the Turkish Conquest, see E. Pears' *The Destruction of the Greek Empire.*

CHAPTER VII

AMONG THE CHURCHES OF THE CITY

CONSTANTINOPLE was a city of churches. Clavijo, the Spanish envoy, who visited the city in 1403, was assured that it was hallowed by the presence of no less than 3000 sanctuaries, counting large and small. This was obviously an exaggeration, intended to impress the stranger's mind with a due sense of the city's grandeur and sacredness. Ducange in his great work, *Constantinopolis Christiana*, gives the names of some 400 churches mentioned by the Byzantine authors whose works he had examined. But a wider acquaintance with Byzantine literature since the time of that great student of the antiquities of Constantinople has discovered the names of many churches not upon his list. It is therefore impossible to reach exact figures here, and we must be content with the vague statement that the number was so large as

to form a striking feature of the city's aspect. This was only what might be expected in a city where the number of churches would be determined not only by the ordinary religious needs of a devout population, but also by the demands of the many monasteries which sought security from violence behind the bulwarks of the capital, notwithstanding the temptations of the world, the flesh, and the devil, encountered there. What does cause surprise, however, is that so few of the numerous churches which once adorned the city, and embodied the piety of its people, have left one stone standing upon another to recall their existence. At most, thirty-five remain, and of these several of them are so dilapidated that they only serve for the identification of an interesting site, or to emphasise the vanity of earthly things.

Of course all the churches of the city were never contemporaneous. In a city which had a life of more then eleven centuries, the list of almost any class of edifices erected in the course of that period would necessarily be a long one, without implying the existence of numerous edifices of that class at one and the same time. According to the description of Constantinople which dates from the first quarter of the fifth century, the number of churches

then in the city is given as only fourteen. Churches appeared and disappeared, and while some of them were, for special reasons, maintained throughout the whole course of the city's history, many came to flourish for a while and then decayed in the ordinary course of things, bequeathing as their memorial only the withered leaves of their names. Then we must remember the frequent and disastrous earthquakes which shook the soil of Constantinople during the Middle Ages, and the terrible conflagrations which again and again reduced the wealth and glory and beauty of extensive tracts of the city to dust and ashes. For example: the three fires associated with the capture of the city by the Latins in 1203-1204 inflicted a blow from which the city never recovered. One of those fires raged for a night and a day; another for two days and two nights, with the result that almost all the territory along the Golden Horn, as well as the territory extending thence to the Hippodrome and the Sea of Marmora, as far away as Vlanga, were turned into a wilderness of smoking ruins. "The fire," says Ville-Hardouin, a spectator of the awful scene, "was so great and so terrible that no man could extinguish or check it. It was a sad and pitiful spectacle for the barons of the

VIEW FROM AN OLD CEMETERY

Close to the busy thoroughfare of Pera large tracts
of land lie unoccupied save for a few modern
tombstones, they are the remains of old Turkish
burying-grounds

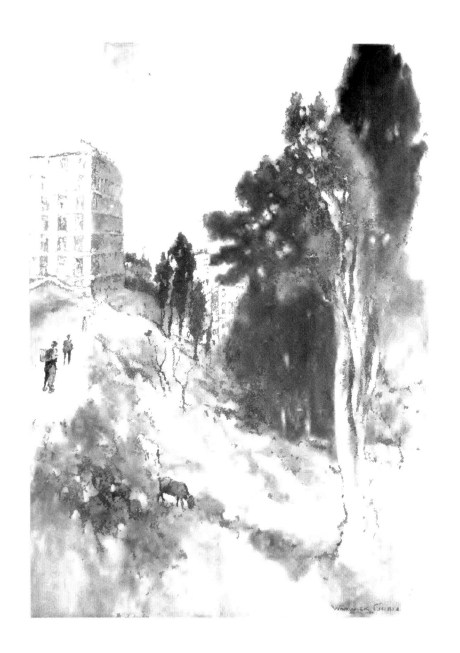

army encamped on the other side of the harbour to
see those beautiful churches and those rich palaces
fall in and be destroyed, and great business streets
burned by the scorching flames; but they could
do nothing. The fire spread beyond the harbour
across to the densest part of the city, quite close to
S. Sophia, and as far as the sea on the other side.
It lasted two days and two nights, without being
ever touched by the hand of man, and the front of
the fire was fully half a league long. Of the
damage done, or of the property and wealth thus
lost and consumed no estimate can be made, nor
of the number of men, women, or children who
perished." It is true that churches injured by
the hand of time were often restored. There
were even periods when such renovation was
carried out on an extensive scale, as for instance
under Justinian the Great and under Basil I.
(867-886). But not less frequently the old fabric
was so weakened by age or shaken by earthquake
that to repair it was out of the question, and the
only thing to be done was to use its stones and
bricks and marbles as materials in the construction
of other buildings. Much of the material, for
instance, employed in the erection of the Tower of
Isaac Angelus, in front of the Palace of Blachernæ,

was taken from the ruins of old churches. While for the construction of the citadel which John VI. Palæologus (1341-1391) built near the Golden Gate, material was taken from the remains of churches so noted in their day as the Church of All Saints, the Church of the Forty Martyrs, and the Church of S. Mokius.

Upon the recovery of Constantinople from the Latins in 1261, something indeed was done to repair the damage due to the occupation of the city, for some fifty-seven years, by barbarous and covetous strangers. But the last two centuries of the Empire were years of wars and civil broils, years of decline and poverty, and at length of despair, so that comparatively little could be undertaken to rebuild the sad ruins inherited from the past, or to arrest the decay whose withering touch was laid on the monuments that still survived more or less intact. Even the Imperial Palace beside the Hippodrome was allowed to fall into such neglect and desolation, that when the Turkish conqueror visited its empty halls they echoed to his ear the couplet of the Persian poet · "The spider has become the watchman of the royal abode, and has spread his curtain over its doorway." The decay which had smitten the city impressed every visitor

during the half-century preceding the Turkish Conquest. "Although the city is large," says the Spanish envoy already cited, "and has a wide circuit, it is not thickly populated everywhere; for it contains many hills and valleys occupied by cultivated fields and gardens, and where one sees houses such as are found in an outlying suburb; and all this in the heart of the city. . . . There are still many very large buildings in the city, houses, churches, monasteries, but most of them are in ruins." The great disproportion between the size of the city and the number of the population made a similar impression on Bondelmontius, who came here from Florence in 1422. He speaks of vineyards flourishing within the city bounds, and adds, "There are innumerable churches and cisterns throughout the city, remarkably large and constructed with much labour, and found in ruin." La Broquière, to cite one witness more, who was here in 1433, observes that the open spaces in the city were more extensive than the territory occupied by buildings. Times had indeed changed since the days of Themistius and Anthemius.

Constantinople was therefore far from being a rich and splendid city when it fell into the hands of its Turkish conquerors in 1453, and the scarcity

18

of the monuments of its former wealth and grandeur must not be ascribed wholly to the action of its new masters. The ravages of time, and the vandalism of the Latin Crusaders, had left little for other rude hands to destroy.

In his dealing with the religious rights of the Christian community the Ottoman lord of Constantinople proved conciliatory. While appropriating S. Sophia and several other churches for Moslem use, he allowed the Greeks to retain a sufficient number of their former places of worship.

He, moreover, ordered the free election of a new patriarch, who should enjoy, as far as possible under altered circumstances, the privileges which the chief prelate of the Great Orthodox Church had formerly possessed. Upon the election of Gennadius to the vacant post, the Sultan received him graciously at the palace, and presented him with a valuable pastoral cross, saying "Be patriarch and be at peace. Depend upon my friendship so long as thou desirest it, and thou shalt enjoy all the privileges of thy predecessors." The Church of the Holy Apostles, only second in repute to S. Sophia, was assigned to the patriarch as a cathedral, and he was not only allowed free access to the

MARKET IN THE COURT OF THE
MOSQUE OF SULTAN AHMED I

The courts of the mosques are often used for market-
places

Seraglio, but was even visited by the Sultan at the patriarchate. The loss of S. Sophia was, indeed, a terrible humiliation, one from which the Greek Church has never recovered ; a humiliation which all Christendom feels to this hour. But the preservation of the fabric is doubtless due to the fact that it passed into the hands of the conquerors. It is difficult to see how the Greek community could have maintained that glorious pile, even "shorn of its beams," after 1453. At the time of the fatal siege, the population of the city counted at most one hundred thousand souls. When the city fell, upwards of fifty thousand of its inhabitants were sold into captivity. Nor did the subsequent efforts of the Sultan to attract Christians to the city meet with great success. Hence extensive portions of the city were abandoned by the Christian population, on account of paucity of numbers, and the dread inspired by Turkish neighbours. Even the Patriarch Gennadius soon begged to be transferred from the Church of the Holy Apostles to the Church of S. Mary Pammacaristos, in a district where Greeks were more numerous. This request was made because the dead body of a Turk had been discovered, one morning, in the court of the Church of the Holy Apostles, and there was reason

to fear that the Turkish inhabitants of the quarter would avenge the murder of a Moslem, by reprisals upon the few Christians in the vicinity. Naturally, churches situated in districts abandoned by the Christian population passed into Turkish hands, and were disposed of as the new proprietors might find most convenient. It was thus that the Church of the Holy Apostles itself was lost to the Greek communion, and made way for the erection of the mosque named after the Conqueror. Other old churches shared a similar fate, either immediately upon the fall of the city, or later under succeeding Sultans. For, as might be expected, extensive building operations were carried on in the early days of Turkish rule, and every ancient edifice which could not be turned to better account was brought into requisition to provide ready-made material for the new structures. During the reign of the Conqueror not less than sixty mosques rose within the city bounds. The Fortress of the Seven Towers, built in 1457, at the Golden Gate, was largely constructed with materials taken from old buildings, as an examination of its walls will prove. The first palace of the Sultan, on the site now occupied by the War Office, must have played havoc among the Byzantine buildings, secular and

sacred, in that neighbourhood. While the palace which was erected later, in the unrivalled situation at the head of the promontory of Stamboul, encroached upon a territory crowded with such churches as S. Demetrius, S. George Mangana, S. Mary Hodegetria, and S. Irene. All were swept away, with the exception of the last, which was converted from a temple of peace into an arsenal of war.

The Turkish occupation is therefore accountable for the destruction of many ancient churches of the city. Indeed, if we may believe the historian of the Greek Patriarchate from 1453 to 1578, there was a moment when the Christian community was threatened with the loss of every church, old or new, in its possession. The graphic story is too long to be told here in all its details, but it is so characteristic of the parties concerned, and of the prevalent method (not yet quite obsolete), of creating and turning a difficult situation, that a summary account of the affair may be permitted. The scene is laid either in the reign of Selim I. or of his son Suleiman the Magnificent, when the Patriarch Jeremiah occupied the patriarchal throne for the second time. And the play opens with the determination of a fanatical Turkish party to insist upon

the law that the inhabitants of a city captured by
force of arms should be denied the right of worship,
and should have their churches either confiscated
or levelled to the ground. The Sheik-ul-Islam of
the day had issued his fetva to that effect, and in
five days the sentence was to be carried into execu-
tion. A high Turkish official, who was in the
secret, informed a Greek notable of the storm at
hand, and the latter reported the matter immedi-
ately to his ecclesiastical chief. After much weep-
ing and many prayers, the patriarch mounted his
mule and hastened to the residence of the Grand
Vizier, with whom, happily, he was on the best of
terms. The result of a long interview was that
the patriarch was dismissed with an invitation to
attend the Council of Ministers, and inform them
that, while it was true that Sultan Mehemet
attacked the city and destroyed a portion of the
fortifications, the Greek Emperor had not carried
matters to the bitter end, but went betimes to the
Sultan, surrendered the keys of the city, and, after a
friendly reception, brought him into Constantinople
in a peaceable manner. Whereupon, the patriarch,
somewhat relieved, paid a round of visits to the
various Ministers of State and to other influential
personages, not forgetting to leave in each case a

COURT OF THE SULEIMANIYEH

Along the low wall to the left are a number of water taps for the Moslems to perform their ablutions before going to prayer

suitable parting gift. An extraordinary Council of
Ministers was then summoned to consider the
question, and before that assembly the patriarch
duly appeared. Meantime the news of the im-
pending catastrophe had spread, causing great
excitement, so that an immense crowd of Greeks,
Armenians, and even Jews, collected outside the
Council Chamber, to learn as early as possible the
result of the deliberations within. The terrible
fetva was solemnly read, accompanied by the
announcement that not only would it be applied
to the case of Constantinople, but to every town
captured by the sword throughout the Empire.
"O my lord," cried the patriarch in a loud voice,
addressing the Grand Vizier, "as to other cities I
am not sufficiently informed, but as regards this
city I can vouch that when Sultan Mehemet came
to fight against it, Constantine, with the consent
of his nobles and people, did homage to him and
surrendered the place voluntarily." "Have you,"
inquired the Grand Vizier, "any Moslem witnesses
who were in the army of Sultan Mehemet when
he took the city, and who can tell us how he
took it?" "I have, O my lord," was the prompt
reply. "Then come to-morrow to the Council,
and meantime we shall take the Sultan's pleasure

on the subject," said the Grand Vizier. Followed
through the streets by the whole Christian popula-
tion of Stamboul and Galata, the patriarch stood
next day before the Council once more, and was
informed that His Majesty would be pleased to
accept Moslem testimony to the correctness of the
statement that Constantinople had capitulated and
was not taken by force. "But O my lord, the
witnesses you demand are not here; they are at
Adrianople; and to send for them and to bring
them will involve a delay of twenty days,"
pleaded the patriarch. The delay was granted;
messengers, provided with a large sum of money
and other gifts, were forthwith despatched to
Adrianople; the witnesses sought were found;
and soon they were welcomed with raptures of joy
at the gates of the patriarchate. After resting for
two days, they were received in private audience
by the Grand Vizier, and were assured that they
could safely affirm whatever the patriarch might
desire them to say. Accordingly, at another
meeting of the Council, the patriarch was asked
to produce his witnesses, failing which the fetva
would be carried out. "They are standing out-
side," he answered. Two aged men were then
introduced, "their eyes running with rheum and

red as raw flesh, their hands and feet trembling beneath the burden of years, their beards white as driven snow. Never before had the assembly beheld men so venerable with age.

"What is your name?" the first witness was asked. "Mustapha," "What was your father's name?" "Genouze." "And (to second witness) what may your name be?" "Pirez." "And your father's name?" "Rustem." "How long is it since Sultan Mehemet took this city?" "Eighty-four years, to a day." "How old were you then?" "Eighteen." "How old are you now?" "One hundred and two years old." "Mashallah, Mashallah" (God protect you), exclaimed the members of the Council, and stroked their long beards. "In what capacity did you serve under Sultan Mehemet?" "As janissaries." "How was the city taken, by fighting or by surrender?" "By surrender." Then followed a long garrulous narrative of the circumstances of the capitulation of the city, all of which went to prove the historical trustworthiness of everything the patriarch had stated on that subject. Finally, a report of these proceedings was drawn up and presented to the Sultan, who, after expressing his surprise, natural or feigned, ordered that the patriarch should have no further

19

anxiety about the churches of his communion "so long as the world standeth."

Notwithstanding that order, however, the Greek community subsequently lost several churches in its possession at that time, including S. Mary Pammacaristos, then the patriarchal cathedral, with the result that it can now boast of only some six insignificant sanctuaries which were founded in the period of the Byzantine Empire. But excepting certain portions of S. Mary Mouchliotissa in the Phanar quarter, none of them can claim to be ancient fabrics. There are in Turkish hands about twenty-five Byzantine churches, and, though sadly altered, most of them retain enough of their original features to be interesting objects of study.

CHAPTER VIII

AMONG THE CHURCHES

As historical landmarks, these churches are of very great value, and if Byzantine history were more generally studied they would enjoy wider fame. They enable the historian to fix a date, to give a local habitation to many events and scenes, to grasp a solid fragment of a form assumed by the life of humanity, and to feel how thoroughly real that life was. In them one touches hands that have vanished, and hears the echoes of voices that are still. The Church of S. Irene, which, under Turkish control, has been employed both as an arsenal and as a museum, carries the mind back to the foundation of the city. Indeed, there is reason to think that it was one of the Christian sanctuaries of Byzantium before the town was transformed into the capital of the East, for two early authorities assert that Constantine only

enlarged and beautified the church in order to make it match its new surroundings. But be that as it may, it is certain that, since the destruction of the Church of the Holy Apostles to make room for the Mosque of Sultan Mehemet, S. Irene has been the only sanctuary in the city that can claim connection with Constantine. Within its walls, it is said, the General Council summoned by Theodosius I. to restore the orthodoxy of the Church and Empire in 381 held its meetings. Occasionally, when S. Sophia for any reason was not available, S. Irene served as the patriarchal church, and is therefore sometimes designated the Patriarchate, and the Metropolitan Church. It was burned to the ground during the Nika riot, but was included by Justinian in the splendid restoration of the buildings destroyed on that occasion. It was ruined again by the earthquake of 740, and once more restored by Leo III. the Isaurian. To it, therefore, is attached the memory of the hero who defended Constantinople in the second siege of the city by the Saracens, a service to the world as important as the defeat of the same foe on the field of Tours by Charles Martel fourteen years later. "At this time," to quote Professor Bury, "New Rome, not Old

Rome, was the great bulwark of Christian Europe, and if New Rome had fallen it might have gone hard with the civilised world. The year 718 A.D. is really an ecumenical date, of far greater importance than such a date as 338 B.C. when Greece succumbed to Macedon on the field of Chæronea,· and of equal importance with such dates as 332 B.C., when an oriental empire (Persia) fell, or of 451 A.D. which marked the repulse of the Huns."

Another church of historical interest is S. Saviour-in-the-Chora (country), now Kahriyeh Djamissi, and popularly known as the Mosaic Mosque, on account of the remarkable mosaics it still contains. It was clearly in existence previous to the year 413, as thereafter it stood within the line of the Wall of Anthemius, and could not then acquire the distinction of being situated "in the country." Accordingly, it is a topographical landmark as regards the original extent of the city, only second in importance to Isa Kapou Mesdjidi, which we have seen indicates the line of the Con-stantinian Wall, the position of the first Golden Gate, and the situation of the Exokionion. Like every church with so long a life, S. Saviour-in-the-Chora has known many changes. It saw its best

days in the fourteenth century, when it was thoroughly renovated by Theodore Metochites, and invested with the splendour which still glows upon its walls, and makes it one of the most beautiful of the old churches of the Byzantine world.

Not less interesting historically is the Church of S. John the Baptist (Mir-Akhor Djamissi), situated in the quarter of Psamatia. It was founded about 463 by Studius, a Roman patrician who, like many other persons, when old Rome was tottering to its fall, fled from the West to the East, as when New Rome neared its end, some thousand years later, men escaped from the East to the West. The church was attached to a large monastery belonging to the order of the Accœmetæ or Sleepless Monks, who were so named because they celebrated Divine service in their churches day and night without intermission. According to the original constitution of the society the members of the order represented various nationalities, Greek, Latin, Syrian, and were divided into companies which passed from hand to hand, in unbroken succession, the censer of perpetual prayer and praise. They sought thus to make the worship of God's saints on earth resemble that of the assembly gathered from all nations and peoples

and tongues that serves Him without ceasing in heaven.

> Even thus of old
> Our ancestors, within the still domain
> Of vast cathedral or conventual church
> Their vigils kept; where tapers day and night
> On the dim altar burned continually,
> In token that the House was evermore
> Watching to God Religious men were they;
> Nor would their reason, tutored to aspire
> Above this transitory world, allow
> That there should pass a moment of the year,
> When in their land, the Almighty's service ceased

As might be expected from the number and zeal of its inmates, the monastery of Studius was highly venerated, and wielded immense influence. Its abbot ranked first among the abbots of the capital, and to it the Emperor was bound to pay an annual State visit on the 29th August, one of the Baptist's festival days. On that occasion the Emperor usually came by water in the imperial barge from the Palace beside the Hippodrome, and landed at the Gate (Narli Kapoussi) on the shore below the monastery, where the abbot and his monks waited to receive the sovereign. In this monastery the Emperor Isaac Comnenus in 1059, and the Emperor Michael VII. in 1078, assumed the monk's cowl. The former even served as porter at the monastery gate, and so

happy was he in his retirement from the pomps
and vanities of the world, that when his wife, who
had taken the veil at the time of his abdication,
visited him, he said to her, "Acknowledge that
when I gave you a crown I made you a slave, and
that I give you freedom when I took it away."
His wife's last command was "that her body
should be buried in the cemetery of the Studion
as a simple nun, with no sign to indicate that she
was born a Bulgarian princess and had been a
Roman empress."

No monks in the history of Constantinople
showed themselves so independent of ecclesiastical
and State control as the monks of the Studion.
Enough to recall the fact that in the controversy
which agitated Constantinople and the Church at
large for over a century (725-842), as to the law-
fulness of using pictures and statues in religious
worship, the monks of this monastery were the
boldest and most determined opponents of the
Iconoclast emperors. The abbot Theodore, who
for many years led the opposition to the imperial
authority in that matter, is one of the great
figures of the Eastern Church. Eight occupants
of the Byzantine throne found him a man who
for conscience sake defied all their authority,

rejected all their favours, and endured any suffer-
ing they chose to inflict. When the Synod, held
in 815, ordered icons to be banished from the
churches, Theodore and his monks carried the sacred
pictures in procession through the streets, and gave
them an asylum in his monastery. Nor was he
only stern. He caused the rejection of the treaty
of peace with Crum, the King of Bulgaria, because
of the demand it contained to surrender the
fugitives from that monarch's hard rule, many of
whom had become Christians. To do so, Theodore
argued, would be to make void the gracious words,
"Him that cometh unto me I will in no wise cast
out." He held the view that no monk should
keep slaves, and condemned the persecution of the
Paulicians, urging that they who are ignorant
and out of the way should be instructed, not
persecuted. There is a prevalent impression that
the pages of Byzantine history contain nothing
but the recital of the life of a servile and ignoble
community, of a race of men who trembled at
the nod of any despot and were void of all in-
dependence of thought and action. That such a
spirit often prevailed is undoubted. But if the
Byzantines had the faults of our human nature,
they were not altogether without some of its

virtues. And whatever our opinions on the ques-
tions, political or ecclesiastical, that divided parties
in Constantinople, may be ; although we may think
that good men in that city did not always take the
wisest course ; it is but common justice and fair
play to recognise that there also was found, in
the face of great difficulties, what we admire else-
where—a sense of the rights of conscience, some
demand for freedom of thought, the feeling that
right and truth are the supreme authorities over
human life, and that rulers, like other men, should
do justly and love mercy. There, as well as else-
where, men and women were found who preferred
to suffer and to die rather than prove faithless to
their convictions.

The monastery of Studius is, moreover, cele-
brated for its attention to hymnology, counting
its great abbot Theodore, his brother Joseph, and
two monks, both named Simon, among the writers
of sacred poetry. It had also a scriptorium in
which the Scriptures and other religious works
were copied. It was, moreover, famed as an
"illustrious and glorious school of virtue," and
thither youths of the higher classes of society
went for a part of their education. One of the
attractions offered by the school was the facility

with which students in an institution so near the
fortifications could get out of the city to hunt in
the open country. The relics preserved in the
church drew devout pilgrims to its shrine from far
and near. Many Russians visited the monastery
on that account, and even entered the order of
the Accœmetæ to live and die beside the sacred
remains. The humble tombstone of one of these
Russian monks is built in the base of the modern
wall enclosing the ground behind the apse. It
bears the inscription, " In the month of Septem-
ber of the year 1387, fell asleep the servant
of God, Dionysius a Russian; on the sixth day."
The honour of burial in the cemetery in which
the Sleepless were at last laid to rest was accorded
also to men distinguished for their public services,
as in the case of the patrician Bonus, who bravely
defended Constantinople in 627 against the Avars
and the Persians, while the Emperor Heraclius
carried on his daring campaigns far away in Persia
itself.

SS. Sergius and Bacchus (Kutchuk Aya Sofia)
and S. Sophia still reflect the splendour of the
spacious days of Justinian the Great; days in
which men still dreamed of the restoration of the
Roman Empire to its ancient bounds; days in

which the justice which Rome had developed was
codified and enthroned to be the eternal rule of all
nations that seek to establish righteousness be-
tween man and man. The former sanctuary was
built by Justinian, probably in 527, as a thank-
offering to the martyrs to whom the church was
dedicated, for having saved him from the death to
which he had been sentenced, on account of his im-
plication in a plot against the Emperor Anastasius.
No wonder that, when the lustre of the imperial
diadem shed light upon the full meaning of his
deliverance, his saviours became the objects of his
special gratitude and veneration. The erection of
the church was one of the first acts of his reign ;
he placed it in the immediate vicinity of his
residence while heir-apparent, and at the gates of
his palace when Emperor ; to it he attached a
large monastery, endowed with his private fortune.
There cleaves therefore to the building the per-
sonal interest that belongs to anything done in
a man's most earnest mood. Among the historical
associations that gather around the edifice is the
fact that it was the church assigned to the
Papal Legates at the Court of Constantinople,
for the celebration of Divine service in the Latin
form. Originally, indeed, that distinction belonged

to the basilica of SS. Peter and Paul which stood be-
side SS. Sergius and Bacchus. The special regard
cherished for the two great apostles in the West
would naturally make a church dedicated to them
in Constantinople the most acceptable religious
home for the Roman clergy on a visit to the city.
But the basilica of SS. Peter and Paul soon dis-
appeared, under circumstances of which we have
no record, and then SS. Sergius and Bacchus,
virtually a part of it, was placed at the disposal of
Latin priests. This fraternal custom was often
interrupted by the quarrels which, from time to
time, rent Eastern and Western Christendom even
before their final separation, but it was restored
whenever the two parties were reconciled. Pope
John VIII., for instance, thanks Basil I. (867-886)
for granting the use of the church again to the
Roman See, in conformity with ancient rights.
Among the Papal representatives in Constantinople
was Pope Gregory the Great (590-614), while
still a deacon, and at a time when the ecclesiastical
rivalry between the Sees of Old Rome and New
Rome was keen. It must have been with some-
thing of the feeling that sprang from personal
acquaintance with scenes and men in the rival
metropolis that he protested, when Pontiff, against

the assumption of the title "œcumenical bishop" by the Patriarch John the Faster in 587, and that he adopted in contra-distinction the well-known style of the Popes "the servant of the servants of God." Pope Vigilius spent several unhappy years (547-554) in Constantinople, in controversy with Justinian and the patriarch of the day, and in the course of the dispute had occasion to flee to the Church of SS. Peter and Paul, for refuge from the Emperor's displeasure. Notwithstanding the right of sanctuary, Justinian gave orders for the arrest of the Pope in his place of retreat. But when the officers sent for that purpose appeared, Vigilius, a man of uncommon size and strength, clutched the pillars of the altar, and refused to obey the imperial summons. Thereupon, the officers pulled him by his feet and hair and beard, to force him to let go his hold. But the bishop held fast, and could not be moved until the pillars to which he clung gave way, and threw him and the altar to the ground. This was too much for the indigna-tion and sympathy of the spectators who crowded the church. Coming to the rescue, they put the assailants to flight, and left the Pope master of the situation. It was only after a distinguished deputation, led by Belisarius, waited upon him next

INTERIOR OF S SOPHIA

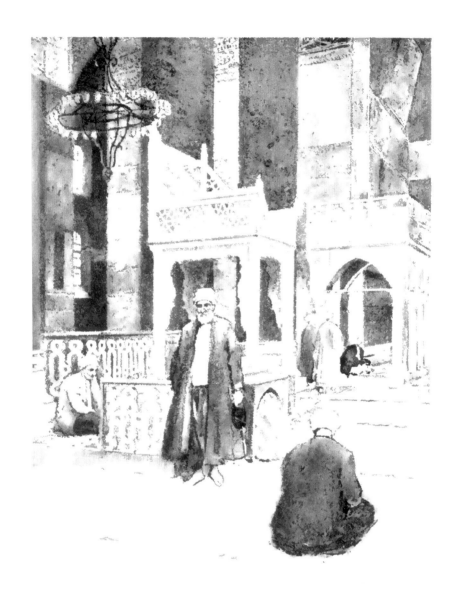

day, warning him that resistance to the Emperor's authority would be vain, and assuring him that submission would prevent further ill-treatment, that Vigilius came forth from the church. This was in 551. The church was attached to a large and rich monastery known as the monastery of Hormisdas, after the name of the district in which it stood. Like the members of other monasteries in the city, the monks of this House took their full share in the theological controversies of their day.

Among the crowd of events witnessed under the dome of S. Sophia, there are three scenes of paramount importance in the religious history of the world that lend to the Great Church an extraordinary interest. The first occurred on the day on which the envoys of Vladimir attended service in the cathedral, and were so overwhelmed by the splendours of the worship, that they hastened back to Russia to tell their sovereign that they had seen the glory of the true God. "We know not," they are reported to have said, "whether we were not in heaven; in truth, it would be impossible on earth to find such riches and magnificence. We cannot describe to you all that we have seen. We can only believe that there in all likelihood one is in the presence of God, and that the worship of

other countries is there entirely eclipsed. We
shall never forget such grandeur. Whosoever has
seen so sweet a spectacle will be pleased with
nothing elsewhere." The conversion of the Slavic
peoples to the Christian faith, a work commenced
in the ninth century by the mission of Cyril and
Methodius to the Slavs of Bulgaria and Moravia,
is one of the most important services rendered by
the Church of the Byzantine Empire to the cause
of European civilisation. So far as its political
significance is concerned, it can stand comparison
with the conversion of the Teutons by the Western
Church. It accomplished what the victories of
Zimisces failed to achieve.

It was the moral conquest of Russia, and the
source of her upward life, until that country was
opened also to the influence of Western civilisa-
tion. It probably saved Russia from becoming a
Mohammedan State. The Slavic peoples rightly
cherish a regard for Byzantine Constantinople,
similar to that which Western Europe feels for
Athens and Rome.

The second scene, to which we refer, took place
on the 15th July 1054. On the morning of that
day, as Divine worship in the cathedral was about
to commence, three papal legates, Cardinal Hum-

bert, Cardinal Frederic, and the Archbishop of Amalfi, made their way through the crowd of worshippers to the steps of the altar. Having denounced the Patriarch Michael Keroularius for insubordination to the Holy See, the legates placed upon the altar a bull of excommunication against him and his adherents. They left the church, shaking its dust off their feet, and exclaiming, "Videat Deus et judicet." In due time the patriarch hurled back a counter-anathema; and, thenceforth, the Christian world was divided in two bitterly hostile camps. It was the wave precipitated against the shore by waves that had tossed the ocean's expanse, for league upon league. It was the consummation of a long process of disruption between the West and the East, the course of which is marked by such events as the foundation of Constantinople, the jealousy between Old Rome and New Rome, the invasion of the Teutons, the establishment of the Holy Roman Empire, race antipathies, and wrangles over the phrase Filioque, the use of images, the celibacy of the clergy, and the employment of unleavened bread in the Eucharist. Behind all this discord, we may be able to detect men groping for the truth, and resisting absolutism in Church and State. But it has left Christendom

21

weakened both as a political and a religious power
to this day.

On the 29th or 30th of May 1453, Sultan
Mehemet the Conqueror alighted from his horse
at the gate of S. Sophia. It was most probably
at the "Beautiful Gate," at the southern end of
the noble inner narthex of the church, the entrance
through which the Emperors of Constantinople
usually proceeded to the cathedral. According
to one account, the Sultan stooped down at the
threshold, took some earth, and scattered it on his
head in token of humiliation before God. Entering,
he saw a Moslem breaking the marble pavement.
He struck at the vandal with a scimiter for daring
to injure a building that belonged of right to the
sovereign. Then, in what to the Eastern world
was the Holy of Holies of Christendom, an imaum
ascended the pulpit and cried aloud, "There is no
God but God, and Mahomet is His prophet." And
so it has been ever since.

The Church of S. Saviour Pantepoptes, the All-
Seeing (Eski Imaret Djamissi), the Church of S.
Saviour Pantocrator, the All - Powerful (Zeirek
Kilissé Djamissi), and the interior of S. Saviour-in-
the-Chora (Kahriyeh Djamissi), recall the period of
the Comneni and the Angeli (1081-1204).

In their erection ladies of considerable importance in the history of Constantinople had a part. The first was built by Anna Dalassena, the mother of Alexius I. Comnenus; the last was restored by his mother-in-law, Mary Ducæna, a Bulgarian princess famous for her beauty; the second was an erection of the Empress of John I. Comnenus, the daughter of Geysa I., King of Hungary. These churches represent the age when Constantinople was stirred by the march of the earlier Crusades through the territory of the Empire, when Peter the Hermit and Godfrey de Bouillon encamped their followers within sight of the city walls, to be dazzled by the splendours of the Palace of Blachernæ, and cajoled by the diplomacy of Alexius I. Comnenus. They also recall the time when Henrico Dandolo, the Doge of Venice, brought his fleet and the troops of the Fourth Crusade to the Golden Horn, and founded the short-lived Latin Empire of Constantinople. It was on the terraced ground beside the Church of Pantepoptes that the Emperor Alexius Murtzuplus pitched his vermilion tents and drew up his reserve forces. There he stood to see the walls on the shore below attacked by the Venetian ships and carried by Frankish knights. From that position he fled at the approach of a

body of the enemy's horsemen, and under his un-
stricken vermilion tent Count Baldwin of Flanders
and Hainaut, soon to succeed him as Latin Emperor
of Constantinople, spent the night of that memor-
able day.

The monastery of the Church of the Pantocrator
became the headquarters of the Venetians during
the Latin occupation of the city. In the relations
of Western and Eastern Christians to each other
during the period of the Crusades there is nothing
of which we can feel proud. The former were
barbarous, the latter were decadent; neither of
them worthy to recover the San Graal in search of
which so much heroism and devotion were displayed
for two centuries. But it is well to remember that
the encounter of the East and the West during those
expeditions contributed not a little to the "infiltra-
tion," as it has happily been phrased, "of ideas,
knowledge, and art from the Grecised Empire into
Western Europe." It brought the influence of an
older and riper civilisation to bear upon the younger
life that had come into the world, and aided that
life to evolve a new and better order of things.

The Venetian occupants of the monastery of
Pantocrator, for instance, could learn much from
the admirable organisation of the hospital main-

tained by that House for the benefit of the poor. The hospital contained fifty beds, of which ten formed a ward for surgical cases, eight a ward for acute diseases, ten for ordinary maladies, and twelve a ward for women. A fifth ward contained ten beds for the reception of applicants for admittance into the other wards of the hospital, until the physicians should decide upon the gravity of the cases. Each ward was in charge of two doctors, three medical assistants, and four servitors.

To the women's ward were attached a lady-physician, six assistant lady-surgeons, and two female nurses. All patients were treated gratuitously. Upon arrival at the hospital a patient's clothes were laid aside, and replaced by a white dress provided by the institution. There was a liberal allowance of bread, beans, onions, olive oil, and wine, for all able to partake of such food, while from time to time gifts of money were distributed. The beds were kept clean, and a house-doctor went through the wards every day to inquire of the patients, whether they were satisfied with their treatment, and to examine their diet. In addition to the hospital, the monastery maintained, on the same liberal scale, a Home for Old Men, accommodating twenty-four persons.

The inhabitants of Constantinople were sinners, though not sinners above all men, as they are often represented. But in their hospitals, orphanages, asylums for the aged, free caravanseries, asylums for lepers, and other institutions "to give rest to those whom trouble had distressed," which humanised the city with compassion, they were distinguished also for that charity which covereth a multitude of sins.

The Churches of S. Mary Pammacaristos Fethiyeh Djamissi), the Church of S. Theodosia (Gul Djamissi), and portions of S. Saviour-in-the-Chora, carry us to the times of the Palæologi, the dynasty that occupied the throne of Constantinople during the last one hundred and ninety years of the city's history as New Rome. It is the period of the long struggle with the Ottoman Turks, and the culmination of the conflict between the Mohammedan world and Christendom which had filled more than eight centuries with its hate and din; when the sign in which the Empire had conquered yielded to the sign of the crescent, and the benediction of the prophet of Islam—" Whoso taketh the city of Constantine, his sins are forgiven "—found at length a man upon whose head it could settle. It is a sad period of Byzantine history; yet one noble

idea, at least, appealed to its mind—the Reunion of Christendom — which, if realised, would have changed the history of Europe. But it was not to be.

Like all the churches of the city situated near the fortifications, the Church of S. Saviour-in-the-Chora was regarded with special veneration as a guardian of the safety of "the God - defended capital," and there, during the siege of 1453, was placed, as an additional pledge of security, the icon of S. Mary Hodegetria, attributed to S. Luke. But the church was the first sanctuary into which Turkish troops broke on the fatal 29th May for pillage. They spurned to take the icon as a part of their plunder, and in mockery of its vaunted power hacked it to pieces. The Latin Church of S. Peter in Galata claims to possess one of the fragments.

With S. Theodosia is connected the pathetic association that the festival day of the church coincided with the day on which the city fell in 1453. The area and galleries of the building were packed by a large and earnest congregation that kept vigil through the night-watches, praying for the safety of the Queen of Cities, when suddenly, soon after the sun had risen, the wild rush of soldiers

and shouts of victory in strange accents told that the enemy had triumphed, and that the day of vengeance was at the door. No massacre ensued, but the whole congregation was doomed to slavery.

The Church of the Pammacaristos served as the cathedral of the patriarchs of Constantinople for one hundred and thirty-five years after 1456, when deprived of the Church of the Holy Apostles.

These churches put the period of the Palæologi before us in also a pleasing aspect. The mosaics which adorn the narthex and exo-narthex of the Church of S. Saviour-in-the-Chora imply, that love for the beautiful and skill to express it had not fled the city which reared S. Sophia. The proportions of S. Theodosia are exceedingly fine, and the chapel attached to the Pammacaristos is, at least externally, remarkably attractive. Nor had intellectual life and scholarship altogether ceased. The historian Nicephorus Gregoras was a monk in the monastery of S. Saviour-in-the-Chora, and wrote his work in the retirement of his cell. The historians Pachymeres, Cantacuzene, Phrantzes, Ducas, were not the products of an ignorant age. The Greek scholars who took refuge in the West, and contributed to its intellectual revival, represented a society which, with all its faults, had

not lost its interest in the literature of ancient Hellas, or in general knowledge. Indeed, in studying the period of the Palæologi, one continually meets a spirit akin to that which produced the Renaissance in Western Europe. And, notwithstanding the vanity of indulging in dreams of what might have been but never has been, the mind obstinately asks, What if that upward movement had not been checked by a great political catastrophe? What if it had been accompanied by moral reform and military prowess?

CHAPTER IX

AMONG THE CHURCHES

BUT however interesting the old churches of the city are as historical landmarks, however useful as a clue to guide us through the labyrinth of the life of New Rome, their supreme value after all consists in the fact that they are monuments, one of them the finest monument, of what is styled Byzantine Art — the art which blended artistic elements derived from Greece and Rome with artistic elements borrowed from Nineveh, Persia, Syria, and unfolded a new type of beauty. It was the flower developed by that fusion of Western and Oriental æsthetic ideals and tastes resulting from the long intercourse maintained between Europe and Asia, sometimes at the point of the sword, and sometimes by the peaceful ministries of commerce. Nowhere could that Art find a more congenial atmosphere in which to

flourish than in the city which binds the West and
the East together. Like all else in the world,
Byzantine Art was not a sudden creation, inde-
pendent of all antecedents, unheralded by previous
analogous forms. The dome was reflected in the
waters of the Tigris and of the Tiber before it was
mirrored in the Bosporus. Columns were bound
together by arches instead of by a horizontal entabla-
ture, in the Palace of Diocletian at Spalato, before
they were so united in the Sacred Palace beside the
Hippodrome of Constantinople. Walls glistening
with variegated marbles, marble floors glowing
with colours that vied with meadows in flower,
mosaics radiant with the hues of the rainbow, had
adorned homes and made palaces beautiful before
the witchery of such coloration cast a spell over
the courtiers of Justinian, or suffused the light in
S. Sophia. Even the pendentive that fills the
triangular space between two contiguous arches
at right angles to each other, so characteristic of
Byzantine architecture, is claimed to be an earlier
device in domical construction. Be it so. In one
sense, there is nothing new under the sun. The
new grows out of the old, the present is the product
of the past. And yet, while a new order of things
must spring from an old order, it is not the bare

repetition of what has been ; while it must employ
materials shaped originally for the use of other
days, it is not the mechanical combination of those
materials. It employs them in another spirit, under
the control of ideas different or more mature than
have yet been known, as the utterance of feelings
acting with peculiar force at particular moments
in history, with more skill, on a larger scale, with
happier effect, and the result is that something
appears with an individual entity perfectly dis-
tinguishable from all that ever was before, or that
will ever come after. Byzantine Art is its own
very self, however many adumbrations prophesied
its advent.

The oldest ecclesiastical edifice in the city—the
Church of S. John the Baptist, attached to the
monastery of Studius—does not, however, repre-
sent Byzantine architecture. Built in 463, it is a
basilica, and accordingly is a specimen—the only
specimen in Constantinople—of the earliest type
of a Christian sanctuary. It was well-nigh de-
stroyed in a conflagration that devasted the district
of Psamatia in 1782, and its roof was crushed in
by a heavy fall of snow some three winters ago.
But, though only the shadow of its former self, its
primitive character can be clearly recognised. The

old atrium before the church is still here, with a
phiale or fountain in its centre for the purification
of the gathering worshippers. Of the colon-
naded cloister along the four sides of the atrium,
the western portion, borne by four columns and
forming the narthex of the church, still stands.
There catechumens and penitents, unworthy to
tread the holy ground within the sanctuary, stood
outside and afar off. Beautiful trees now spread
their branches over the court, and the shaded light
falls upon turbaned Moslem tombs, as of yore it
fell upon the graves of Christian monks, from the
trees growing in the Paradise of the monastery.
It is the most peaceful spot in all Constantinople,
and as fair as it is calm and quiet. The narthex
belongs, undoubtedly, to the original fabric. Its
marble pillars crowned by Corinthian capitals of a
late type bear a horizontal entablature, and the
egg and dart ornament, the dentils, the strings of
pearls, familiar in the friezes of Greek and Roman
temples mingle with foliage, birds, and crosses,
expressive of new ideas and tastes. Within, the
interior was a hall 89 feet by 83, divided by a
double row of seven columns of verde antique
marble, into a nave and two aisles. The proportion
of length to breadth is greater than is usual in

basilicas of the West, and an indication of the
tendency to assume the square plan which Byzan-
tine architecture so strongly manifests. The long
lessening vistas so impressive in Western churches
are rarely, if ever, found in an Eastern sanctuary.
In the latter the structure is more compact,
and the worshipper stands before a Presence that
compasses him about alike on every side. At the
eastern end of the nave is the usual apse, semi-
circular within, a polygon of three sides on the
exterior. Triforium galleries, now gone, divided
the aisles in two stories, the upper storey bearing
also columns of verde antique. The columns of
the lower tier were bound by a horizontal entabla-
ture, while their fellows above were united by
arches, a mingling of old and new forms. The
roof was of wood, as in similar basilicas elsewhere.
The church recalls the Church of S. Agnes at
Rome. Its disappearance will be a matter of deep
regret, not only as an ancient landmark, but as an
edifice which preserved the surroundings of early
Christian congregations, and reflected, however
faintly, the light of classic days, through all the
changes of the city's tastes and fortunes.

The Church of S. Irene, notwithstanding the
serious restorations it underwent in the sixth

century and again in the eighth, retains so much of its early basilican type that it can claim a place among the churches of the older style. In spite of the two domes placed longitudinally upon its roof, it is basilican in the proportion of its length to its breadth, in the retention of lines of piers and columns to divide its nave and aisles, in its single apse, and the galleries on three sides. The apse has the interest of still preserving the tiers of marble seats for the clergy, as in the Cathedral of Torcello. Its conch is adorned with the mosaic of a large black cross on gold ground, and on the face of the triumphal arch may be read the invocation calling upon the Hope of all on the earth or upon the sea to enter His temple, and pour His Spirit upon His people.

SS. Sergius and Bacchus, styled by the Turks little S. Sophia (Kutchuk Aya Sofia), on account of the resemblance it bears to the greater church of that name, is interesting from more than one point of view. It deserves attention as a thing of beauty. Imagine an octagonal building constructed of eight lofty piers united by arches. Cover that structure with a dome furrowed by sixteen flutings. Let the sides in the diagonals be curved and the sides in the axes be straight, to

secure more room, to avoid monotony of contour, stiffness, angularity, and to introduce the variety, freedom, softness, which give wings to fancy. Within each archway, except the one at the east, where the semicircular apse recedes to make room for the altar and the seats of the clergy, place four columns in two tiers, now green mottled with black spots, now cream-coloured marked with red veins, now white marked with veins of dark blue. Crown the lower columns with capitals, whose lobed form has been compared to a melon partly cut open, but which might, more gracefully, be likened to a tulip bud breaking into flower. Bind these columns, after the old fashion, with a horizontal entablature, where acanthus, egg and dart, reeds and reel, dentils, strands of rope and the ornamental letters of an inscription, in honour of S. Sergius and of the founders of the church, Justinian and Theodora, combine to make a splendid frieze. Join the upper columns, according to the new taste, with arches supporting conchs, and resting on long, flattened capitals covered with marble lace. Revet all surfaces up to the cornice with variegated marbles, and above the cornice spread mosaics. Then put this octagonal fabric, with its undulated interior surface, thus carved and coloured and gemmed,

into a square edifice, like a jewel into a casket; so that the apse may protrude beyond the square's eastern side, and the aisle, between the octagon and the square, may be divided into two stories by galleries, and the round dome may soar aloft visible to all without, and you have some idea of the plan and beauty of this gem of Art.

Another consideration that lends interest to SS. Sergius and Bacchus is its striking resemblance to the Church of S. Vitale at Ravenna. The latter was commenced in 526, a year earlier than the former, while Theodoric the Great ruled his Ostrogoths in the fair city beside the Adriatic. It was not completed, however, until 547, after the arms of Justinian had restored Ravenna to the Roman Empire. A comparison between the kindred buildings would be invidious. Let it suffice to say, speaking broadly, that the exterior arrangements of SS. Sergius and Bacchus are superior to those of its western companion, while the interior of S. Vitale is more beautiful than the interior of the church on the shore of the Sea of Marmora. But, leaving comparisons between two beautiful objects alone, it is pertinent to recognise the artistic influence of Constantinople over Art in the West here manifested. For,

23

although the churches are too different for the one
to have been copied from the other, they are so
similar as to prove the existence of a common
school of Art; a school which had its chief seat in
the studios and workshops beside the Bosporus.
Even some of the materials of S. Vitale were
imported from the East; among them, "melon-
capitals" like those which adorn the columns on
the ground-floor of SS. Sergius and Bacchus.

The similarity of the two churches has yet
another interest. Their likeness constitutes them
symbols of Justinian's great policy—the reunion
of the East and the West, a reunion maintained
for some two hundred years after its consumma-
tion. Since that unity was impaired, they have
stood, one beside the Adriatic, the other beside the
Marmora, like hills which erewhile formed sides of
the same mountain, and rose to the same peak, but
which a cruel tide has torn apart and holds separate,
in spite of their kinship.

But, perhaps, the chief interest attaching to
SS. Sergius and Bacchus is the fact that it repre-
sents a stage in the solution of the problem how to
crown a square building with a dome, the charac-
teristic mark of Byzantine architecture.

To cover a round building, round from summit

to base like the Pantheon, with a dome is com-
paratively an easy matter, for in that case two
circular structures meet and fit together along the
whole circuit of their circumferences. On the other
hand, to set the round rim of a dome upon a square
substructure seems an attempt to join figures which
from the nature of things can never coalesce.

Such a union is conceivable, only if, by some
device, the different figures can, at least at some
point, be cut to the same shape. The problem
to be solved may therefore be stated as the ques-
tion, whether the summit of a square structure
can be converted into a circle corresponding to
the rim of the dome it is to support. In SS.
Sergius and Bacchus we have the type of a build-
ing in which a step was taken in that direction.
There, as we have seen, the base upon which the
dome rests is formed by a substructure consisting of
eight arches arranged in the figure of an octagon;
the gaps at the angles, where arch bends away
from arch, being filled with masonry to the level
of the heads of the arches. Such a base, it is true,
does not match the dome as accurately as a round
substructure like the Pantheon. Still, an octagon
approximates to a circle more closely than a square
does. Its contour offers more points of contact

to the orbed canopy set upon it, and the gaps at
its angles, being comparatively small, can readily be
filled up to afford the dome a continuous support.
If the fit is not perfect, it is sufficient to secure
a decided advance beyond the simpler art, which
knew only how to put one round thing upon
another round thing. And what beautiful results
could be gained by this advance, SS. Sergius and
Bacchus in Constantinople and San Vitale at
Ravenna are there to prove. But the end was
not thus reached. Circular buildings and octagonal
buildings are exceedingly beautiful; they should
always stay with us. But they are not the most
convenient, and cannot become the buildings in
general use. For the practical purposes of life,
square or oblong halls are in greater demand; such
as the basilica, which could serve as a court of
justice, a church, a school, a market, or a throne-
room. Hence the question still remained, Can
the summit of a square structure be turned into
a circular base for a dome?

And it is the merit of the architects of
S. Sophia, Anthemius of Tralles and Isidorus of
Miletus, his nephew, to have applied the method
which solves that problem, with such ability, such
splendid success, and to have made it so con-

INTERIOR OF S. SOPHIA, THE
SULTAN'S GALLERY

This gallery, built of marble and screened with gilt
fretwork is for the exclusive use of the Sultan, it is
approached by a separate entrance

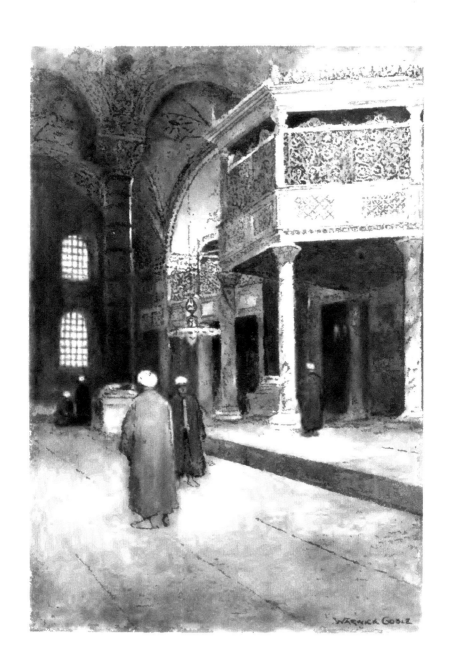

spicuous and famous, that they seem the discoverers of the method, and not only its most illustrious exponents. The object which these men set themselves to accomplish was to combine the advantages of a basilican edifice with the advantages of a domical building. For, in S. Sophia, the lineaments and beauty of a basilica are still retained— the threefold division of a stately hall into nave and aisles, the recess of the apse at the east end, the galleries dividing the other sides into two stories, long lines of columns, the lustre of marble and the glow of mosaics all are here. But the ceiling of a basilica, whether flat, pointed, or vaulted, was an insignificant feature. It cramped the upward view; it vexed the eye as heavy. In a church, it seemed to fling back to earth the aspirations which sought the heavens. It was dark; through it the Light of the world could not stream into the soul.

Whereas a dome was something bold and striking; its construction evinced great architectural skill; and rewarded the labour bestowed upon it, by the dignity and the grace it gave to the building whose brow it crowned. It also appealed to the spiritual mind; it lifted the heart on high, it was kindred to the skies; it was a cloud through which the glory beyond the earth could come, in the subdued

light that permits mortal eyes to behold the vision
of God. For, most assuredly, the architects of S.
Sophia were not content to rear only a marvel of
mechanical skill. Like true artists they intended
to compose "a poem in stone," nay, to build a
"gate of heaven." But first that which is natural,
afterwards that which is spiritual And we must
therefore glance at the method they employed to
cover a basilica with a domed canopy.

In the central area, let us say, of a rectangular
building, 235 feet N. and S. by 250 feet E.
and W., erect a square structure of four arches.
Where arch bends away from arch, there are tri-
angular empty spaces breaking the continuity of
the lines of the square summit. Such a base is
not round, and it is broken. Can it be made con-
tinuous and circular—that is the question ? It can.
Fill the yawning triangular spaces with masonry to
the level of the heads of the arches; only let that
masonry be made concave, as though portions of the
proposed dome were inserted between the arches,
to dovetail with them. And to your surprise,
perhaps, but inevitably, the square summit is trans-
formed into a circle, capable of becoming the bed
on which a dome may rest as accurately and
securely, as though the square of arches was round

and solid to the very floor. It is all very simple, after you have seen it done; but the device which introduced into those triangular gaps at the upper corners of the square the pendentives which, when they mounted to the height of the arches, converted a square into a circle was a master-stroke of genius, whoever conceived it first, and an epoch in the history of architecture. But how is this domed square structure to be connected with the walls of the rectangular area within which it is enclosed? How, especially, is it to be held in position, lest it be split open by the thrust of the dome and hurled to the ground? The double-storied aisles to the north and the south furnish the required support in those directions. But it was in the means devised to sustain the dome on the east and the west, that Anthemius and Isidorus displayed all their daring, and secured an effect that has never been matched for grandeur and beauty.

They placed two comparatively small piers to the east of the dome-crowned fabric and two to the west of it; arched the piers, and connected them to the right and the left, still with arches, with the great piers to the rear of which they respectively stood. Filling up the triangular void spaces between these arches, they thus gained a

semi-circular base upon which to rear, at either
extremity, a semi-dome, climbing with gentle curve
to the feet of the great dome, to support it in
its lordly place, and (if the expression may be
pardoned) to stretch it from one end of the nave
to the other. It is as though the octagon of
SS Sergius and Bacchus had been cut in twain
and set east and west of a square surmounted by a
dome, converting the central area of the church
into an elliptical or oval figure.

For elasticity of spring, for the grace and majesty
of its upward flight, for amplitude, for the light-
ness with which it hangs in air, there is no
canopy like the arched roof spread over the nave
extending from the Royal Gates to the altar of
S. Sophia.

Poised on arches and columns, soaring from
triple bays to semi-dome, and from semi-dome to
dome, bolder and bolder, higher and higher, more
and more convergent, culminating above a circle
of forty lights, through which the radiant heavens
appear, it is not strange that it has seemed a
canopy merged in the sky, and that for more than
thirteen centuries men have worshipped beneath
it with the feeling "This is none other than the
House of God!"

FOUNTAIN IN S SOPHIA

One of the two great alabaster water-jars e r the
entrance

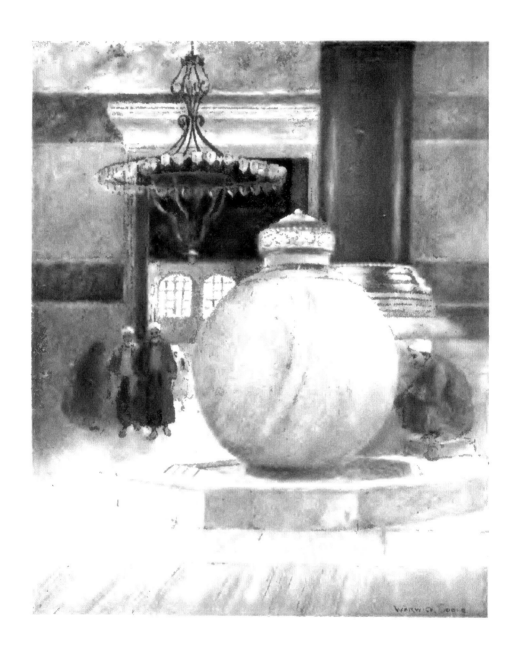

Only one thing more was needed to make the fabric artistically complete—to spread over it what Ruskin terms, "that most subtle, variable, inexpressible colour in the world—the colour of glass, of transparent alabaster, of polished marble, and lustrous gold." Accordingly, all that porphyry, verde antique, white marble, marbles of variegated hues, in the form of pillar, slab, capital, inlaid patterns, could contribute, all that delicate carving, with its lights and shadows, all that mosaics bright and soft as sunset tints could lend, was brought into requisition, until every part of the interior surface was suffused in a splendid coloration, and the solid fabric stood transfigured into a pavilion of some iridescent tissue, overwrought with gorgeous embroidery, and held up on shafts of prophyry and emerald.

Many persons are, it is said, disappointed with the first view of even the interior of S. Sophia. Of course the church is not in the state which made Justinian exclaim, when he first crossed its threshold, "O Solomon, I have surpassed thee." But, after making every allowance for the effect of what detracts from the original glory of the church, those disappointed with S. Sophia must be reminded that, as some one has remarked, "it costs

24

an expensive education to admire a sunset"; and, furthermore, that it is the mark of what is truly great to transcend our immediate grasp, and to reveal its majesty only to prolonged and reverent contemplation.

S. John Studius, SS. Sergius and Bacchus, S. Sophia, and S. Irene, notwithstanding their great differences, agree in following, to an extent that can be recognised, traditions of ancient art. The light of a day, that is past and over, is still reflected from them; or, to change the figure, in them the foliage of a bygone summer mingles sparse and faded forms with the leaves of a new spring In the other churches left in the city, old features disappear, and what is new reigns supreme. The influence of S. Sophia upon the history of Art has, it is said, been greater than that of any other single building. And yet S. Sophia has never been repeated.

Nor is this strange. A masterpiece cannot be reproduced. But we must seek farther for a complete explanation of the fact. While S. Sophia is, from one point of view, a culmination, it is, from another point of view, a stage in a process of development. The combination of basilican and domical features which it displays is a tribute at

once to the influence of old tastes and to the influence of a new fashion. The result of the cross, so to speak, of the two influences was superb, and might well have arrested further change. But considerations, practical and theoretical, were at work urging movement onwards. Although the dome of S. Sophia was a great triumph, it was not a complete success. It rested squat upon the building, when viewed from without. And what was more serious, its thrust against the walls of the church was so strong as to demand external buttressing to prevent a fall. Furthermore, while to stand in a forest of pillars was impressive, it was a pleasure that interfered with the duty of following readily the services at the altar, and broke the unity of the congregation of worshippers. Then, men had grown somewhat weary of the basilica, and were enamoured with the dome. Accordingly, a logical necessity urged the mind to draw all the conclusions involved in the premises which had won the faith of the world of Art. Henceforth, the architectural ideal would be a domed rectangular edifice as free from pier or pillar, and as wide open to view, if that were possible, as the area beneath the dome of the Pantheon.

Consequently, the columns or piers bordering the nave decrease in number until they are reduced to the four necessary to carry the arches upon which the dome rests. Lateral aisles become narrow ; galleries disappear, or are represented by a gallery only over the narthex. Indeed, in such churches as S. Saviour-in-the-Chora, the piers that bear the dome are not free-standing supports, but narrow projections from the walls of the edifice, so that the interior is practically open to view in all its length and breadth, having neither aisles nor gallery. In dealing with the dome, the thrust was reduced, by carrying a cylindrical or polygonal turret (drum) to a moderate height above the roof, and surmounting the structure with a cupola. That the fundamental idea inspiring this movement, from the basilica to the perfect development of a domical building, was legitimate, and capable of producing magnificent results, cannot be disputed. But, for some reason, Byzantine architects in Constantinople did not realise their ideal to the extent we might expect. At least, no large church constructed on this plan is found in the city. Then a dome set upon a turret lacks mass and dignity, when viewed from without, and fails to dominate the interior, or lift eye and heart upwards, the moment the

worshipper crosses the threshold. To look into such a dome and admire its mosaics is also difficult; sometimes, even painful.

In order to obtain a church of considerable size, the device was adopted of building several small churches side by side, furnished with a continuous narthex, and communicating with one another through their common wall or walls. The Church of S. Mary Panachrantes, situated in the Lycus valley, is an example of twin churches, while the Church of the Pantocrator offers an example of an agglomeration of three churches. At other times the same result was obtained by adding to an older church a small chapel, as in S. Saviour-in-the-Chora, and the Pammacaristos.

To overcome the lack of grandeur in a dome placed on a drum, recourse was had to the system of adorning a church with several domes, in the hope that multiplicity would compensate for the absence of mass. This employment of several domes appears already in the reign of Justinian, who crowned the Church of the Holy Apostles with five domes. When a church is small, this arrangement produces a graceful and pleasing effect, as may be seen in the domes of S. Saviour-

in-the-Chora, S. Mary Pammacaristos, and the charming Church of S. Theodore Tyrone (Kilissé Djamissi, near Vefa Meidan). It is seen at its best in the domes of S. Mark's of Venice. But after all, this multiplication of domes does not harmonize with lofty sites and broad spaces. Under the wide sky, and on the hilltops of Constantinople, it looks a petty thing. It can never attain the grandeur and sublimity essential to the highest achievements of artistic architecture. Strangely enough, the ideal of Byzantine architects is realised better in the imperial mosques that crown the summits of Stamboul, and rise above the hills on which they stand, as naturally and proudly as a peak lifts its head into the sky. How puny are the domes of the Pantocrator or those of the Pante-poptes compared with the dome of the Mosque of the Conqueror, or the dome over the Mosque of Suleiman the Magnificent, or the dome of the Mosque Shahzade, or even the dome of the Mosque of Sultan Selim! Nor is it only in their exterior aspect that the great mosques fulfil the Byzantine ideal. They do so likewise within. The long pillared lines of the basilica have vanished. In the Mosque of Suleiman the Magnificent, only four piers and four columns, the latter from Byzantine buildings,

break the interior view. In the Mosque of Sultan
Achmed, only four piers uphold the roof. And at
the same time, what spaciousness! What loftiness
and grandeur! If in these mosques one misses the
warmth of feeling awakened in S. Sophia, one finds
the same sense of the majesty of Heaven, the same
suggestion of the littleness of man.

But, if we must not look for grandeur in the
churches of Constantinople outside S. Sophia, we
meet with much that is exceedingly attractive.
This would be more evident were it not for the
neglect, the wilful destruction, the inane attempts
at decoration, to which the buildings have been
subjected. The groined ceiling, edged with a broad
band of marble lace, in the lateral apses of the
Pantepoptes is very graceful. As a general rule,
considerable fancy and taste are displayed in the
ornamentation of capitals. The exterior of apses
is sometimes rendered pleasing by tiers of blind
arches, or of niches and pilasters. The portico of
S. Theodore Tyrone, with its columns, melon-
capitals, sculptured balustrade, retains, even in its
decay and neglect, traces of remarkable beauty.
There is fine work to be seen likewise in the
Pantocrator. While in S. Saviour-in-the-Chora,
one can spend days in admiration of its mosaics,

frescoes, marbles, carvings, cornices, and borders. The undercut foliage, upon a dark background, which crowns the mosaic figure of the Virgin on the south-eastern pier of the church, is exquisite. Very fine also are the faces and the robes of some of the archangels in the dome of the side-chapel of the church. The mosaics on the vaulted ceiling of the inner narthex, representing traditional scenes in the life of the Virgin, are among the finest to be found anywhere. They are wonderfully rich and brilliant in colour. The marble revetment of the narthex is a splendid specimen of that style of decoration. There must have been excellent artists in Constantinople in the reign of Andronicus II., when the narthexes and the side-chapel of this church were so beautifully embellished.

Yet the visitor to the churches of Constantinople must be armed with such enthusiasm for what is historically great and artistically beautiful, that he will be stirred to pursue his way by even the minutest fragments of objects invested with these attributes. For it cannot be said of these old sanctuaries, that they have—

> No need of a remoter charm
> By thought supplied, or any interest
> Unborrowed from the eye

They have stood where no general appreciation for such things exists. They have been in the keeping of those who have no pride in their preservation, no reverence for their associations, no admiration for certain features of their beauty. They are covered not only with the dust of ages, but of neglect, ignorance, and depreciation. In visiting these churches, diverted from their original destination, and shorn of their glory, one is sometimes reminded of Gibbon sitting on the Capitoline hill of Old Rome, and listening to the barefooted monks who chanted vespers in the ruined temple of Jupiter. To his mind the spectacle suggested the Decline and Fall of the Roman Empire. So, as one hears the muezzin's call sounding above the decayed sanctuaries of New Rome, one may feel disposed to muse on the destruction of the Roman Empire in the East. That is a natural, a legitimate, a profitable, line of thought. But it should not be the only direction our thoughts follow. The Past comes before us not only with its faults, and weaknesses, and failures. It had its virtues, its strength, its achievements. The landmarks which it has left behind are not here to recall only the vanity of human things. They are with us to carry our minds and hearts back to great examples

25

and to glorious deeds. Sometimes the visitor to
these "church-mosques" is offered pieces of mosaic
that have fallen from the dome under which he
stands. They tell of decay, it is true. But with
those radiant little cubes in his hand, an artist may
reconstruct the forms of saints, the figures of
apostles and martyrs, the faces of angels, the
majesty of the Pantocrator. So these churches,
even in their humiliation, recall the great com-
munity of our fellowmen who lived their lives, and
wrought their deeds, in this city for more than a
thousand years, and they aid us to think the noble
thoughts, to catch the love for beauty, to cherish
the high aspirations, and to emulate the services
which glorified that community—that these things
may never pass away.

CHAPTER X

So much has been written about Constantinople in its Turkish character, that to say anything entirely fresh and new upon the subject is impossible. The reader must, therefore, look to the illustrations which adorn this work for the impression which the Oriental aspect of the city makes upon an artistic eye. If the writer of the text ventures to repeat some parts of a well-known tale, it is only because different ways of telling an old story vary the points of view from which the matter is regarded, bring different features into relief, and set them in another atmosphere and colour; as the appearance of the same landscape changes, according as it is seen at dawn, or at noon, or by the light of the setting sun.

Speaking of the bridge that spans the Golden Horn from Galata to Stamboul, De Amicis

remarks that; "where every day a hundred thousand people pass, not one idea passes in ten years." The slowness with which the East changes is, perhaps, the impression which the spectacle of life in Constantinople naturally makes upon the mind of a stranger. His attention is arrested by the differences between the scenes he observes for the first time and the scenes with which he is familiar. A fresh eye is quick to detect distinctions and peculiarities. On the other hand, "an old resident," on the same principle, is more deeply impressed by the changes which have been wrought in the life and aspect of the city of his abode, since the days of his early recollections. To the visitor the old is new, and the new is old; while to the resident the old is familiar, and the new is strange. If the former observer has the advantage of seeing things from a more striking and picturesque point of view, the latter is closer to fact and truth. Colonel White, writing in 1844, in his interesting book, *Three Years in Constantinople,* which such a competent authority as Sir Henry Layard pronounced to be the best work on Turkish life, said, that if a certain policy were pursued, "fifty years cannot elapse ere travellers will flock to Constantinople in search for

A WET DAY ON THE GALATA BRIDGE

The men in long, white pocketless coats stationed at
either end of the bridge collect the toll levied on
every man, beast, and vehicle using the bridge—
professional beggars alone being exempt

relics of Moslem institutions with as much eagerness
as they now seek for vestiges of Christian or Pagan
antiquities. " It would be an exaggeration to say
that this prophecy has been literally fulfilled. But
events have verified its forecast to such an extent,
that one is tempted to assume the prophet's
mantle, and predict that Colonel White's words
will come to pass in the next half-century. At any
rate, if the world here has moved slowly, it has
moved very far. The descriptions of Constantinople
in such works as Miss Pardoe's *City of the Sultan,*
and Colonel White's *Three Years in Constan-
tinople,* seem to-day descriptions of another city.

In the political situation, in the matter of
education both among the Turks and the Christian
populations, the changes are simply enormous.
This is, however, not the place to expatiate upon
these serious topics, although it is only by their
consideration that the greatness and far-reaching
consequences of the new state of things can be
properly appreciated. But look at the change in
the matter of dress. Where is now the variety of
costume, where the brightness of colour that made
the movement of the population at all times a
procession in gala dress? So far as her garb is
concerned, a Turkish woman to-day is a sere and

withered leaf. She is almost a European lady, thinly disguised. And where are the men who moved about, crowned with turbans, and attired in long, coloured, flowing robes? You meet them occasionally on the street, or see them gathered about the mosques, weary and tattered stragglers of generations of men, whose mien and gait were the look and motion of princes. Some one has said that the Turks committed a great mistake when they adopted the European dress; for the change makes you suppose that they have ceased to be Orientals, and are to be judged by European standards in all respects. Too much is therefore expected of them. Certainly the change has not improved their appearance. It has robbed them of that quiet dignity and commanding air which imposed immediate respect. The eagle is shorn of his plumes.

The Turkish pasha, for instance, is now a shadow of his former self. What a master of men he looked when seated on a fine Arab horse and glittering saddle-cloth, he rode slowly through the streets, accompanied by a retinue of servants on foot, the crowd making way for him to pass as though a king went by. What an incarnation of dignity he was when he floated on the Bosporus

IN THE GRAND BAZAAR

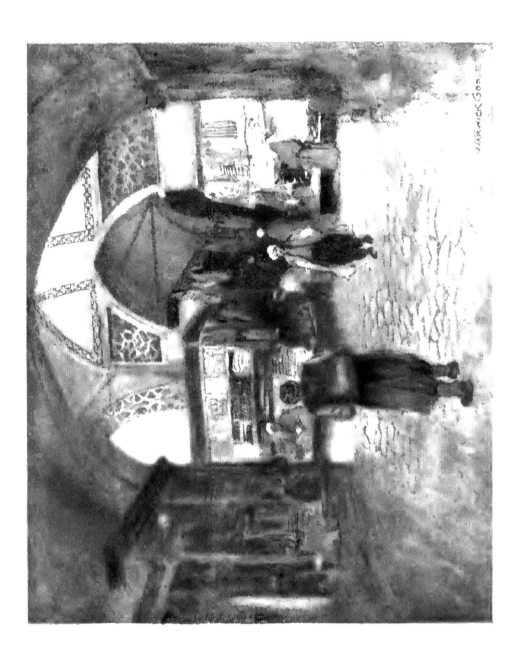

in a caique of five pairs of oars, two servants
squatting in front of him, with folded hands, in the
bottom of the boat; his pipe-bearer, behind on the
poop, ready to present him with a long-stemmed
pipe of cherry or jasmine wood, surmounted by an
amber mouthpiece, adorned with diamonds. With
the disappearance of such things, there has been
a sensible weakening of the awe which the ruling
race excited in the rest of the population. If any
one wishes to experience the fall, so to speak, in
the temperature of the feeling of awe produced by
the change from an Oriental to a European garb let
him visit the Museum of the Janissary Costumes.
What terror those costumes must have inspired!
Or let him visit the Imperial Treasury in the
Seraglio, and walk down the line of lay-figures
attired in the costumes worn by successive Sultans.
The eye pays instant homage to every master of
the Ottoman Empire clad in native apparel. But
when the figure of Mahomet the Reformer, who
swept away the janissaries and other old institu-
tions, is seen dressed in European clothes (except
for the red fez), one reads there the sign that
the glory of the House of Othman was on the
wane. The dread and majesty by which the Turk
was formerly hedged round have vanished.

Within the memory of men still living, eunuchs carried swords to chastise indiscreet admirers of Oriental beauties, and did not hesitate to slash a European guilty of casting long, lingering looks upon the fair faces. It was forbidden, within days that one recalls, to pass the imperial palace on horseback or with an umbrella opened. So strictly was the rule enforced, that even the "Great Elchi," Sir Stratford Canning, riding by the palace, was once compelled to dismount from his horse. This proved too much for the great man. Furious at the indignity, he sent instantly for his dragoman, demanded an immediate audience of the Sultan, and obtained the order which put an end to the humiliating custom.

It is not, however, among the Turkish population alone that a marked change in dress has occurred. Within the memory of living persons, Armenian and Jewish women appeared in public wearing distinctive veils. Baggy trousers, head-kerchiefs, striking colours, embroidered jackets, turbans, were in vogue among the non-Moslem inhabitants, making the scenes in the streets kaleidoscopic, and furnishing also a ready means whereby to identify the nationalities that seemed inextricably mingled together. It is surprising how a resident

A FORTUNE-TELLER

In Stamboul, on the way to the Sublime Porte, an old negress may often be seen telling fortunes by means of coloured beads and shells

of Constantinople can recognise the nationality of the peoples he meets, even since a common style of dress has come into fashion. But in days not very remote, every native wore his country upon his sleeve. His costume was the badge of his race and people. Now, the order of the day is "à la Franca."

Again, what a change has come over the style of building in the place. The palaces of the Sultan are on European models.

The day has vanished, when to go up or down the Bosporus was to move through a scene in which the charms of nature were heightened by the fascinating primitiveness and fancifulness of the Orient. The large old-fashioned Turkish house, almost nothing but stories of windows, painted deep red, or left to assume the natural grey of the wood, with broad eaves under which small attic windows, filled with little diamond-shaped panes of glass nestled, have disappeared, or are fast falling into decay. Venetian shutters are replacing the latticed screens, which invested a Turkish home with so much mystery ; conservatories have taken the room of the old green-houses of orange-trees and lemon-trees. And, worst of all, boats of European form are supplanting the caique, so light, so graceful,

26

floating upon the water like a seabird, and making
the Bosporus seem a stream in fairyland.

Nowhere, perhaps, is the mark of change more
evident than in respect to the means of communica-
tion, whether in the city or on the straits. Long
lines of tramways run from the Galata Bridge to
the Golden Gate and the Gate of S. Romanus,
from one end of Stamboul to the other. Along
the railway that forms the highway to Europe,
there are five stations within the city limits for the
accommodation of the districts beside the track.
The sedan chairs in which ladies were usually
carried, in making calls, are now occasionally
employed to convey them to and from evening
parties. The groups of horses standing at con-
venient points in the great thoroughfares to carry
you up a street of steps or to a distant quarter, with
the surudji, switch in hand, running beside you to
urge the animal onward and to take it back at the
close of your ride, have given way to cabstands, and
to a tunnel that pierces the hill of Galata. A
tramway carries one through Galata and Pera as
far out as the suburb of Chichli, while another line
runs close to the shore from the Inner Bridge to
Ortakeui. There are persons still living who remem-
ber the first steamer that plied on the Bosporus, in

STREET SCENE, TOP-KHANEH

Top Khaneh is a continuation of Galata

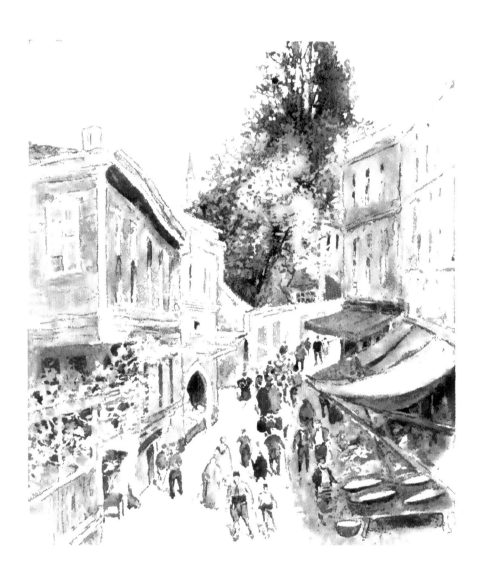

the forties of last century. Its main occupation was to tug ships up or down the straits ; but once a day, in summer, it conveyed passengers between the city and the villages of Therapia and Buyukderé. A second steamer soon followed, and charged eleven piasters for the trip each way. Owing, however, to the opposition of the caiquedjis, the steamer could not moor at the quay, so that passengers were obliged to embark and disembark at both ends of the journey in caiques, at the rate of one piaster each way. Thus a return trip, which now costs one shilling and eight pence, involved an expense of four shillings and four pence.

No one, of course, undervalues the advantages of steam navigation, or suggests a return to sailing ships. At the same time it remains true, that never again will men see the Bosporus so beautiful as it looked in days when its waters were untroubled by steam. Owing to the prevalence of northerly winds in these regions, ships bound for the Black Sea were liable to long detention on their way up from the Mediterranean. Great fleets of merchantmen were accordingly apt to collect in the Dardanelles and in the Golden Horn, waiting for a favourable breeze. They had sometimes to wait six weeks ere they could stir. When at

length the south wind did come, every stitch of canvas the ships could carry was unfurled, and an immense procession of winged sea-coursers and chariots rode through the Bosporus day after day so long as the south wind blew. In an hour, a hundred, two hundred, vessels might pass a given point, all panting to reach the open sea before the wind failed, and racing one another to get there first. Ships of all sizes and of every form, European and Oriental, sails and rigging of every style; huge three-masted merchantmen, "signiors and rich burghers on the flood," schooners, brigs, barges, caiques, "petty traffickers," with their white wings stretched over the blue waters, from one green bank across to the other, flew before the wind, and formed a spectacle solemn and stately as a royal or religious ceremonial. It was a magnificent scene of colour, motion, and variety of form; of eagerness and achievement.

When we think of the means of communication with the outer world, the change is extraordinary. For the voyage from England to Constantinople a sailing vessel took usually thirty to sixty days. It might be even three months, as an Englishman still living in the city found, in 1845, in his own case. To-day one travels by rail to London in three and

a half days. Letters from England took ten days.
There was a weekly European mail *viâ* Trieste,
and three times a month *viâ* Marseilles. Now, a
European mail arrives daily. The postage on a
letter was 1s. 4d. where now it is 2½d. It is
impossible to exaggerate the influence upon the
life of the place due to this close connection by
steamship and by rail with the Western world.
The Ottoman authorities were not altogether
mistaken, from their point of view, when they
looked with disfavour upon the junction of the
railroads in Turkey with the European railway
system. That junction, it was thought, would
facilitate the military invasion of the country.
But ideas travel by rail, as well as soldiers. And
the invasion of a country by new ideas may have
consequences as formidable and far-reaching as any
that arms can introduce. The completion of the
railroad between Constantinople and Vienna in 1888
may be regarded as the conquest of the city by
foreign thought and enterprise. Little, perhaps,
did the crowds, that gathered at the Stamboul rail-
way station on the 14th of August in that year
to witness the arrival of the first train from the
Austrian capital, appreciate the significance of
that event. But it was the annexation of Con-

stantinople to the Western world. New ideas, new fashions now rule, for better and for worse. And soon the defects and the charms of the old Oriental city will be a dream of the past.

Owing to the narrowness and steepness of the streets of Constantinople, the transportation of heavy loads through the city by means of wheeled vehicles has always been a difficult, and often an impossible, undertaking. Much has been done in recent years to widen and grade the chief thoroughfares. The authorities are even accused of having occasionally secured that improvement, by setting fire to the houses along an old narrow but picturesque lane in order to take advantage of the law, that when a house is rebuilt the municipality has the right to appropriate a part of the old site to broaden the public way, without giving compensation to the owner of the ground. Moreover, during the Russo-Turkish War of 1876-77, the Moslem refugees from Bulgaria introduced the use of a rough four-wheeled cart drawn by one horse, and that conveyance is now extensively employed. The old-fashioned, long, narrow, wagon drawn by a pair of oxen or buffaloes, so primitive that it might be a wagon which the Huns left behind in their march through the land, still crawls

A SIDE STREET

A typical street in the old Turkish quarter, the houses are built almost entirely of wood, brilliantly painted, and hardly two in the street are on the same level, the lattice work at the windows indicates the women's quarters

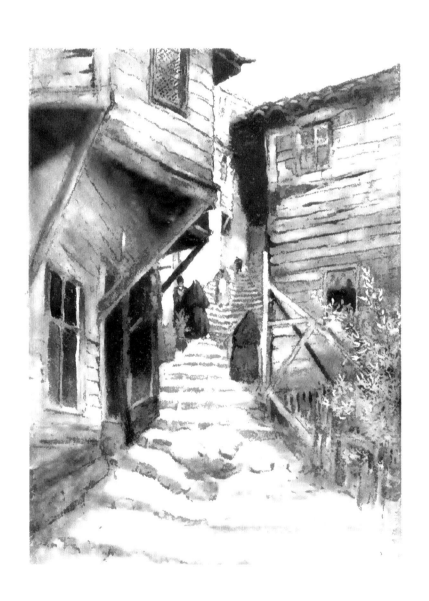

and creaks under a pile of the household furniture of a family removing from one house to another, or from town to country, or from country to town. But the means of transportation most characteristic of the place are the backs of animals and of men. To an extent seen nowhere else, at all events, in Europe, the streets are obstructed by long trains of donkeys and horses carrying planks, or stones, or lime, or bricks, to some building in course of erection, or hurrying back from it for fresh loads. It is, however, in the employment of human beings as beasts of burden that Constantinople excels.

The traveller soon makes the acquaintance of these hamals, as they are called, upon his arrival, whether by sea or by land, and beholds with surprise that, while he drives to his destination in a cab and pair, his luggage is perched on the broad back of a fellowman, and proceeds thither, so to speak, on foot. And the surprise grows into wonder at the number of articles and the weight which can be put on that stooping figure. In the affairs of residents, hamals occupy an important place. No business at the Custom House can be done without their assistance. They carry the merchant's goods to and fro. They bring your charcoal, your coal, your wood, your stoves, your piano, your chest

of drawers, every heavy piece of your furniture.
They chop your wood, and store it in your cellar.
They will even carry a child in their arms up a hill
or to a distant house, as tenderly as any nurse.
Sometimes a poor sick man is taken on a hamal's
back to the hospital. To relieve the pressure of
his loads, a hamal wears a thick pad on his back,
suspended from the shoulders by straps through
which he passes his arms, and curved upwards at
the lower end to furnish a hollow in which his
burden may lodge. Thus equipped, he stoops low,
as a camel does, for friendly hands to load him ;
a cord, by which he may steady himself and keep
what he carries in position, is then passed round
his burden and given him to hold, and thereupon
he rises slowly and moves off. When a street is
unusually steep, it is customary to place, at con-
venient intervals, a series of large stones or small
platforms, upon which a hamal may rest his load
without removing it, and take breath for a few
moments. To provide stones of rest for these
burden-bearers is considered a pious act. When
the load is too heavy for one man, it is slung upon
a long ashen pole and given to a couple of hamals
to carry, by placing the ends of the pole upon their
shoulders. In the case of still heavier weights,

SIMIT-SELLER

When moving about he carries on his head his tray balanced on the red pad resting on his turban

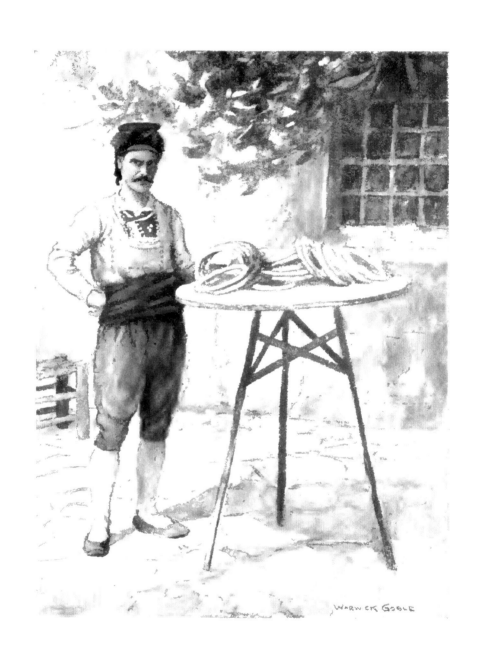

four, six, or eight hamals perform the task in a
similar way. The load is then attached to as many
poles as are required ; the men, ranged both in
front and in the rear in an oblique line, put the
ends of the poles on the left shoulder, and the
right hand, where possible, upon the shoulder of
the comrade to the right ; and thus bound and
locked together the band swings forward, shouting
Varda. Many a person turns round to watch the
fine stalwart figures bearing off their burden, like a
trophy in a triumphal march.

The hamals are not natives of the city, but
come from various districts of Asia Minor. They
form part of that numerous body of men in Con-
stantinople who have left their homes and families
in the interior of the country to find work in the
capital for a term of years, in order to support
their parents, or their wives and children. It is a
practice due to the scarcity of work in the interior,
and a considerable portion of the money thus
earned is sent home to pay the taxes for which
the relatives there are a security. At intervals of
five, or even ten years, these men make a long
visit to their homes, and then return to their work,
until they become too old for it, or have earned
enough upon which to retire. They generally own

27

a cottage and a field, property sufficient to afford
the family the bare means of existence, and to
furnish a convenient retreat at last for the weary
bread-winner at his final home-coming. An igno-
rant, stubborn lot of men they may be, but their
simple lives, their hard labour, and the frequency
and fidelity with which they serve you, give them
a place among the kind memories of a resident in
Constantinople.

A company of hamals, generally natives of the
same district or village, acquire the monopoly of
carrying loads in a particular quarter or suburb
of the town. One of their number acts as their
chief, and it is through him that arrangements
with them for work are made. All earnings are
put into a common fund, and divided fairly
between the members of the society. The various
companies of hamals are as jealous of their claims
upon a particular locality as are the dogs of the
quarter. They may carry a load in a district not
their own, only if the load is taken up first in their
own quarter. Any attempt to commence work in
another company's territory results in a fierce fight
between the parties concerned, and exposes the
articles in dispute to serious damage. The Moslem
hamals are very attentive to their religious duties.

It is often impossible to get them to attend to your wants at the hours of prayer.

At one time, by far the larger number of hamals employed in the city were Armenians. Those of them who were attached to merchants' offices, as caretakers and confidential messengers, were renowned for their fidelity and honesty. Any sum of money could be entrusted to their keeping with absolute safety. Since the massacres of 1896, when this class of the Armenian population was the object of special attack, and was almost exterminated, the hamals of the city are chiefly Kurds. It took some time for the newcomers to learn their duties, and merchants were seriously inconvenienced by the consequent accumulation of their goods at the Custom House, and the slowness of delivery. But, to all complaints on the subject, the authorities, as though the injured parties, returned the characteristic reply, "Why do you bring so many goods?" Armenian hamals used to have one great holiday in the year—Easter Monday—which they spent in dancing together, in their best garb, on a great mound of rubbish beside the military parade ground at Taxim. On their return, through the Grand Rue of Pera, "it was not uncommon to see a band of them,

carrying their long, massive poles, heaving with every appearance of intense strain and fatigue; the burden hung in the centre—an egg!" With the growth of a higher sense of human dignity this species of a beast of burden will become extinct.

To omit all reference to the dogs of a city which has been styled a "dog-kennel" is impossible, however well worn the theme may be. They are one of the prominent features in the street-scenery of the city, and attract the attention of all travellers. Along with other "improvements" their number has been greatly diminished during recent years, but they are still in evidence in every thoroughfare of the place. Tawny in colour, with a furry coat, bushy tail, and pointed ears, they betray their relationship to the wolf and the fox, although the hardships of their lot, and still more the indulgence with which they are treated by a large part of the population, have taken almost all their ferocity out of them, except in their treatment of one another. They are the assistant-scavengers of the city, eating the pieces of food found in the rubbish, which, after an old custom not yet obsolete, is still too often dumped into the street by the inhabitants at night, for the official scavenger to remove in the morning.

MARKET AT SCUTARI

It is always market-day somewhere in Constantinople

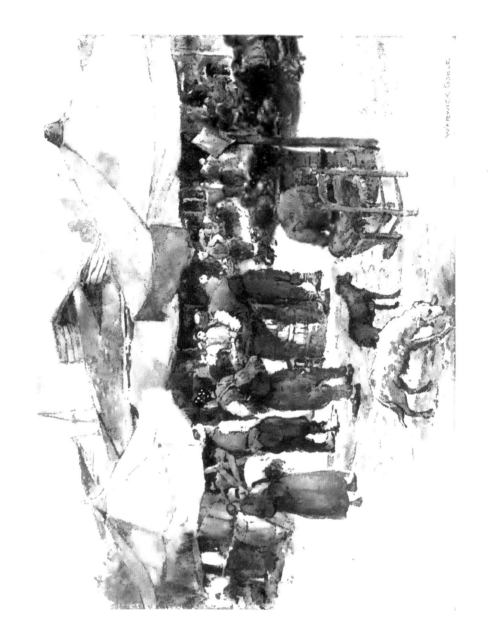

WARWICK GOBLE

To some extent they act also as watchmen, making night hideous with their barking.

For these purposes they divide the city between them; so that the different quarters of Constantinople are respectively the special domains of different companies of dogs, who guard their boundaries as jealously and fiercely as any frontiers between rival nations. No sooner does a strange dog enter a canine ward than his arrival is signalled by a peculiar bark from a faithful defender of the rights of the invaded district. The bark is echoed from member to member of the injured community, until the whole pack is roused, and rushes upon the intruder like a horde of savages, biting and worrying him beyond the bounds he transgressed in an evil hour. Hence it is extremely difficult to take your own dog out for a walk in the streets of the city. A deafening uproar greets you from every community of dogs through which your road passes. You must hold your companion in leash; you must be on the alert, whip or cane in hand, to strike at the infuriated beasts that spring with flashing teeth at him from all directions; and if you are fortunate enough to get your dog safely through the fight, it will probably be owing to the courtesy of some sympathetic onlookers who

came to the rescue in your extremity. When such an encounter occurs on an open road with wilder dogs, the scene may prove a battle royal. In that case the most effective way of driving your assailants off is to throw stones at them, of which they are more afraid than of any stick in your hand. Sometimes even the gesture of stooping to pick up a stone will suffice to put the enemy to flight, yelping with imaginary pain. In view of this state of things among the dogs of the city, a Turk, wishing to say that a certain person is not of his "sort," puts the case in the clearest and most scathing light by the simple remark, "He is not a dog of my quarter."

The dogs are treated very kindly by the Moslem population. Large companies of them encamp near barracks and guard-houses, certain to find friends among the soldiers, and to share their rations. They will gather about the shop of a baker or of a butcher, or wander like beggars from one such place of entertainment to another in their district, sure they will not be left to starve. There is a racy Turkish proverb based upon this habit of dogs to sit in a row before a butcher's shop, expecting scraps of meat. It is pointed against idlers who are waiting for something to turn up, and runs to the following effect, "If looking on were enough

ENTRANCE TO A TURKISH KHAN

The Khans formerly used by travelling merchant
with their laden camels are now almost entirely used
for offices and warehouses

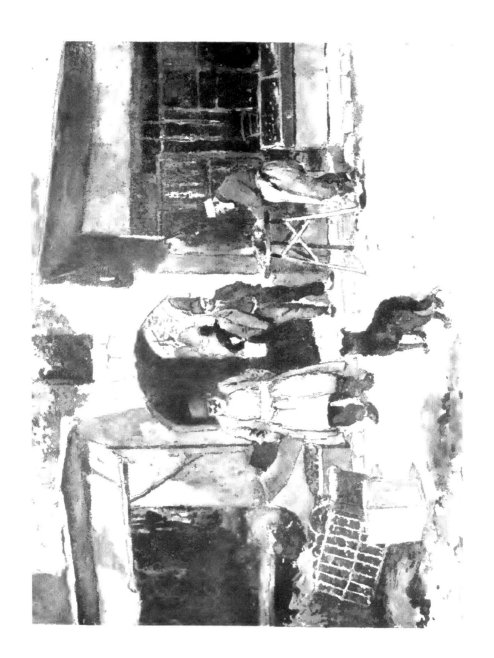

to get on, dogs would become butchers." It is not rare to see Turks purchasing a loaf and distributing it among a company of dogs. Sometimes a dog will take his stand near a baker's shop, and at your approach will place himself at your feet, and with beseeching eyes appeal to your generosity to buy him some bread, wagging his tail in gratitude for the anticipated favour. There are dogs who come to an understanding with a family of their acquaintance as to the most convenient time to call for food, and who, at the appointed hour, tap at the door of their host's house for the promised meal. It is common to see at the door of a Turkish house an earthen jar, or an old petroleum can, half sunk in the ground, and kept filled with water for the dogs; and there is a low drinking-trough, for the benefit of the poor creatures, at many of the public fountains in the city. Frequently also, one sees a bed of straw provided for the comfort of a mother dog and her litter of puppies.

The idea of killing a dog is shocking to a Turk's mind. In his opinion, it is sinful to do so. At one time, a dog in the village of Roumeli Hissar upon the Bosporus became exceedingly dangerous. Not content with keeping stray members of his

own race off his ground, he snarled and showed his
teeth at every decent person who crossed his path,
until at length a European resident, losing patience,
drew a pistol and fired upon the obnoxious animal.
The shot missed, but the gentleman who had fired
it was guilty of a double offence. He had broken
the law forbidding the carrying of firearms, and he
had attempted the life of a dog. The culprit was
instantly surrounded by a fierce mob, arrested by
the police, and taken to the village prison. As
strong influence could be secured for his protection,
his case was easily settled. But the question how
to deal with the dog was a more difficult matter to
arrange. Neither arguments nor backsish could per-
suade the police to kill the dog. The utmost the
guardians of the public safety would do was to trans-
port him to the opposite side of the Bosporus, and
consign him to the tender mercies of the inhabitants
of that shore ; and this would be done, only if the
aggrieved party would defray the expense involved
in executing the decree of banishment. A change
of domicile from Europe to Asia, or from Asia to
Europe, is the most usual remedy applied, when
dogs show bad temper or become too numerous
for the happiness of a particular locality. It is a
remedy, however, that provokes a policy of retalia-

TURKISH WELL, STAMBOUL

The water supply is obtained by means of the primitive pump at the side of the stone tank, the rod attached to the crossbeam is pulled downwards to work the pump

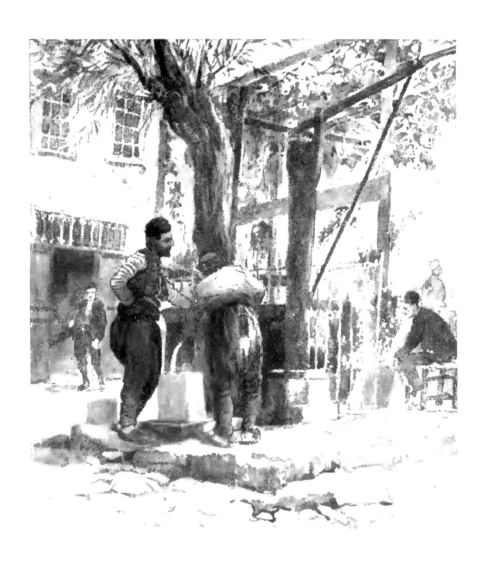

tion, and induces a return of the evil in some analogous form.

Notwithstanding all this kindness, dogs are held in great contempt. They do look a disreputable lot. There are not many grosser insults in Turkey than to call a man "a dog" (kiopek), or to dismiss him with the ejaculation, "ousht," the term employed in driving a dog away.

Among the objects which attract attention, as one moves through the streets, are the public fountains scattered over the city. They are found everywhere, and are often remarkable for their architectural beauty. Their number is explained by the fact that the old system of water-supply did not bring water into the houses, but only to the different quarters of the city, thus making it necessary to have, at convenient points, outlets from which the inhabitants could obtain water, either by coming to draw it for themselves, or by engaging the services of water-carriers. However inconvenient this arrangement may seem, it was always a pleasing sight to see groups of women and children gathered towards evening about the fountain (Tchesmè) of their district to fill graceful, bright-coloured pitchers at the gushing faucets, and then to wend homewards. It took one far back

28

in the ways of the world, and was a bit of the country in the town. Nor are the faithful water-carriers (sakka) forgotten, who brought water in great leathern vessels, shaped like a blunderbuss, hung horizontally by a strap from the left shoulder, and who poured the contents into a large earthen-ware vessel within your house. The aqueducts of Valens, Justinian, and other Byzantine Emperors, as well as the Basilica Cistern (Yeri Batan Serai) still act their part in furnishing the city with water. Until recently, the only other source of water-supply was either rain-water led from the roof into a cistern built under the house, or water brought in barrels from springs in the surrounding country. The introduction of water from the Lake of Derkos, which lies close to the Black Sea, to the west of the Bosporus, has been a great boon to the city, but it is not in favour for drinking purposes.

The most interesting fountains are those known as Sebil, generally pious foundations, and next to the mosques and turbehs, the best specimens of Oriental Art in the city. The finest example of this form of fountain is the well - known Fountain of Sultan Achmed III. (1703-1730), which stands to the east of S. Sophia, near the

A FOUNTAIN BY THE BOSPORUS

In this form of fountain the tank is enclosed within
four marble walls and roofed over

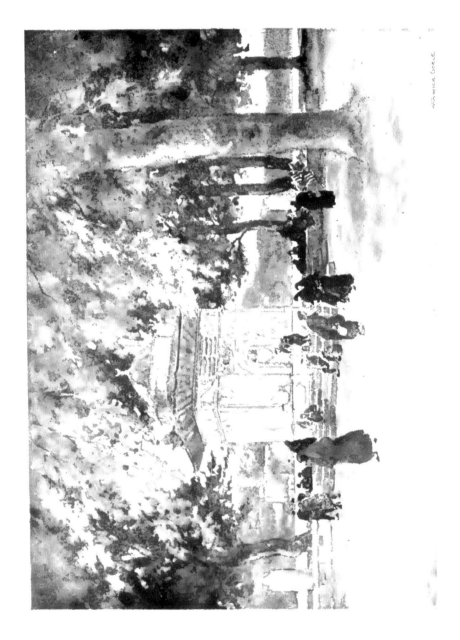

WARWICK CASTLE

Grand Entrance to the Seraglio, and which was de-
signed by that Sultan himself. The fountains are
polygonal chambers ; with broad, brightly-painted,
wooden eaves ; with sides of gilded open iron work,
or of marble slabs, over which carved flowers and
fruits are spread in profusion ; and, often, sur-
mounted by fantastic little domes. Within, is
found a tank from which a man keeps full of water a
number of metal cups, attached by chains to the iron
work, but accessible, through the openings in it,
to every thirsty wayfarer, without money and with-
out price. The living, personal, human element in
this mode of distributing water is as impressive as
the fairy form of the monument. Furthermore,
water-carriers, paid from the funds which endow
a fountain, go about the streets to give "the
water of life" freely to any person who asks for it.

To erect a public fountain is a very usual
form of public benefaction among Moslems, and is
regarded as highly meritorious. It is common to
find, in the garden wall of Turkish mansions along
the Bosporus, a fountain opening on the side of
the quay for the relief of any passer-by, and
especially of boatmen, who come on shore to tow
their craft against the current. To repair a foun-
tain is also a work of merit ; an idea that, on one

occasion, gave rise to a curious incident. The fountain in a certain Turkish district, although very much the worse for use, was for some reason left neglected by the community. Whereupon a Christian neighbour proposed to put the fountain in order at his own expense. The offer was welcome, but it raised a difficult question. Would the original Moslem builder of the fountain not lose the merit of having constructed it, if his work were restored by a Christian? Would the Moslem community in the district not lose merit, for allowing the fountain to be repaired by an alien in creed? And so the matter was laid aside for consideration. At last it was settled to the satisfaction of all parties on the following understanding. The Christian might be allowed to execute the necessary repairs, if he renounced any merit for doing so, and agreed that all the merit of the good deed should belong to the original Moslem builder of the fountain. To this way out of the difficulty, the Christian had no objection, and, after signing a legal document to that effect, he was permitted to carry out his kind intention.

Turks are extremely particular in regard to the quality of the water they drink, and are willing to be at much trouble and expense to obtain water

of the kind they prefer. To be a perfect beverage, water must issue from a rock, fall from a height, be of medium temperature, flow rapidly and copiously, taste sweet, spring in high and lonely ground, and run from south to north, or from east to west. The excellence of any water is accordingly determined by the number of these conditions it fulfils. It is remarkable how much pleasure Turks find in visiting a famous spring in the country, to spend the whole day beside it, under the shade of trees, doing little else but drink carafe after carafe of the water, as the elixir of life. Resorts of this description abound on the shores and in the valleys of the Upper Bosporus, under such names as "The Water of Life," "The Silver Water," "The Water under the Chestnut Trees," "The Water beside the Hazels." The spectacle of the great gatherings there, on Fridays, arrayed in bright colours, seated tier above tier on the terraced platforms built against the green slope of a hill, the women above, the men below, all in the deep shade of branches meeting overhead, forms a picture beyond a painter's power to reproduce.

In this connection may be mentioned also the attractive little scenes upon which one comes frequently in walking through the city—quiet

nooks, a little off the great thoroughfares, with a vine or westeria spread on a trellis across the street for an awning, and a group of humble workmen, seated on low stools at the door of a cafeneh, sipping tiny cups of coffee, drinking water, smoking the narghileh, too happy to speak much. Occasionally, the court of a small khan, or a portion of a large court, is thus canopied by a trellised vine, making an oasis in the desert of lowly toil.

OPEN-AIR CAFÉ STAMBOUL

Smoking the narghileh and drinking coffee occupy
large part of the Turk's time

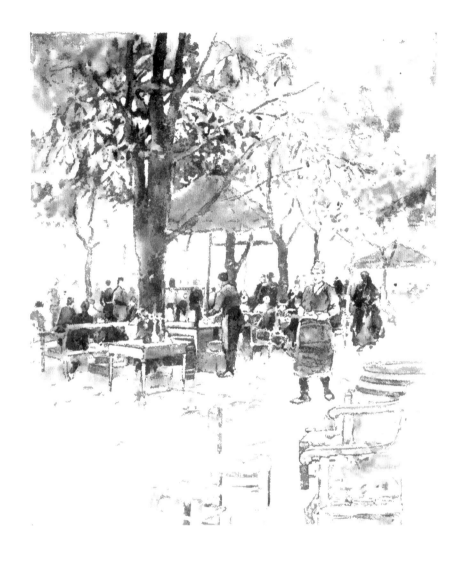

CHAPTER XI

ANOTHER striking feature in the life of Constantinople is the extent to which life here has a religious colouring. The Turkish State is a theocracy. Its supreme law is a code reputed to be Divine. Citizenship is secured by the profession of a particular religion. Obedience to the law of the land is obedience to the will of God. The defence of the State is the defence of a faith. Patriotism is piety. To die in battle is to belong to the noble army of martyrs. The cemetery on the hill above Roumeli Hissar is known as "The Field of the Witnesses" (Martyrs), because the resting-place of soldiers who died while Mehemet the Conqueror was building, in 1452, the castle which should command the passage of the straits, and cut the communications of the city with the lands around the Black Sea during the forth-

coming siege, "when the bud would open into flower." The picturesque cemetery, shaded by oaks, on the hill above the Genoese Castle, over-looking the entrance to the Black Sea, a view that Darius I. and Herodotus came to admire, is also named "The Field of Witnesses," because there, it is supposed, Saracen soldiers who fell in an attack upon the castle were buried. Such cemeteries are holy ground, and sepulture in them is regarded as a great honour. The attendance of the Sultan at the midday public prayers on Fridays is the official act of the Caliph of the Mohammedan world. He ascends the throne after girding his sword at the grave of the first standard-bearer of the Prophet, in the Mosque of Eyoub. The mantle of the Prophet, his green standard, his staff, sword, bow, are enshrined in the Seraglio as the sovereign's regalia, and are annually visited by the Sultan as a great State function. Around that standard all true Moslems must rally when Islam is in peril. No great act of Government may be performed until the chief doctor of the Sacred Law, the Sheik - ul - Islam, has been consulted, and sanctions the act, as in accordance with the supreme authority of faith and righteousness. Sultan Abdul Azis and his nephew, Sultan Murad,

ROUMELI HISSAR

One of the towers of the old Turkish castle built by
Mehemet II ("The Conqueror") The distant hills
seen across the Bosporus are on the Asiatic coast
The Judas tree in full bloom is a prominent feature
in the spring

were deposed only after such sanction had been obtained.

Upon this theocratic conception of the State, the exclusion of the Christian subjects of the Empire from the army is based. For, how can aliens in religion be enlisted under the banner of the Faith? Hence the institution of the janissaries in the early history of the Ottoman Power, whereby children of Christian parentage were taken from their homes and brought up as Moslems, to furnish recruits for the army. It was an ingenious device to maintain the religious character of the military force of the Empire, and yet to prevent the burden of filling the ranks from resting exclusively upon the faithful. The abolition of the child-tax, however fortunate to others, proved a great injury to Turkey. It not only deprived the Sultans of their finest troops, but has been one of the principal causes of the great decrease in the Moslem population of the country; as that class of the community alone has since been called to sustain the losses involved in military service. The mortality among the soldiers of the Turkish army from disease and war is so great that the Moslem population is rapidly dying out, and well-informed medical experts are heard to say, "The Eastern Question will

29

be solved by the disappearance of the Turks in the natural course of things."

The theocratic character of a Moslem State facilitates, indeed, the incorporation of different races in the same social and political system, seeing that all distinctions between men are obliterated by community in the faith of Islam. And it is impressive to see how closely the Mohammedan world, though not free from sects, is knit together by religious principle, and how strongly it cherishes the brotherhood of believers. In it, not in theory only but also in practice, the black man and the white man are fellow-citizens and of the same household. But on the other hand, because of its theocratic constitution, it is impossible for a Moslem State to accept reforms which seek to secure equality of rights among its subjects, on the ground of a common humanity. Nothing is more opposed to the deepest convictions of a genuine Moslem than the idea that men of a different faith from his own can be his equals. There is no one who can be more polite than a Turk; no one who can treat you in a more friendly and flattering manner than he. Yet persons who have known him well, nay, who have loved him, testify that even in the relation of private friendship they have

never felt that a Turk had given them his whole
self, but was a friend with reservations that
might lead him to act toward you in the most
unfriendly manner. His religion confers on him
an inaccessible superiority, from which he cannot
descend without becoming a faithless son of Islam.
His interests are superior to those of an infidel.
He is a religious aristocrat, and no patrician of
old or of modern days has resisted the demands of
plebeians or commoners for equality more obstin-
ately or strenuously than a Moslem opposes the
pretensions of unbelievers to be placed on a parity
with him. In the case of the patrician, it was a
matter of pride; with the Moslem, it is a case of
conscience. Though it may seem a small matter,
it is a significant fact that a Turk can wish the
salutation of peace only to a fellow-Moslem, and
that in the exchange of courtesies with persons not
of his faith he expects to be saluted first. Rather
than admit equality in any real and absolute sense,
it would seem as if the wreck of the Empire were
preferred—"faithful unto death."

The outward forms of Mohammedanism are ex-
ceedingly impressive. The muezzin's call to prayer
—at dawn, at noon, in the afternoon, at sunset, and
three hours later at night—floats through the air

like a voice from the upper world. No music of
bells evokes such a sense of the Divine Majesty as
his proclamation, "God is Great, there is no God
but God." However grand or however humble a
mosque may be, whether frequented by the most
intelligent or the most ignorant of the people, it
contains nothing that tells of superstition, nothing
that belittles or lowers the conception of the Most
High. One can understand why, when Islam and
Christianity confronted each other in the Byzantine
Empire, there were emperors who, for upwards of
a century, strove to banish pictures and statues
from the worship of the Church. And where is the
reverence of the human soul before God expressed
so utterly, as when the Moslem worshipper, washed
clean, with shoes off his feet, stands, bows, kneels,
prostrates himself before his Maker, in silent prayer?
There is no more impressive religious service in
the world than that celebrated, under the dome of
S. Sophia, on "The Night of Power," in the season
of Ramazan. Under the dim light of hundreds
of small, hanging lamps, fed with oil, as in days
past, ten thousand men are then gathered upon
the floor of the mosque for evening worship, their
hearts stirred by the associations of the sacred
season. It is essentially a service of silent prayer.

A HOWLING DERVISH ('LA ILAH ILLA LLAH')

The howling dervishes perform their devotion by standing in a row and repeating the confession of faith, ' La ilāh illa 'llah, rocking themselves backwards and forwards meantime, beginning slowly, they gradually quicken the time and work themselves into a frenzy of religious excitement.

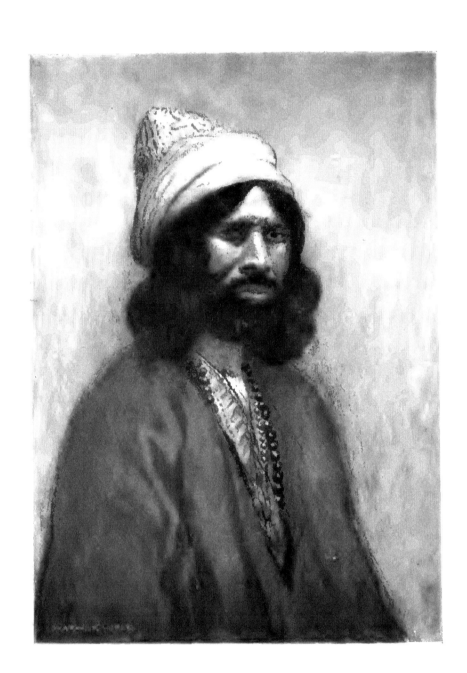

The silence is made only the more impressive by the brief chant or vehement ejaculation that occasionally breaks the stillness, to afford pent feelings some relief. But though dumb with awe, the multitude cannot rest. The emotion is too strong for complete suppression, and the vast congregation heaves to and fro, rises and falls. It stands upon its feet, bends low, sinks to the floor, kneels, prostrates the head to the very earth, filling the great church with a sound as of distant thunder, or the sea breaking upon the shore. It is a scene of intense humility and veneration. And yet it is so grave, so quiet, so controlled, that the dignity of the worshippers is never lost. It is the homage of the great to the Greatest. It is a remarkable combination of reverence and of self-respect. Except in the practices of certain orders of dervishes, the Howling Dervishes for instance, nothing in the attitude of a Moslem at his devotions betrays an overpowering feeling due to the weakness of human nature. The consciousness of belonging to the *élite* of the religious world, the sense that the worship is paid to the One, True, Great Allah, beside whom there is no other God, and that it is offered in a form worthy of the Divine nature, inspire an elevation of soul like the pride of great

nobles in the presence of a mighty over-lord. A devout Moslem is an aristocrat to the tips of his fingers.

Partly because of the natural reserve of Moslems in speaking with Christians on religious matters, and partly on account of the influence of the social institutions, which Moslems have inherited from an inferior stage of civilisation, it is exceedingly difficult to determine the ethical power of Islam in the inner life of its adherents. Perhaps the following remark, made by an intelligent Mohammedan to a Christian friend, gives a glimpse into the spirit of the system. "Christianity is perhaps the best religion, but it is too high for frail human beings. Therefore God, in His mercy, has given us another religion, Islam, which, if not so lofty as yours, is more easy of attainment and practice." Certainly, the distinction of Islam is the force with which it insists upon the unity, spirituality, and greatness of God. A dogma, not a moral ideal, is its chief concern. Nevertheless, although the system does not develop the loftiest character, it does secure a demeanour that commands respect. The submission to the Divine will, which it inculcates, may have its defects ; but it has likewise its merits. If it saps energy, it fosters seriousness, calmness of spirit amid

WHIRLING DERVISH

Member of a religious order whose particular act of
devotion consists in whirling round on the toes until
completely exhausted, the object being to produce
a trance-like condition during which the mind is
entirely withdrawn from material surroundings.

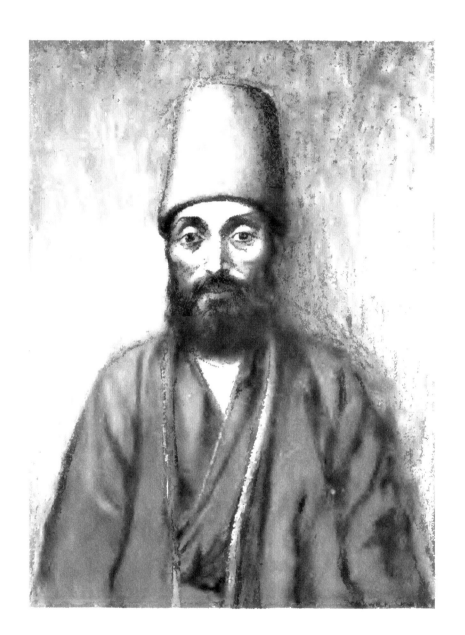

life's vicissitudes, and a dignified acceptance of the inevitable. If Islam fails to inculcate disinterested virtue, or to inspire goodness on a grand scale, it urges the performance of many beautiful deeds of kindness.

Almsgiving is one of the great duties incumbent upon a Moslem. During Ramazan and the two festival seasons of Bairam, tables are set in the houses of the wealthy classes, to which poor neighbours are made welcome. Groups of beggars gather then about the houses of the rich to receive liberal portions of pilaf, and meat stewed with vegetables, besides a present of money or some article of dress. Connected with the principal mosques of the city, there are endowed soup-kitchens (Imarets), at which, along with the softas and imaums of the mosque, the poor of the district can obtain soup every morning, and once a week pilaf and zerdé (sweetened rice, coloured yellow with saffron). During Ramazan, pilaf and zerdé are supplied every evening. The lame, the blind, the halt, are usually allowed to cross the bridges over the Golden Horn without paying toll, and to travel by the steamers on the Bosporus free of charge. The regard of Turks for animals is well known. If, again, the legal and ascetic prohibition of the use

of intoxicants by Mahomet is not the noblest
method of educating free agents in self-control,
the sober habits of a Moslem community and the
rarity of violent crimes in it, when uncontaminated
by foreign influence, are advantages not to be de-
spised. A distinctive feature of a Turkish quarter
in town or village is the absence of a wine-shop. On
the other hand, the segregation of the sexes, while
it diminishes the "social evil," fosters a sensual tone
of thought and feeling in Mohammedan society,
that contrast most unfavourably with the chivalrous
sentiments entertained towards womanhood in
Western civilisation. The martial spirit congenial
to Islam has its admirable side, but, by the un-
fortunate sanction of the use of the sword for the
suppression of unbelievers, unspeakable atrocities
have been committed under the mantle of religion ;
as, indeed, wherever a similar sanction has been
allowed. Opinions differ as to the lengths to which
this spirit would go, if Turkish Power were, under
certain circumstances, driven to despair and brought
to bay. Will the part of Samson Agonistes be
repeated then ?—" The edifice, where all were met
to see him, upon their heads and on his own he
pulled." There are some who think so. But much
may be said in favour of the contrary opinion.

The Turk is a brave man, but he can be cowed by superior strength, firmly applied. A Turkish maxim says : "The hand you cannot cut, kiss, and press to your forehead." This is not like Samson.

It is not, however, only the Turkish community that presents a religious colour. The same is true of the other communities of the country. With them, also, the nation has come to be the Church. This is due, in part, to circumstances anterior to the Turkish Conquest. The theological disputes between Christians in the earlier centuries of the history of the Church, even if purely religious and philosophical at first, erelong assumed a national character, and became respectively the banners around which racial distinctions and political antagonisms rallied, and acquired a consistence which endures to this day. How deeply ingrained in the Christian population of the country, to-day, is the spirit to see things under a religious colour appears, sometimes, in small but significant ways. A poor Greek woman, anxious to find a husband for her daughter, who was neither young nor beautiful, was informed that a worthy boatman was prepared to marry the girl. He had everything to recommend him, but he was an Armenian. "What!" exclaimed the mother, turning indignantly

30

to the friend who recommended the man; " What!
do you wish me to give my daughter to an Arian?
No; let her rather die." Evidently the woman
was not an expert in the use of theological terms,
for the Armenians are not Arians. But her reply
shows that old theological disputes, which one
might suppose had been forgotten, have left their
impress upon the popular mind, and are associated
with national distinctions. The division between
Eastern and Western Christendom is not merely a
religious schism. The organisations known as the
Coptic Church, the Nestorian Church, the Armenian
Church, are not simply different ecclesiastical de-
nominations, or various schools of thought. They
are as much, if not more, the assertion of national
peculiarities. They have maintained, so far as the
times allowed, a people's independence; preserved
the ties which bound a people to its past; and con-
tinued the use of its ancestral speech at home, in
the affairs of social life, and in the worship of God.
With the Turkish Conquest, this fusion of national
and religious sentiments became, if possible, more
complete. The new rule, involving the loss of
political freedom, and the ascendency of an alien
faith, made the Church dearer, and left her to be
the only sphere of anything approaching national

life and independence. The distinction between
Church and Nationality consequently passed out of
sight. And nowhere is the idea that to change
one's religious profession is to be false to one's
people, and that to be a faithful churchman is to
be a patriot, more strongly entrenched than among
the adherents of the Christian communities in
Turkey. On the other hand, the new rulers could
not hope, and did not desire, to assimilate the
Christian populations of the country, or to in-
corporate them in one political body. What with
the differences of race, creed, language, civilisation,
a gulf was fixed between the conquerors and the
conquered. The two parties could be nothing
else but distinct and alien communities. Under
these circumstances, policy and necessity led the
conquerors to maintain the different organisations
in which they found the subjugated peoples already
arranged. To divide and conquer may not be the
highest statesmanship, but it was a principle that,
in the condition of the country, could be quickly
applied. For one thing, by that process the power
of the conquered to rise would be crushed.
Furthermore, to leave the different churches of
the land to their own ways was, after all, the only
solution of the problem how to govern people

who, because of their religious beliefs, and their social institutions, could not be brought under the operation of the Sacred Code of Islam. It would, so far, please the conquered. It would accord with that regard for use and wont, for what he calls *Adet*, which the Turk cherishes. It was practical, and in harmony with the theocratic conception of society familiar to the Moslem mind. Hence the Turkish Government has been accustomed to classify the various peoples of the Empire according to their respective creeds, and has granted them a considerable measure of self-government, in such matters as marriage, inheritance, education, the management of charitable institutions, and jurisdiction over the clergy. As these bodies were ecclesiastical corporations, their ecclesiastical chiefs became at once their rulers, both in religious and in civil affairs, and their representatives in all transactions with the Ottoman authorities. In fact, these communities have enjoyed privileges that give them, in some respects, a status similar to that conferred upon foreigners by the Capitulations. On the principle of religious classification, Greeks, Roumanians, Bulgarians, Servians, were considered members of the same civil community, because members of the same Church.

And, on the same principle, if an Armenian left his National Church to join the Roman Catholic or the Protestant communion, he passed beyond the authority of his former ecclesiastical superiors not only in matters spiritual but also in matters secular, acquiring with his new beliefs a new legal standing, as a "Latin" or an "Evangelical." In this new character, he came under the protection of another chief, was placed under new regulations, and made amenable to a different court. It is because of this intimate union of the religious and the civil, that converts from the National Churches in the Empire have been compelled to form themselves into distinct civil communities, and to incur the odium of, apparently, deserting their own people. But only thus could they escape the pains which their original ecclesiastical authorities had the power to inflict upon dissident subjects ; only thus could the Turkish Government grant the converts a legal independent status in religious life.

This method of dealing with the Christian subjects of the Empire worked, on the whole, smoothly, until the idea of nationality, which has been such a powerful factor in the recent history of Europe, spread also among the various peoples of Turkey, inspiring them to assert their distinct-

ness from one another, and to seek liberation from
the rule of the dominant race. Then great search-
ing of hearts arose. For the new idea was sub-
versive of a system based upon the principle that
the fundamental bond of unity between men is
community of faith. Hence, when the Bulgarians
demanded to be organised into a community dis-
tinct from the Greek community, though one in
doctrine with it, and to have bishops and an
ecclesiastical head of their own nationality, the
request proved a source of considerable difficulty.
The chiefs of the Greek Church, under whose
authority the Bulgarians had been placed since
1767, as fellow-believers, naturally opposed the
demand, taking ground upon the principle that,
"In Jesus Christ there is neither Greek nor
Jew, circumcision nor uncircumcision, Barbarian,
Scythian, bond nor free"; a principle which
Moslems could appreciate. Turkish statesmen
opposed the demand as unconstitutional, and con-
trary to custom; at the same time, suspecting
it to be a step towards ultimate political in-
dependence.

Under these circumstances various expedients
were suggested, whereby the desired result might
be secured in harmony with the law of the land.

TOMB IN SCUTARI

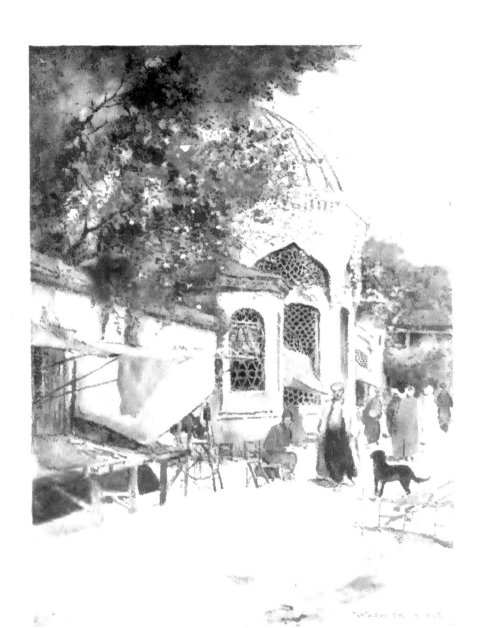

By some of their friends, the Bulgarians were advised to separate from the Greek Church on some unimportant point of doctrine or ritual, and so acquire the right before Turkish law to form a distinct community. Another proposal was to declare themselves Protestants, and thus not only escape from the jurisdiction of the Patriarch of Constantinople, but gain the support of Protestant nations. Yet another plan was to join the Roman Catholic Church, with the advantage of receiving the protection of France. The movement in favour of the last course went so far that a Bulgarian priest was consecrated a Roman Catholic bishop; but the scheme was abruptly terminated by the spiriting away of that personage to Odessa, with all the paraphernalia of his office. Eventually, under Russian pressure, the demand was granted, and the Bulgarians became a distinct civil and religious community on the ground of difference of nationality. They were, however, a religious corporation before the eye of the law, and in view of the large Bulgarian population still under Turkish rule, especially in Macedonia, the Exarch of the Bulgarian Church must reside in Constantinople to have his authority over that class of the community recognised by the

Turkish Government. As though to add more religious colour to the arrangement, the Patriarch of Constantinople, in 1872, laid the Bulgarian Church under the sentence of excommunication as schismatic.

The form in which the Bulgarian question was settled has furnished a precedent which other nationalities, in furtherance of their political aims, have not been slow to appeal to, and which the Turkish Government, with the object of weakening their Christian subjects by sub-divisions, has been, of late, disposed to follow. In the province of Macedonia the system is carried out to perfection. There Bulgarians, Greeks, Servians, and Kutzo-Wlachs, all adherents of the Greek Orthodox Church, have had the fires of their national rivalries fanned into fiercer flame by being organised into different religious communities, under different ecclesiastical superiors, with the result that a situation exists in that province than which nothing more complicated can be imagined.

Before leaving the subject, it is only just to remark that, perhaps, the world has not sufficiently admired the tenacity with which the various Christian peoples of the Near East have adhered to their faith and nationality, in the face of hardships

and temptations to which some of their members succumbed. If their life has been stagnant, it is not altogether their fault. Their circumstances have been exceedingly adverse to growth. But they have kept the treasure, although the vessel which has contained it may be earthen. However much the identification, or confusion, of political and religious issues has wrought mischief among these peoples, however much it has quenched their spirit of brotherly love, it is to their churches that they are mainly indebted for the preservation of their national consciousness and aspirations. Amid the darkness, the churches kept the lamp of hope ever burning. They consecrated patriotism by associating it with loyalty to God. They made faith firmer by uniting it with the love of father-land. And their peoples have lived to see the light of a new day. There is something pathetic in the fact that all this was rendered possible by the degree of self-government in civil and religious matters granted them by their conqueror. There is something tragic in seeing the policy which a conqueror adopted as the only method to establish his rule—nurse the life of his foes, and forge the instruments of his ruin. But men are not always masters of their fate.

31

CHAPTER XII

In the appearance and lot of Turkish women we
see, perhaps, more distinctly than in any other
feature of life in Constantinople the perpetuation
of the ideas and usages which give to Turkish
society its peculiar character and physiognomy.
The assertion is often made that, according to the
Moslem creed, woman has no soul. This is a
mistake. While man, indeed, is considered to be
woman's superior on the ground of his higher
natural endowments and of his services as bread-
winner, the Koran, at the same time, recognises her
spiritual nature and religious capacity. "Verily,"
says that authority, "the resigned men and the
resigned women, the believing men and the believ-
ing women, the devout men and the devout women,
the truthful men and the truthful women, the
patient men and the patient women, the humble

242

men and the humble women, the charitable men
and the charitable women, the fasting men and the
fasting women, the chaste men and the chaste
women, and the men and women who oft remember
God, for them hath God prepared forgiveness
and a mighty recompense." Although the female
companionship which forms one of the delights of
the Mohammedan Paradise will be furnished by
the houris, still earth-born women are also present
in the abodes of bliss. Hence a Turkish mother,
mourning the loss of her little girl, can find comfort
in putting over the child's grave this epitaph :—
"The bird of my heart has flown from its cage
to find a place in the gardens of Paradise." If
Moslem women do not attend public worship in
the mosques, the reason is not any spiritual dis-
qualification, but the idea that the sexes should
associate as little as possible. Yet elderly women
may be seen at their devotions in a mosque out
of the hours of public worship, while during the
religious season of Ramazan special services for
women are held in some of the great mosques of
the city, as well as in the imperial harem and in
the harems of wealthy personages, such services
being conducted by popular preachers. But after
all is said that can be said to prove that honour-

able views concerning woman are cherished in a
society constituted by Moslem thought, it remains
true that the fundamental conception underlying
the organisation of that society and forming its
dominant spirit is of an opposite character. That
conception, we should in justice remember, is not
peculiar to Islam. On the contrary, it has pre-
vailed outside the Mohammedan world; it has
contaminated even the life of Christendom. Never-
theless, the view that man and woman are not
equals, that the latter is chiefly made to minister
to the pleasure of the former, and that they are
morally dangerous to each other, has nowhere been
applied so consistently, on so large a scale, and for
so long a period in the very presence of a higher
civilisation, as in Moslem society. Such a view
demands naturally and necessarily that men and
women should be kept apart as much as the condi-
tions of human existence permit. Where poly-
gamy, concubinage, and easy divorce are lawful
social arrangements, woman must be put behind
the shelter of a jealous protection. She must be
placed out of sight, secluded, guarded, and, when
she appears in public, veiled and forbidden to dis-
play her ornaments. Men, on the other hand,
must avoid looking at a woman they meet abroad,

remembering that "God will reward the Muslim
who, having beheld the beauties of a woman, shuts
his eyes," and that, though the first look is excus-
able, because often unavoidable, the next is un-
lawful. The outward manifestations of these ideas
are seen on every hand in the Turkish life of
Constantinople. Hence the division of a Turkish
home into apartments for men (selamlik) and apart-
ments for women (harem), into the former of which
no Turkish lady enters, and into the latter of
which only the nearest male relatives are admitted.
Hence also the two doors leading from the street
respectively to these divisions of the house; hence
the latticed screens outside the windows of the
harem to conceal the inmates from even the hurried
glance of passers-by. If you have occasion to
call upon a Turk who keeps no man-servant, and
a woman comes to answer the door, she will,
before opening it, inquire who has knocked. If
the caller is a man, and the master of the house
is out, she will refuse admittance in a tone
which makes you feel happy to depart; if the
master is in, she will open the door ajar, leaving
you to open it wide, after you have given her
time to announce your visit, and retire from view.
There is no such thing in Turkish life as a mixed

social gathering of ladies and gentlemen. For husband and wife to walk, or drive, or boat together was unknown until quite recent times, and when such proceedings occur they are regarded with disfavour. In tramway cars, in trains, on steamers, in waiting-rooms, men and women occupy different compartments. Should the ladies' cabin on the steamers which ply between the city and the suburbs on the Bosporus or the Marmora be unoccupied at starting by Turkish women, gentlemen are permitted to seat themselves in it, and to keep their places so long as Moslem women do not appear. But if a Turkish lady embarks at a station on the way, the cabin must be forthwith vacated by its male occupants, who do not present the air of the lords of creation as they wander to find other seats. On one occasion a foreign lady and gentleman reached a certain pier on the Bosporus some time before the arrival of the steamer, which was to convey them to the city, and, finding the ladies' waiting-room empty, seated themselves in it. Presently an elderly Turkish woman, belonging to a somewhat humble class of society, appeared, accompanied by her son, a lad some fourteen years old. According to strict etiquette the gentleman should have left the room. But, as the

lady he was escorting wished him to remain, and as
the Turkish woman looked a motherly person and
had her boy with her, he kept his seat, forgetful
of use and wont. Suddenly the lad in the hanum's
company went out. As the event proved, it was
to bring the man in charge of the pier upon the
scene. The latter approached the gentleman,
whom he knew well, and in the politest possible
manner whispered the information that the Turkish
woman opposite objected to the presence of a
man. There was nothing to be done but for
the intruder to withdraw with as little awkward-
ness as the situation admitted, and the matter
seemed settled to the satisfaction of all concerned.
But the indignation of the foreign lady at the
discomfiture of her escort was too great for the
troubled waters to be calmed so easily. Rushing
out after him, she begged him to protest on her
behalf against the presence of the Turkish lad in
the ladies' room when she was there. So the
faithful man in charge of the pier proceeded to
eject the youth likewise, while the fair complainant
resumed her seat in order to maintain her point
until the steamer came up. How her Turkish
sister felt under the circumstances does not appear,
but the incident illustrates the influence upon the

native mind of the idea that men and women should be kept strictly apart.

For a woman's hair to be exposed to public view is considered an extreme humiliation. A poor Turkish woman on her way to an asylum threw herself in a fit of wild excitement upon the ground, and, in doing so, threw off the veil which covered her head. "Alas, alas," screamed the female friends who accompanied her, "she is showing her hair!" as though that exposure was the worst feature of the case.

It would be a mistake, however, to infer from what has been said that the seclusion to which Turkish women are consigned deprives them of all freedom and social influence. The reverse is true. Wealthy ladies control their own property even after their marriage. Furthermore, if seclusion denies women certain privileges, it wins for them certain rights—the right, above all, to have their seclusion respected. It secures for them the regard cherished for those who have a great public duty to perform, and entitles them to all the support requisite for the discharge of that duty. A highly educated Turk, upon hearing of the annoyance given to some Turkish ladies by the inquisitive gaze of certain foreigners, expressed his indignation

in the following curious fashion : " Such conduct
towards European ladies would not be strange, for
they exhibit themselves to public view, and must
take the consequences ; but to treat Turkish ladies
thus, when they have the right to enjoy perfect
privacy, was intolerable impertinence." Although
it is not becoming for a Turkish lady to go out by
herself, a company of Turkish women may go any-
where, not only without fear of molestation, but
without attracting the slightest notice. Even the
police shrink from interfering with them. Some-
times Turkish women will refuse to pay toll for
crossing the bridges which span the Golden Horn,
and defy all the attempts of the toll-men to enforce
payment. One has seen Turkish women embark
on a Bosporus steamer without tickets, and when
challenged for doing so, take off a slipper, strike
the ticket-collector, and proceed on their way none
the poorer. Like a famous thistle, a Turkish
woman cannot be touched with impunity. Nor
is it strange that a man's female relatives should
influence him in Turkey, as much as they do in
other countries and in similar ways. After all,
men and women are everywhere much the same,
and no artificial arrangements can altogether pre-
vent the operation of natural forces. Indeed, a

32

man is, perhaps, more liable to be swayed by his
female relatives when they are the only women
he meets. But be that as it may, women related
to the great officers of State exercise considerable
political influence. The mother of the Sultan,
known as the Validé Sultana, is the first lady in the
land, and, if a woman of capacity, is a power behind
the throne. It is reported that the famous British
ambassador, Sir Stratford Canning, had once
occasion to suggest to the Sultan of his day that
in taking a certain course of action the sovereign
of the Empire was yielding to a mother's counsels.
"True," replied the monarch, "but she is the only
friend I can perfectly trust as sincerely devoted to
me." Several years ago, delay in the payment of
salaries, no unfrequent occurrence in Constan-
tinople, caused great suffering among the humbler
employees of the Government. Other methods of
redress having failed, the aggrieved parties betook
themselves to the weapon of female force. Accord-
ingly, a large body of women, mostly the wives of
the poor men, but including professional female
agitators, invaded the offices of the Minister of
Finance. They filled every corridor, swarmed
upon every stairway, blocked every door they
could find, and made the building resound with

lamentations and clamours for payment. The
Minister managed to escape by a back entrance.
But the women would not budge. It was vain to
call in the police or soldiers to intervene. The in-
decorum of a public application of force in dealing
with the women would have created too great a
scandal, and so the authorities bowed before "the
might of weakness," and made the best terms they
could induce the victors to accept. A more recent
experience of the power of Turkish women to
interfere, in spite of their seclusion, with the affairs
of the outer world, may be added. The owners of
a piece of land adjoining a Turkish village on the
Bosporus decided to enclose their property with a
substantial wall of stone and mortar. As the
ground had long been a pleasant resort for the
women and children of the village, especially on
Fridays, where sitting on the ground under the
shade of trees they enjoyed the fresh air and the
beautiful views on every side, the villagers very
naturally regretted the loss which the erection of
the wall would involve, and they determined to
prevent the execution of the work to the utmost
of their power. The opposition first assumed a
legal form. It was urged that the wall would
interfere with the water-course which supplied the

village fountain, and furthermore, would include a piece of land belonging to the community. Both objections were shown to be without foundation, and building operations were begun. No difficulties were raised until the wall approached the fountain and the land in dispute, when it became evident that if the work proceeded farther the opposition would resort to violent measures. In the hope of coming to a friendly understanding with the villagers by additional explanations, work was suspended for some time, but the negotiations to establish peace having failed, the erection of the wall was continued. The work had not gone far, when a band of women appeared, led by the principal female personage in the community, who enjoyed the distinction of being both the widow of the late imaum of the village mosque and the mother of the present incumbent of that office; a dark-visaged dame, with a sharp tongue. Not a single man accompanied the women. Armed with sticks and stones, the band of Amazons rushed upon the workmen and drove them off. The intervention of the police obliged the women to retreat, but, when the masons returned next morning to their work, they found the women already upon the scene of action. The imaum's widow

with another woman had seated themselves in the
trench and defied the erection of the wall over their
bodies! Again the police interfered, and, after all
methods of gentle moral suasion had proved useless,
they actually lifted the imaum's widow somewhat
forcibly out of the trench. She took the affront so
much to heart that she kept her bed for several
days. There was a consequent lull in the storm.
But soon the women resumed the struggle, coming
in the dark and tearing down a considerable portion
of the building. The wall had therefore to be
guarded by the police during the day, and by
watchmen during the night. Still the women
would not abandon the contest, and, as a supreme
effort, sent a long telegram to the Palace, invoking
the sovereign's aid and protection. In reply, they
were invited to send a deputation to the Police
Court connected with the imperial residence. The
pasha of the Court was a veteran official who,
though he could not read, and knew to write only
his own name, had reached his responsible position
by force of character and the possession of common
sense. He expounded the law to the women
before him, informed them that he intended to
enforce it, and gave them a tremendous scolding
for the manner in which they and their sisters had

behaved; seasoning justice, however, with mercy, to the extent of presenting them a small sum of money wherewith to meet the expense of their visit to him and of their telegram.

The young imaum of the village was also summoned, and made to understand that, unless his mother's influence was employed to keep the peace, he should lose his place. Accordingly, the war stopped, but there were threats that the two persons most concerned with the erection of the wall would be stoned to death. The threats were so serious that even a brave Croat, in the service of the proprietors of the enclosed ground, advised the superintendent of the works to avoid a road which would expose him to assault. "I am an old man," replied the latter, a Briton, "it will not matter much if I am stoned to death." "But," answered the Croat, "will it not be a shame to be killed by women?" It was an ungallant remark to make, in view of the spirit displayed by the women, yet a characteristic expression of that poor estimate of womanhood against which the weaker sex has still to contend in the East—the estimate which led Abimelech, long ago, when at the point of death by a blow from a woman's hand, to beseech his armour-bearer to kill him, lest men should say "a woman slew him."

THE SWEET WATERS OF EUROPE

A pleasure resort near the upper end of the Golden
Horn much in favour in the spring, when every
Friday afternoon crowds of Turkish ladies with their
children flock there for recreation by the water-side

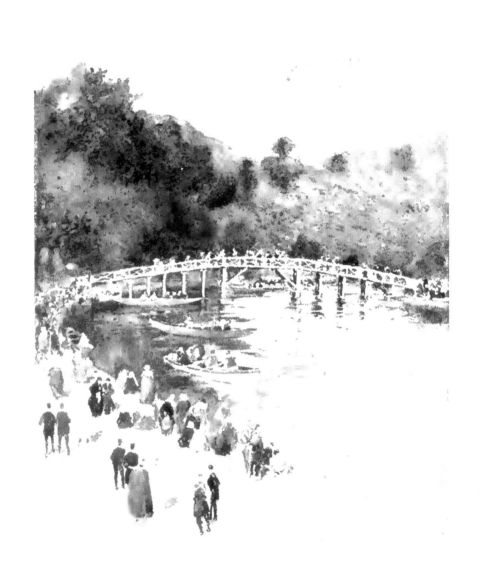

But the world moves, and Turkish women move with it. The last generation has witnessed remarkable changes in their habits both in the capital and in other great cities of the Empire. For one thing, there has been a striking change in the matter of dress. The time was, when a Turkish woman brought vivid colouring into every scene she adorned. Her yashmak, enveloping head and face and neck in white gauze; her feredjé enfolding her form down to the feet in red, green, blue, pink, or any other hue she fancied; her yellow boots and yellow overshoes, worn like slippers, made her as gay and bright as a butterfly or a flower. What wonderful pictures did groups of women thus attired form, as they squatted on a red rug spread on the green grass under the shade of cypresses or plane-trees, beside the Sweet Waters of Europe and the Heavenly Waters of Asia; or as they sat in long rows by the shores of the Bosporus to drink in the salt air, to watch the blue waters and the hurrying to and fro of boats and sails and steamers; or as they floated in a caïque over the quiet sea. What a fantasia of colour they made as they went slowly past, seated in a long, narrow wagon (arabah), its high sides bright with painted flowers and gilded

arabesque, under a scarlet awning edged with gold
fringe, drawn by white oxen, over whose heads heavy
red tassels, attached to rods fixed in the yoke, waved
with every motion of the creaking wheels!

But this feast of colour has ended, and the
world of Turkish womanhood has exchanged the
brightness of summer for the sober tints of autumn.
The yashmak is now universally discarded, except
by the ladies of the imperial household who are still
required to wear it, as well as a black feredjé; the
only bit of bright colour permitted being in the
matter of the headkerchief of tulle they wear under
the yashmak. In the costume of the mass of
Turkish women, the feredjé has been replaced by
the charshaf, a mantle worn over the head and
about the body down to the feet, drawn in slightly
at the waist. The material and the colour of the
garment differ according to the means and taste
of the wearer, but the colour is always quiet and
subdued. To the portion of the charshaf above
the eyes a dark veil is attached, and this can be
worn over the face, or thrown back over the head, as
the wearer pleases. When thrown back, a Turkish
lady's face is seen as plainly as that of her
European sister. The charshaf may also be made
of two pieces of cloth in order to secure a better

THE YASHMAK

'The veil is sometimes so transparent that it so rcely
conceals the features at all

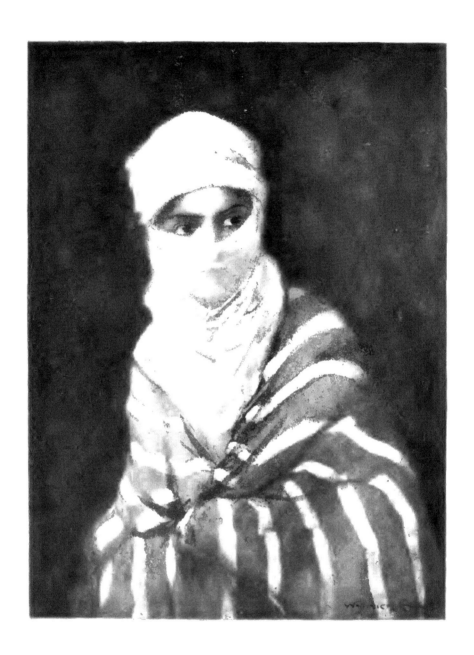

fit, and although the garb might seem to defy
artistic arrangement and effect, it is often very
becoming and graceful. It would appear that
the charshaf was the original dress of Turkish
women, with the important difference from the
present fashion that the veil could not be thrown
back, and was furnished with two holes for the
eyes, as among Moslem women to-day in Persia
and India. The yashmak, it is said, came into
vogue at the time of the Conquest, being an
adaptation of the veil worn then by women of
the Christian peoples of the land. Its abandon-
ment for the sake of a style which permits greater
freedom is a sign of progress. But the change,
which was made some thirty years ago, roused
considerable opposition. Merchants in the bazaars
objected to it, because a charshaf required less
material to be made up than a feredjé, and con-
sequently injured trade. Others found fault with
it simply because it was an innovation; while
others feared that when worn with the veil down
it might facilitate disguise in carrying on social
or political intrigues. Nay, imperial iradès de-
nounced and forbade the new mode. But all was
in vain, for even in Turkey it is possible for
women to have their own way. Nor is it only

in their out-door dress that Turkish women have introduced alterations. They have done so likewise in their dress when at home. The baggy trousers, the embroidered vest and jacket, which constituted the costume in which a Turkish hanum reclined upon her divan, have been replaced, in the progressive section of Turkish female society, by garments after European fashions. A Turkish bride belonging to a wealthy family wears a wedding dress like that which adorns a young lady under similar circumstances in Western lands, the only difference being that the former allows her hair to hang down, and decorates it with long narrow streamers of tinsel, pieces of which she presents to her young friends for good luck. Elegant tea-gowns and the latest Parisian robes are worn in wealthy harems. Turkish ladies, indeed, have yet to adopt the low-necked dress, but, not to be altogether behind the times, they make their servant-maids don that attire on great occasions. When the maids are dark-skinned daughters of Africa, the effect is not flattering to the costume. But after all, these changes are interesting chiefly as indications of the fact that the spirit of Turkish women has come, to some degree, under the influence of new ideas. Poly-

gamy is on the decline. Greater attention is now
paid to the education of girls among all classes of
the community. In wealthy families it is common
for the daughters to have English or French or
German governesses, and to be instructed in the
ordinary branches of education, even to the extent
of doing something so foreign as to learn to ride.
In a few instances, Turkish girls attend foreign
schools, and it is a most significant sign of the times
to see the female relatives of such girls present
at the public proceedings of these institutions.
Periodicals providing special literature for ladies
have appeared, and there are Turkish authoresses,
some of whom enjoy a great reputation among
their countrywomen. As might be expected, this
upward movement meets with opposition, as up-
ward movements always meet wherever they occur.
Such a thing has been known as an imperial iradè,
commanding all foreign governesses to be dismissed
from Turkish homes, because teachers of pernicious
ideas. On the eve of Ramazan it is usual to issue
strict orders for Turkish ladies to keep their veils
down. A Turkish lady once attended, with her
husband, an "At Home" in a foreign house. Shortly
thereafter, the police called upon the gentleman,
late in the evening, as the custom is in this part

of the world, and informed him that he was wanted
at the police-court next morning on important
business. What that business was the police did
not condescend to say, preferring to make night
uncomfortable for the couple, by keeping them
in suspense. Upon appearing at the court, the
husband learned that the visit of his wife to a
foreign house, on the occasion referred to, had
been noticed and duly reported to the authorities,
and he was warned (under threat of severe penalty)
not to allow the offence to be repeated. At
public gatherings at the Sweet Waters of Europe
and Asia, the police watch the behaviour of
Turkish ladies as though so many naughty or
helpless children were abroad. One has seen
a policeman order a lady to put up the window
of her carriage, because she attracted too much
admiration. At another time, one has seen a
company of respectable Turkish ladies, who were
enjoying a moonlight row on the Bosporus, packed
home by the police. The life of educated Turkish
women is rendered hard and humiliating by such
restrictions. On the occasion of a visit to a
Turkish gentleman in his garden, it so happened
that two of his nieces, not knowing that any one
was calling, came to greet their uncle. Surprised

THE SWEET WATERS OF ASIA

Another favourite pleasure resort much frequented by
Turkish ladies in summer

at seeing a man with him, the young ladies
started back, as gazelles might start at the sight
of a hunter. Their uncle, however, summoned
them to return, and with extreme courtesy intro-
duced them to his visitor, with the information
that one of the young ladies could speak English.
Conversation in that language had not gone far,
when another gentleman was announced. In-
stantly the girls sprang to their feet and darted
away as for dear life. "See," said the uncle in
tones of mingled vexation and sorrow, "See what
it is to be an educated Turkish lady!"

A Turkish gentleman of high rank wishing his
daughters to enjoy the advantage of a European
education, but anxious to spare them as much as
possible the chagrin and ennui of being educated
above the station of a Turkish lady, hoped to
attain his object by having his girls learn to speak
French without being able to read in that
language. Such experiences are disheartening.
But, as the pale flowers which come ere winter has
wholly gone herald the spring and foretell the
glory of summer, so the recent improvements in
the lot of Turkish women, however slight they
may appear meantime, warrant the hope of further
progress and final emancipation.

CHAPTER XIII

EPILOGUE

To live in Constantinople is to live in a very wide
world. The city, it is true, is not a seat of lofty
intellectual thought. Upon none of its hills have
the Muses come to dwell. It is not a centre of
literary activity; it is not a home of Art. Here
is no civic life to share, no far-reaching public
works of philanthropy to enlarge the heart, no
comprehensive national life to inspire patriotism,
no common religious institutions to awaken the
sense of a vast brotherhood enfolded within the
same great and gracious heavens. If one is so
inclined, it is easy for life here to be exceedingly
petty. And yet, it is certain that to live in Con-
stantinople is to live in a wide world. It is not for
any lack of incentive that a resident here fails "to
think imperially" or to feel on an imperial scale.
When a man possessed by the genius of the place

262

quits the city to reside elsewhere, the horizon of his life contracts and dwindles, as when a man descends from the wide views of a mountain peak to the life pent within the walls of a valley. For nowhere else is the mind not only confronted, but, if one may thus express it, assailed by so many varied subjects demanding consideration, or the heart appealed to by so many interests for its sympathy.

The very geography of the place offers a wide outlook. As a part of his everyday experience, a resident of Constantinople lives within sight of Europe and Asia. Every day of his life, he sees the waterway that runs between the two great continents thronged with vessels of every nation, hurrying to and fro to bring the ends of the earth together. Then, how much human power has been enthroned here—the dominion of Byzantium for one thousand years; the rule of Constantine and his successors for eleven centuries; the sway of the Ottoman Sultans through four hundred and fifty years. If what we see has aught to do with what we are, here is a mould in which to fashion a large life. But Europe and Asia are present in more than their physical aspects, or in long periods of their history. Their civilisations also meet here.

On every side there is the pressure of a dominant Oriental society and polity, with its theocratic government, autocracy, the creed of Islam, polygamy, slavery, eunuchs, secluded and veiled womanhood, men in long robes and turbans, sluggishness, repose, the speech of Central Asia softened by the accents of Persia and Arabia, minarets, domes surmounted by the Crescent, graceful but strange salutations, festivals which celebrate events in a course of history not your own, and express joys which have never gladdened your soul. And mingling, but not blended, with this world of Asiatic thought and sentiment and manner, is a European world, partly native, partly foreign, with ideas of freedom, science, education, bustle, various languages, railroads, tramways, ladies in the latest Parisian fashions, church bells, the banner of the Cross, newspapers and periodicals from every European and American capital, knitting scattered children to the life of their fatherland. The members of the foreign communities in the City of the Sultan do not forget the lands of their birth, or of their race and allegiance. Though circumstances have carried them far from their native shores and skies, physical separation does not sever them from the spirit of their peoples. Nay, as if to

make patriotic sentiment more easy, foreigners are placed under the peculiar arrangements embodied in what are termed the Capitulations, whereby, in virtue of old treaties, they enjoy the privilege of living to a great extent under the laws of their respective countries, with little interference on the part of the Ottoman Government. When your house is your castle, in the sense that no Turkish policeman dares enter it without the authorisation of your Consulate or Embassy, when legal differences between yourself and your fellow-countrymen are submitted to judges, and argued by barristers, bred in the law which rules in your own land, when your church and school can be what they are at home, and when you can forward your letters, not only to foreign countries but even to some parts of the Turkish Empire, with a stamp bearing the badge of your own Government, it is natural that European residents in Constantinople should be able to preserve their special character, both after living here for many years, and also from generation to generation. A Mohammedan polity is opposed to the assimilation of strangers, unless the aliens become converts to Islam. Whatever process of assimilation goes on in Constantinople appears in the slow changes of the East towards some likeness

34

to the West. Otherwise, the European world is
as present to the view as the Asiatic, and together
they spread a wide vista before the mind.

Furthermore, what a broad outlook does the
heterogeneous population afford! Whether you
walk the streets or stay at home, on the mart of
business, at all large social gatherings, in all public
enterprises, you deal with diverse nationalities and
races Everywhere and always a cosmopolitan
atmosphere pervades your life. One servant in
your household will be a Greek, another an
Armenian, a third a German or an Englishman.
Your gardener is a Croat, as tender to flowers as
he is fierce against his foes. The boatmen of your
caïque are Turks. In building a house, the founda-
tions are excavated by Lazes; the quarrymen must
be Croats; the masons and carpenters are Greeks
and Armenians; the hodmen, Kurds; the hamals,
Turks; the plumbers, Italians; the architect is an
Englishman, American, or a foreigner of some
other kind; the glaziers must be Jews. Fourteen
nationalities are represented by the students and
professors of an international college.

When the season of pilgrimages comes round,
the streets are thronged by Tartars, Circassians,
Persians, Turcomans, on their way to Mecca

and Medina, wild-looking fellows in rough but picturesque garb, staring with the wonder and simplicity of children at the novelties they see, purchasing trifles as though treasures, yet stopping to give alms to a beggar, and groping for the higher life.

Nor is it only in great matters that this wideness of human life comes home to the mind in Constantinople. It is pressed upon the attention by the diversity that prevails, likewise, in matters of comparatively slight importance; in such an affair, for example, as the calculation of time. For some, the pivotal event of history is the birth of Christ; for others, it is the Flight of Mahomet from Mecca to Medina, and accordingly, two systems of the world's chronology are in vogue. One large part of the populations still adheres to the primitive idea that a new day commences at sunset, while another part of the community defers that event until the moment after midnight. Hence in your movements and engagements you have constantly to calculate the precise time of day according to both views upon the subject. The time-tables of the steamers which ply between the city and the suburbs on the Bosporus and the Sea of Marmora, adopt "Turkish time," and require you to convert

the hour indicated into the corresponding hour
from the European or "Frank" standpoint; and
the same two-fold way of thinking on the subject
is imposed upon all persons having dealings with
the Government and the native population in
general. A similar diversity exists in regard to
the length of the year. The Turkish year consists
of twelve lunar months, a thirteenth being added
from time to time to settle accounts with the sun.
The question when Ramazan, the month of fasting
by day and of feasting at night begins, or when the
festival of Bairam commences is determined, at
least formally, by the appearance of the new
moon, upon the testimony of two Moslem wit-
nesses before a judge in any part of the Empire.
Thus these religious seasons might commence on
different days in different localities, the moon not
being visible in some places, on account of the
state of the weather. The formula in which the
approach of these seasons is now announced to the
public, since the increase of astronomical knowledge
in Turkish circles, is a curious compromise between
former uncertainty and actual assurance on that
point. "Ramazan begins (say) on Tuesday next,
provided the new moon is visible. If not, the
Fast will date from Wednesday." Alongside the

Turkish mode of measuring the year, there is
the method introduced into the Roman world
by Julius Cæsar, the "Old Style," followed by
Greeks and Armenians, and also the "New Style,"
the mode of reckoning inaugurated by Pope
Gregory XIII., now thirteen days in advance of
the Julian Calendar. Accordingly, to prevent mis-
takes in regard to a date, letters and newspapers
are often dated according to both styles. With
some the year begins in March, with the advent
of spring; with others it commences in September,
when autumn gathers in the fruits of the earth;
others make January, in midwinter, their starting-
point. The difference between the "Old Style"
and the "New Style" involves two celebrations, as
a rule, of Easter, two observances of New Year's
Day, while Christmas is celebrated three times,
the Armenian Church having combined the com-
memoration of that festival with the more ancient
festival of the Epiphany. For one section of the
community, moreover, the day of rest is Sunday,
for another Saturday, for yet another the day of
special religious services is Friday. All these differ-
ences are not matters seen at a remote distance of
place or time; they are not curious items of archæo-
logical lore. On the contrary, they enter into the

practical experience of your workaday life, compelling you to see things from various points of view, and to conform with the ways of humanity in manifold directions.

Then what a diversified scene is spread before the mind by the variety of religious faiths professed here. A native of Constantinople put the case before the Parliament of Religions, held at the Chicago Exposition, thus: "We have a Parliament of Religions every day in Constantinople." The faith of Israel, Mohammedanism, and Christianity, are here matched against each other in great organised communities, with the marks of the controversies and wars which form so large a part of the history of this Eastern world fresh and clear upon them.

Here are the sects and schools of thought which divide Islam; the Sunnites who maintain the legitimacy of all the Caliphs, the Shiites who hold that Ali, the cousin and son-in-law of the Prophet, was his first lawful successor, and who gather annually in the court of the Validè Khan in Stamboul, to cut and gash themselves, like their brethren in Persia, as they mourn the murder of Ali's sons, Hussein and Hassan; the Howling and the Dancing Dervishes who hope to apprehend the Divine in

their ecstasy, the Bektashs Dervishes, more rational-
istic, more tolerant, more latitudinarian. Here are
the sects that divide the Christian world ; Orthodox
Greek, Roman Catholic, Gregorian Armenian,
Protestant, representatives of the Nestorian
Church, and of the Syrian Jacobites. What long
vistas of Church History are thus open on every
hand; what different modes of conceiving truths
stare you in the face at every turn !

Finally, but not least, there is the spacious out-
look afforded by the political situation, of which
Constantinople has long been the centre. The
question of the continued existence of the Ottoman
rule in Europe, if not also in Asia, has been a
burning question for many generations, affecting
both the destiny of the peoples subject to that rule
and the interests and relations of all the Great
Powers of Europe. It is one of the biggest, most
important, most complicated problems that can
occupy the minds of the statesmen of the world,
and it has no less magnitude in its appeals to the
concern of philanthropists. Here, to speak with
malice to none and with charity for all, is a rule
established by the might of conquest over different
races, rival nationalities, various creeds. As already
observed, the conquerors have neither wished nor

been able to efface these distinctions, nor have
the conquered had any inclination to be merged
into a common life and polity. In such a
state of things it is not surprising that no love
has been lost. Legend has it that the battle of
Chalons was waged with such ferocity, that,
after the bodies of the combatants lay cold upon
the ground, their spirits continued to fight in the
air. The struggle between the conqueror and the
conquered in Turkey has raged in their hearts
even when, to all appearance, it seemed to have
ended. In thought and sentiment the country has
always been in a state of war. That a rule carried
on in the spirit of conquest and of religious ex-
clusiveness should have involved intolerable treat-
ment of the subject peoples is only what might be
expected, notwithstanding occasional good inten-
tions. And that peoples thus treated, and per-
sistently reminded of their subjugation and inferior
legal standing should never abandon the hope of
deliverance, and should even endeavour to create
opportunities to achieve emancipation is, like-
wise, only what might be expected. Whether the
subject peoples could have already gained their
liberty, if they had been united, is a question open
to debate. But what is certain is that their rivalries,

their dissensions, and their natural but incompatible expectations, have retarded the realisation of their ambitions. To a large extent, this is their misfortune ; the fate imposed upon them by their circumstances. Look, for example, at the situation in the European portion of the Empire. How can any one expect Roumanians, Servians, Bulgarians, Greeks, and Albanians to forget their historical antecedents, their race distinctions, and their associations with different parts of the country, in order to become one nationality ? How can they be persuaded to combine in a common effort to become free, while the points in dispute between themselves remain unsettled ? The question is rendered yet more difficult when these peoples, as is often the case, dwell side by side in the same section of the country.

Here is a tangle of claims which an impartial mind finds hard to unravel, and feels tempted to relegate to the sword that cuts the Gordian knot. The fundamental difficulty that hinders the solution of what is known as "the Eastern Question" is the absence of a large homogeneous population within the bounds of the Empire, to which the Government of the country can be transferred from the hands of the present ruling race. No single people, under

Ottoman rule, can replace the Turk in the master-
ship of the whole Empire. It is a property that
must be divided, and the division of the inherit-
ance, if it is to be carried out in the spirit of
justice and common sense and not of partisanship,
is a matter of extreme perplexity. Hence the
occasion for the interference of the Great Powers
of Europe, sometimes to assist the weak, sometimes
to repress risings, sometimes to limit the area of
disturbance, sometimes to extort concessions, some-
times to appropriate a portion of the spoils, always
to guard their own interests, real or artificial. That
interference is crippled, often paralysed, by mutual
jealousies, by native dissensions, by greater concern
for the success of foreign schemes than for the wel-
fare of the country, by the dread of a great war, by
inability to answer clearly the question, What next?
The spectacle presented by the action of the Powers
is not always edifying. It has, at times, provoked
the opinion that they are not powerful, but power-
less. But the historical evolution which is in
process has brought great actors upon the scene.
It keeps great themes continually before the mind.
Again and again, it has been accompanied with the
tramp of armies, and resounded with the thunders
of war. It is studded with Conferences and Con-

gresses, at which the foremost statesmen of the day have discussed the destiny of this city and land, as the most momentous problem of European politics. It is still overshadowed by war-clouds.

Nor has all this been a vain show. In the course of the past century, liberty has won many victories in the Near East. Servia, Roumania, Bulgaria, Greece, have risen from the dead and become independent and progressive nations. Old national memories, stretching, in the case of Greece, as far back as classic times, have united with modern ideas to restore the continuity of history, and to hasten the day when the whole of Europe will move forward together. The flood which covered the land has slowly subsided. Tract after tract of the devastated earth has risen above the waters, and is reclaimed for new life and fruit. And the forces which have produced this wonderful transformation still operate. Who can stay their power? What precise form the final consummation will assume—a federation, the rule of a Free Russia, a group of independent but friendly States, partition between the Great Powers—is a secret no one can meantime divine. The unexpected may happen. But the future destiny of a city which has acted so great a part in the past, and which is

capable of acting an even greater part in the time to come, is only another reason why life here is so large. What other city presents such a problem? One may as soon dwell by the shore of an ocean, or in view of peaks rising to heaven, and fail to be impressed by the greatness of the world, as live in Constantinople without realising the vastness of human interests and problems.

INDEX

THE END

Printed by R & R CLARK, LIMITED, *Edinburgh*

Milton Keynes UK
Ingram Content Group UK Ltd.
UKHW022005040923
428063UK00005B/319